HISTORIC PHOTOS OF
BOSTON

TEXT AND CAPTIONS BY TIMOTHY ORWIG

Turner®
Publishing Company
Nashville, Tennessee • Paducah, Kentucky

In 1911, people gather in front of the Boston Public Library in Copley Square to inaugurate Lemeuel Murlin as the new president of Boston University. Boston University was established in 1869 with a mission to educate students without regard to race, sex, or creed. It began on Beacon Hill before moving to quarters next to the library.

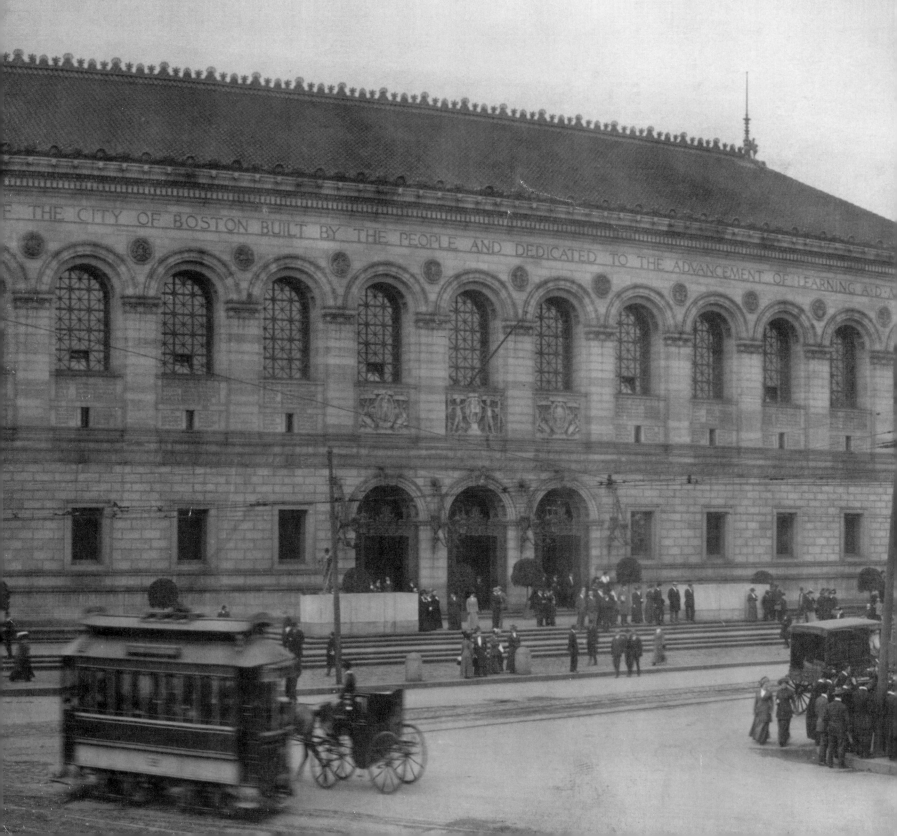

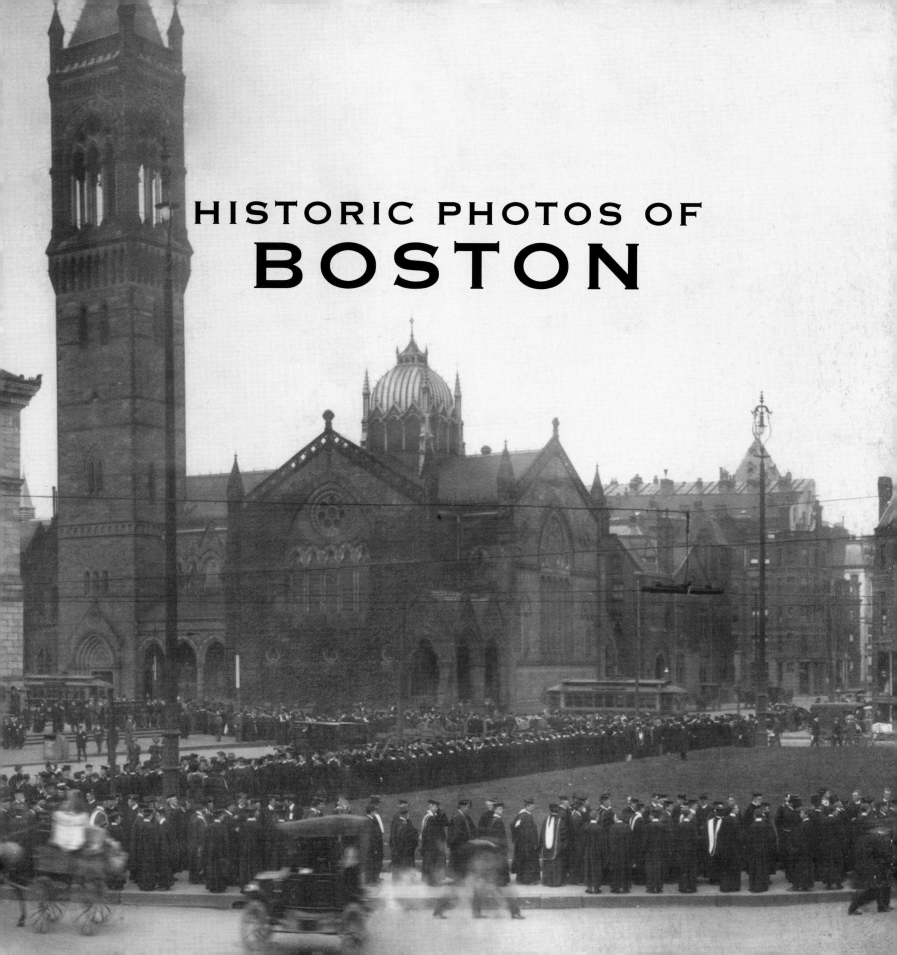

HISTORIC PHOTOS OF
BOSTON

Turner Publishing Company

200 4th Avenue North • Suite 950 412 Broadway • P.O. Box 3101
Nashville, Tennessee 37219 Paducah, Kentucky 42002-3101
(615) 255-2665 (270) 443-0121

www.turnerpublishing.com

Library of Congress Control Number: 2006933653

ISBN: 1-59652-305-0

Printed in the United States of America

0 9 8 7 6 5 4 3 2 1

CONTENTS

ACKNOWLEDGMENTS..VII

PREFACE...VIII

NINETEENTH-CENTURY BOSTON ...1
 (1850–1899)

BOSTON IN THE NEW CENTURY..49
 (1900–1919)

BOSTON BETWEEN THE WARS ..109
 (1920–1939)

WAR, RECOVERY, AND BOSTON AT A CROSSROADS173
 (1940–1960s)

NOTES ON THE PHOTOGRAPHS ..200

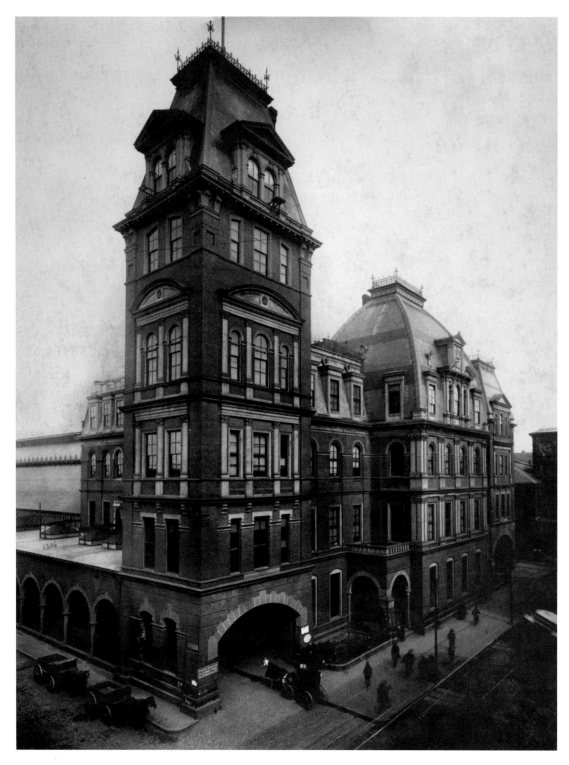

The Boston and Lowell Railroad Station on Causeway Street, shown here upon its completion in 1871, was a grand French Renaissance structure. Designed by Levi Newcomb and Son, its concourse was paneled with oak and floored in marble. It was demolished 1927.

Acknowledgments

This volume, *Historic Photos of Boston,* is the result of the cooperation and efforts of many individuals and organizations. It is with great thanks that we acknowledge the following for their generous support:

Boston Public Library
City of Boston Archives

We would also like to thank the following individuals
for their valuable contributions and assistance in making this work possible:

Roger Reed
Aaron Schmidt, Boston Public Library Print Department
Kristen Swett, City of Boston Archives

PREFACE

Boston has thousands of historic photographs that reside in archives, both locally and nationally. This book began with the observation that, while those photographs are of great interest to many, they are not easily accessible. During a time when Boston is looking ahead and evaluating its future course, many people are asking, "How do we treat the past?" These decisions affect every aspect of the city—architecture, public spaces, commerce, infrastructure—and these, in turn, affect the way that people live their lives. This book seeks to provide easy access to a valuable, objective look into the history of Boston.

The power of photographs is that they are less subjective than words in their treatment of history. Although the photographer can make decisions regarding subject matter and how to capture and present it, photographs do not provide the breadth of interpretation that text does. For this reason, they offer an original, untainted perspective that allows the viewer to interpret and observe.

This project represents countless hours of review and research. The researchers and writer have reviewed thousands of photographs in numerous archives. We greatly appreciate the generous assistance of the individuals and organizations listed in the acknowledgments of this work, without whom this project could not have been completed.

The goal in publishing this work is to provide broader access to this set of extraordinary photographs that seek to inspire, provide perspective, and evoke insight that might assist people who are responsible for determining Boston's future. In addition, the book seeks to preserve the past with adequate respect and reverence.

With the exception of touching up imperfections caused by the damage of time and cropping where necessary, no other changes have been made. The focus and clarity of many images is limited to the technology and the ability of the photographer at the time they were taken.

The work is divided into eras. Beginning with some of the earliest known photographs of Boston, the first section

records photographs from before the Civil War through the end of the nineteenth century. The second section spans the beginning of the twentieth century up to the start of Prohibition. Section Three moves from the twenties to the close of the Great Depression era. The last section covers the forties and beyond, from the World War II era up to the recent past.

In each of these sections we have made an effort to capture various aspects of life through our selection of photographs. People, commerce, transportation, infrastructure, religious institutions, and educational institutions have been included to provide a broad perspective.

We encourage readers to reflect as they go walking in Boston, strolling through the city, its parks, and its neighborhoods. It is the publisher's hope that in utilizing this work, longtime residents will learn something new and that new residents will gain a perspective on where Boston has been, so that each can contribute to its future.

Todd Bottorff, Publisher

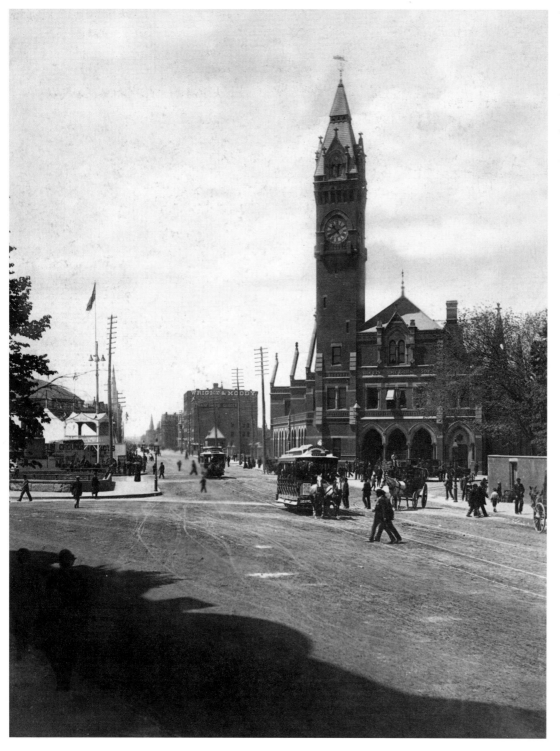

The Boston and Providence Railroad Station opened in Park Square in 1872. Designed by Peabody and Stearns, it was the world's longest station at 850 feet. Abandoned after South Station opened in 1900, the station was eventually replaced with the Statler Building (Park Plaza Hotel).

Nineteenth-century Boston

1850–1899

By the time photography was introduced to Boston in 1840, the city was already more than two centuries old. Governor John Winthrop and his fellow Puritans had settled on the Shawmut peninsula in 1630, naming it Boston after a city in Lincolnshire, England. Winthrop's "City on a Hill" soon became the largest, wealthiest, and most influential settlement in the English colonies in America. Among its many innovations, Boston established the first public school (1635, Boston Latin) and college (1636, Harvard) in the colonies. The revolution which ended British rule began largely in Boston, with the Boston Massacre, Boston Tea Party, Paul Revere's ride, and the Battle of Bunker Hill.

With the formation of the United States, Boston continued to grow and shape American culture. Its importance as a maritime trading power continued, while Boston also became a center for textile production, water-powered manufacturing, banking, and finance. Boston's elite hereditary class, dubbed "Brahmins" by Oliver Wendell Holmes, used its wealth to erect innovative buildings designed by Charles Bulfinch and Alexander Parris, to found private and public libraries, and to support the arts and education. A literary renaissance grew in Boston, led by Ralph Waldo Emerson and driven by Henry David Thoreau, Nathaniel Hawthorne, Margaret Fuller, and John Greenleaf Whittier. This intellectual climate made Boston a center for many reform movements, including free public education, education of the blind, humane treatment of the mentally ill, women's rights, and the abolition of slavery.

The Boston shown in the earliest photographs here, on the eve of the Civil War, was undergoing tremendous growth and change. Early in the eighteenth century, Bostonians had begun cutting down their hills to build wharves out into the harbor. By the early nineteenth century, whole neighborhoods were built atop former bays, most prominently the South End from the 1850s on, and the Back Bay from the 1860s. Fires swept the city periodically, culminating in the 1872 fire which leveled much of the business district. Boston expanded by annexing neighboring towns, including Brighton, Charlestown, Dorchester, Roxbury, and West Roxbury, all in the decade after the Civil War. Linked to Boston by streetcars, these and other neighboring towns made Boston a metropolis by 1900.

These physical changes in the city were driven by population growth. A large town of 18,320 in 1790, by 1890 Boston had grown to a city of nearly half a million people. As the Brahmins established strongholds on Beacon Hill and later the Back Bay, Irish immigrants arrived in increasing numbers (37,000 in 1847 alone) and reshaped Boston's other neighborhoods. Drawn by the promise of a new life, they literally did the heavy lifting that built Boston. In their footsteps came countless other immigrants, including Germans, French Canadians, Italians, Asians, Greeks, Poles, and Jews from Lithuania and Russia. By the time Boston opened the first American subway in 1897, it was a diverse, world-class city.

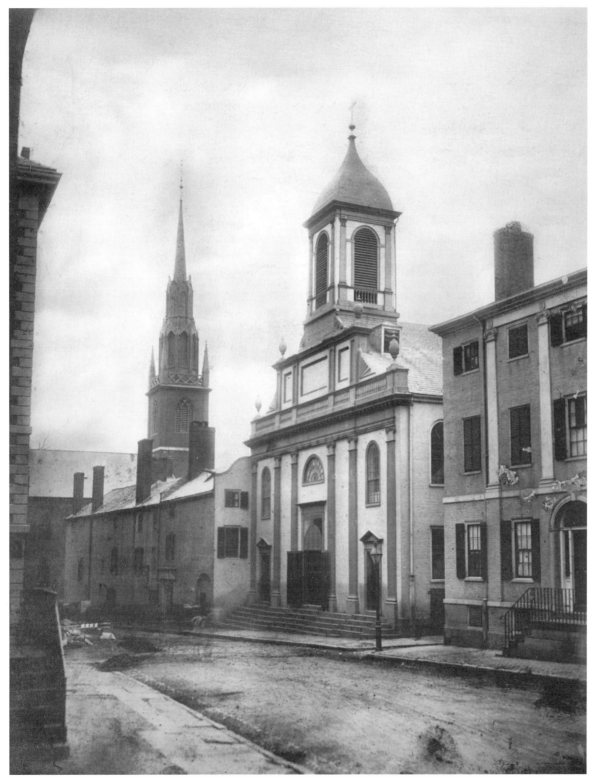

The Cathedral of the Holy Cross, on Franklin Street, was designed by architect Charles Bulfinch and built 1800-1803. Bulfinch drew up the plans as a gift for his friend Bishop John Cheverus, and President John Adams and others subscribed to build Boston's first Roman Catholic cathedral. This view dates to ca. 1850. The building was demolished in 1862.

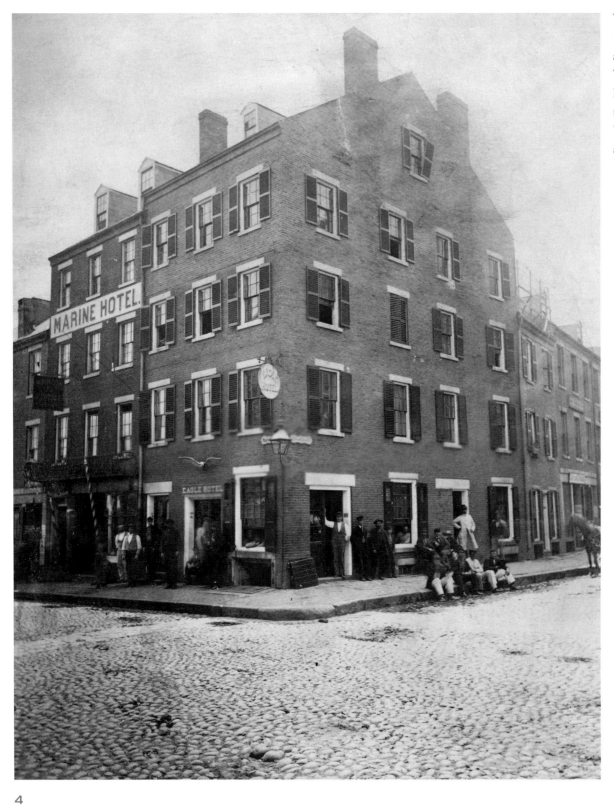

This photograph from ca. 1855 shows the Marine and Eagle (at right) hotels. They stood at the corner of Lewis and Fulton streets in the North End, near Lewis Wharf, convenient to sailors and travelers.

On September 17, 1856, spectators crowd the ledges and rooftops on Court Street for a parade inaugurating the statue of Benjamin Franklin. Sculptor Richard Greenough's monument to Boston's favorite son stands in front of Old City Hall on neighboring School Street.

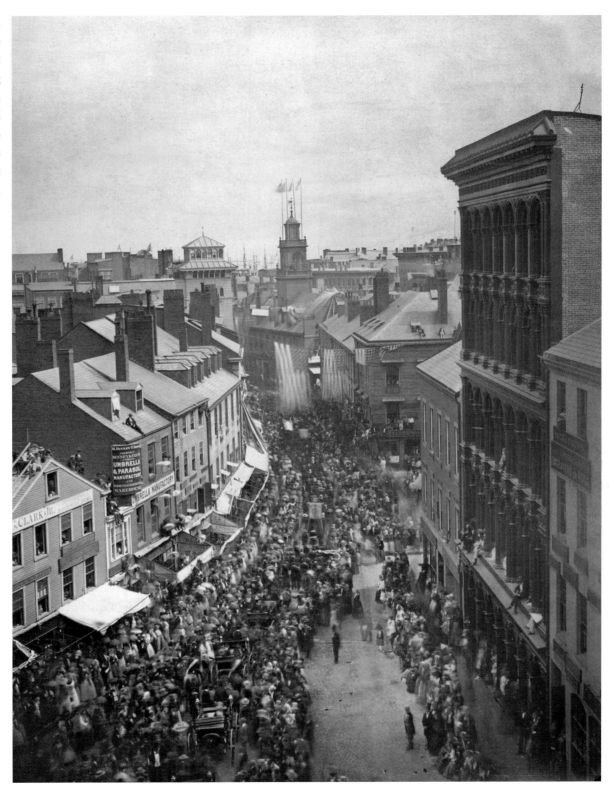

India and Central wharves are shown in 1857 crowded with ships.
They were built out into the harbor between 1803 and 1816. The New
England Aquarium was built on Central Wharf in 1969.

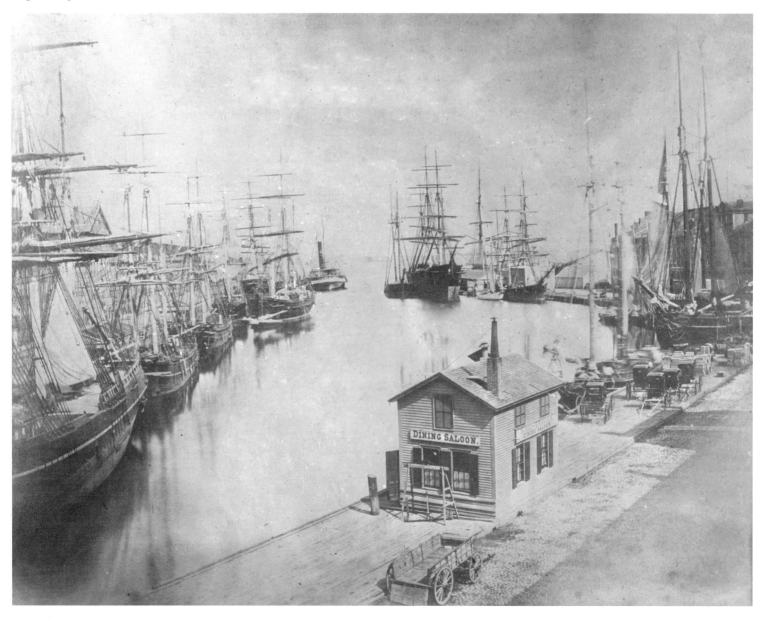

The National Theatre began in 1831 in a building on Traverse Street, in the Bulfinch Triangle. The building was destroyed by fire. This 1860 image shows its Italianate-style replacement, fronting on Portland Street, which opened in 1852.

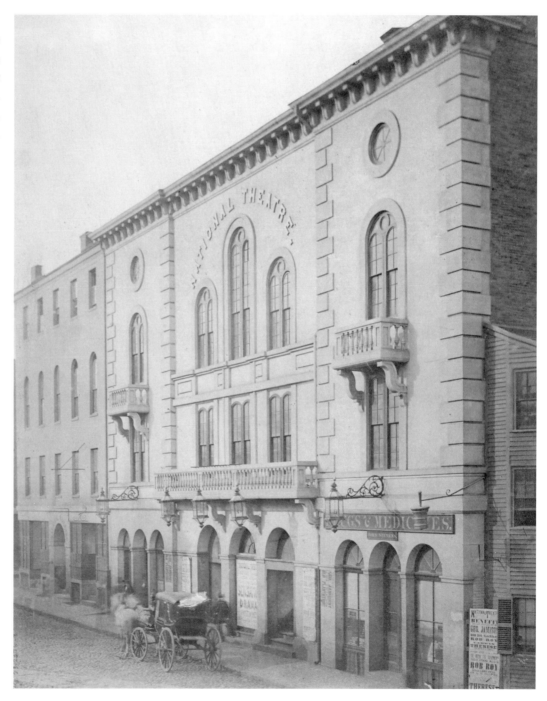

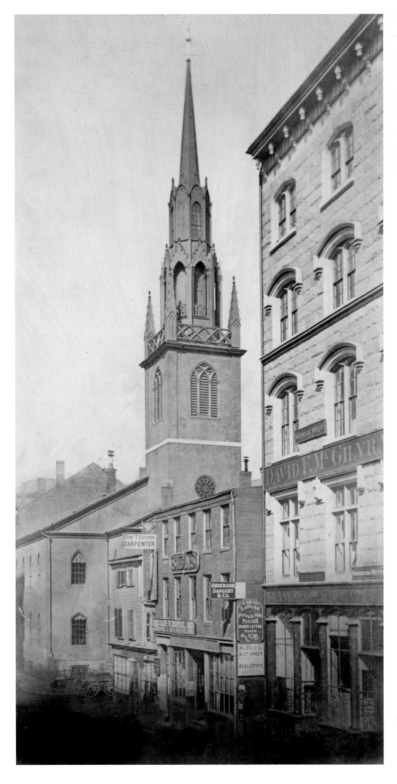

The Federal Street Church (1809) was Charles Bulfinch's only Boston attempt at Gothic Revival. By 1859, the year the church was demolished, Federal Street had become commercial, and the congregation was building the Arlington Street Church in the Back Bay.

Members of the Torrent Six company pose in front of their Roxbury fire station, about 1865. Eustis Street Fire Station, designed by local architect John Roulestone Hall and built in 1859, still anchors this historic district near Dudley Station.

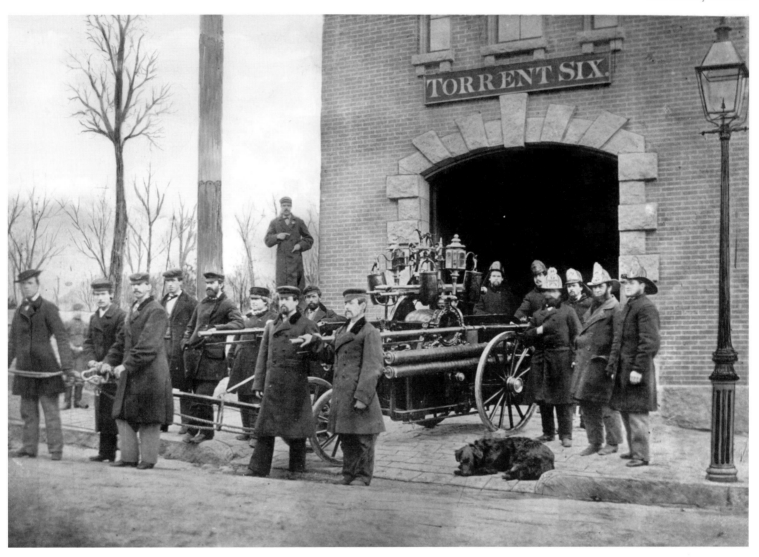

This 1865 view of Washington Street shows the Old South Meeting House, Boston's second-oldest church, built by Joshua Blanchard in 1729. The congregation included Samuel Adams, Benjamin Franklin, and Phyllis Wheatley, and the church hosted the debates that led to the Boston Tea Party.

This 1869 view shows the Old Masonic Temple (1832), designed by Isaiah Rogers, at Tremont Street and Temple Place, which stood next to St. Paul's (Episcopal) Cathedral. Bronson Alcott, father of Louisa May Alcott, ran a school on the second floor of this Gothic granite building.

Quincy Market, designed by Alexander Parris and completed in 1826, was named after Josiah Quincy, the mayor who demolished a maze of wharves and alleys for its construction. In 1870, as shown here, it held agricultural businesses such as Ames Plow Company, and butchers hung carcasses in the halls where tourists shop today.

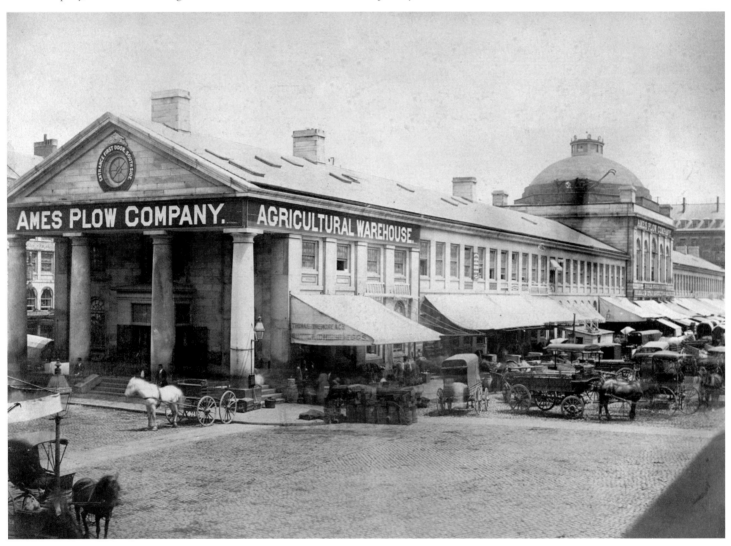

Shown in the 1870s, Central Wharf included a warehouse 1,200 feet long designed by Charles Bulfinch and completed in 1817. As Boston grew, the docks were gradually filled in. Atlantic Avenue (1870s) and the Central Artery (1950s) cut through the old wharf buildings. Only a small part of the Bulfinch Wharf remains today.

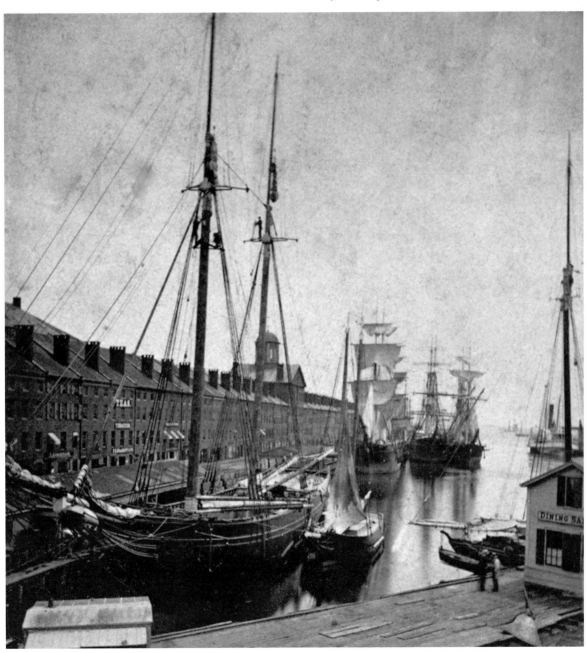

Established in 1800, the Charlestown Navy Yard built and repaired
hundreds of ships, such as the U.S.S. *Kearsarge,* shown here in 1870. The
wharves of the North End can be seen across the Charles River.

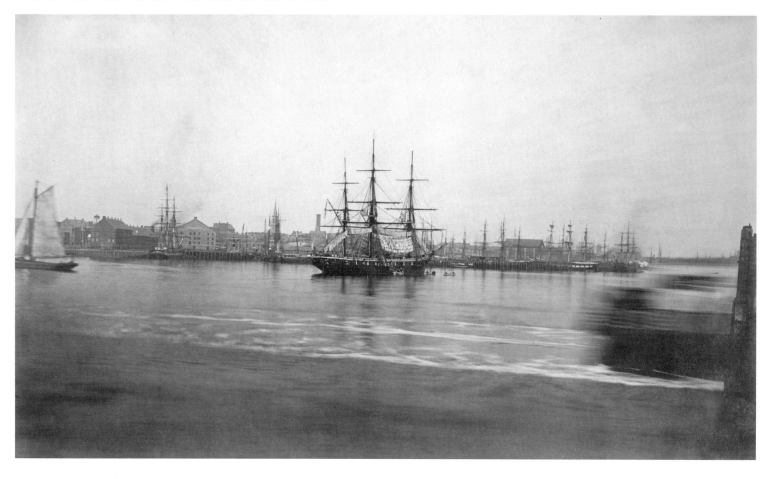

The Rogers Building (built 1863-65) on Boylston Street, shown in the 1870s, was designed by William Gibbons Preston. The Massachusetts Institute of Technology held its first classes here in 1875, but moved to a new campus in Cambridge in 1913. The building was demolished in 1939.

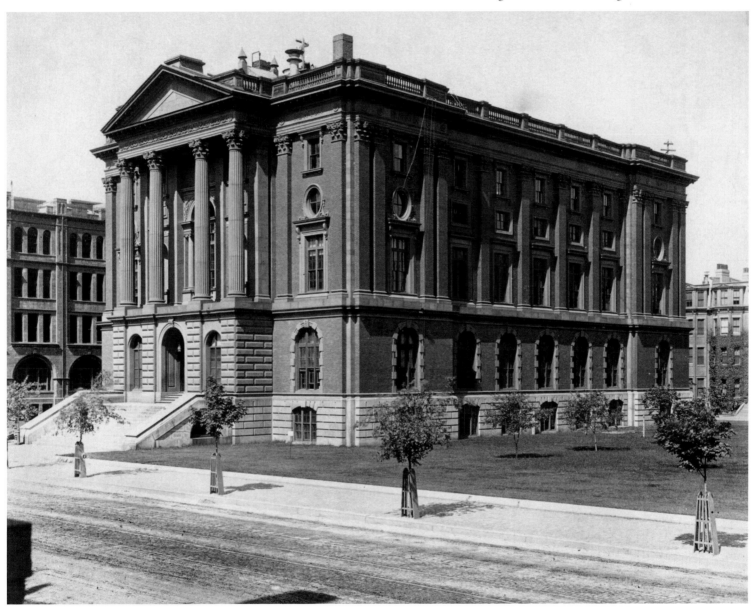

Fort Hill was an 80-foot hill overlooking the harbor and home to a colonial fort. The fort was replaced with a fashionable neighborhood around a circular square, but gradually the grand houses became tenements. The city leveled Fort Hill in 1870, loading it by steam shovel into horse-drawn tipcarts and railcars, which dumped the earth and rock into the harbor below. Today the Financial District skyscrapers reach higher than the hill they replaced.

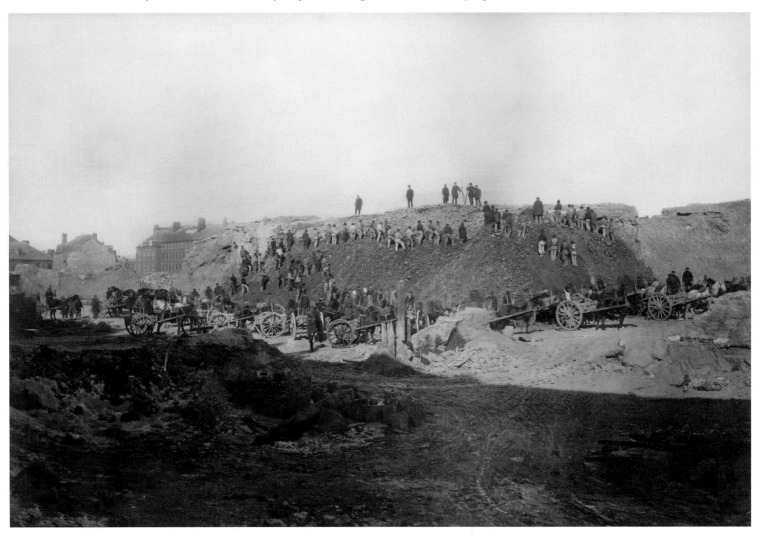

Nothing remained of Franklin Street after the fire of November 9, 1872. Bostonians took comfort, though, in stories of the brave battle which saved the Old South Meeting House, whose spire stands a block away over the ruins in the background.

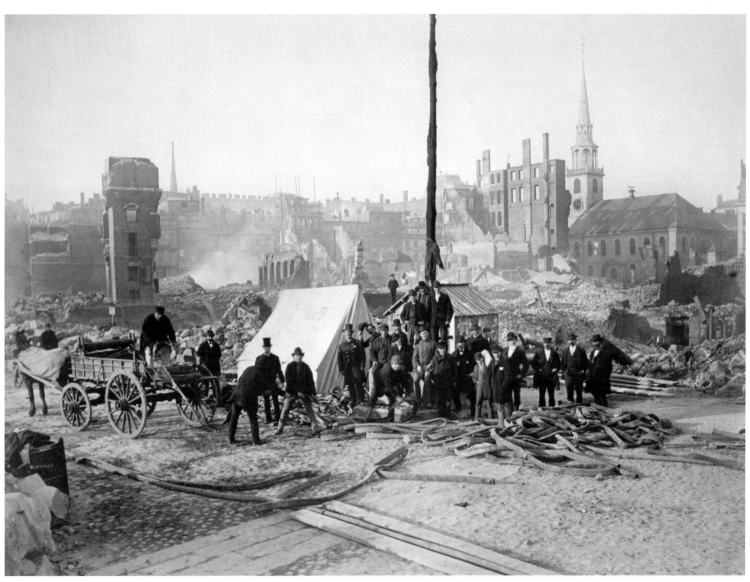

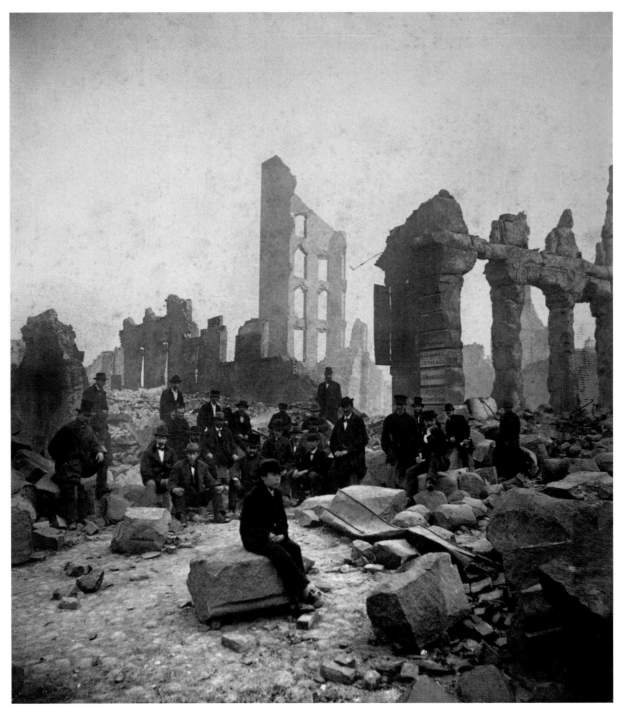

Pearl Street was also leveled in the Great Fire of 1872, which consumed 776 buildings crowded into 60 acres. The fire began in the basement of a hoop-skirt factory at Summer and Kingston streets.

The Union Club, at 8 Park Street, is decked out in patriotic bunting on June 17, 1875. Built about 1809 as a house and extensively enlarged in 1838 for U.S. Rep. Abbott Lawrence, the building has hosted the prestigious Union Club from its founding in 1863 to the present.

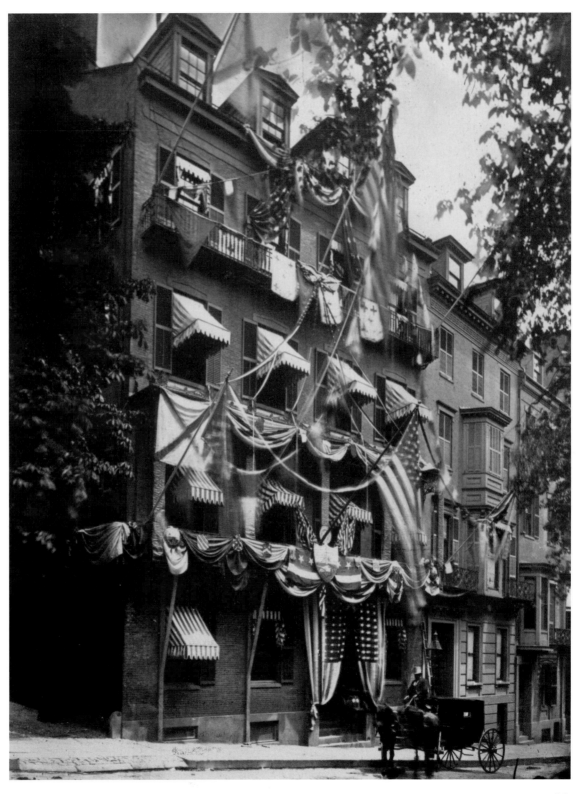

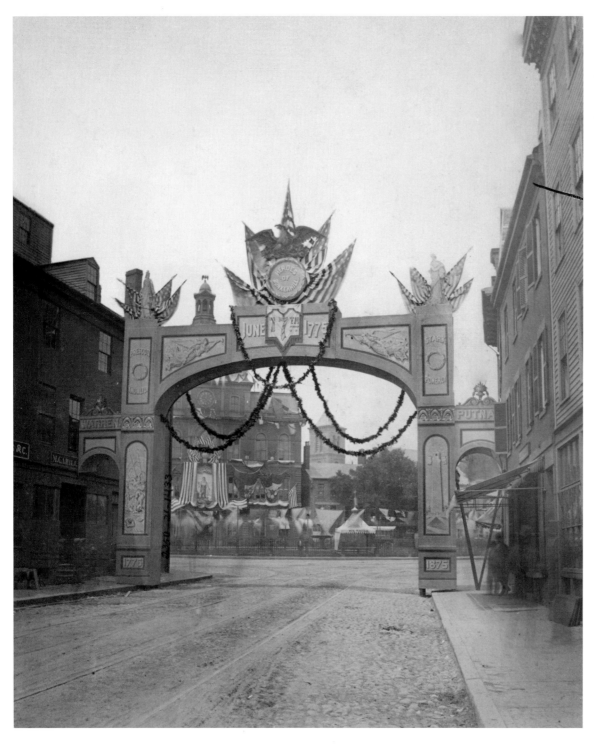

Charlestown celebrated the centennial of the Battle of Bunker Hill on June 17, 1875, with a triumphal arch at City Square. Although the Colonial defenders lost that battle (which actually took place on Breed's Hill), Boston celebrated their fierce resistance.

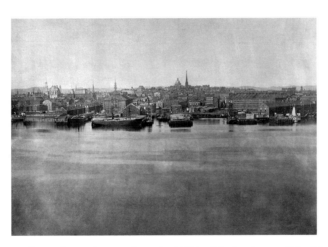

This panorama shows Boston's waterfront in 1877, with the dome of the Massachusetts
State House at center. The photograph was taken from East Boston, originally a group of
islands which became a shipbuilding center in the 1830s.

The Royal Arcanum, one of the oldest fraternal benefits (insurance) societies in the country, was founded in Boston in 1877. This image, from about 1880, shows its early building on Shawmut Street in the South End.

22

Son of a carpenter, Solomon Willard (1783–1861) designed and built the Bunker Hill Monument (1825-43) in Charlestown, shown here in the 1880s. Willard not only opened the famous Quincy Granite Quarry and invented tools for working stone blocks, but he also carved ship figureheads and the gateposts for Old Granary Burying Ground.

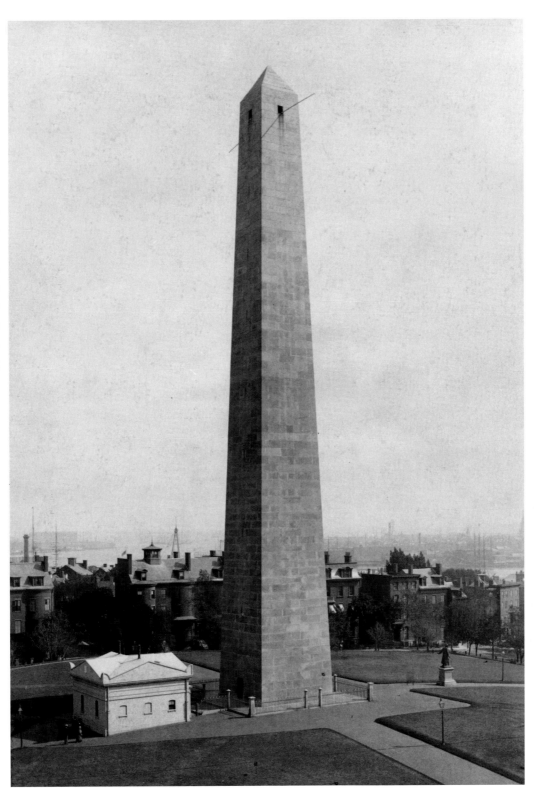

Once widely known throughout New England, Ferdinand's Blue Store began in this building (photographed around 1880) at the southeast corner of Washington and Warren streets in Roxbury. By 1899, the growing store had replaced this building with a 5-story brick and limestone commercial palace, followed by an 8-story addition.

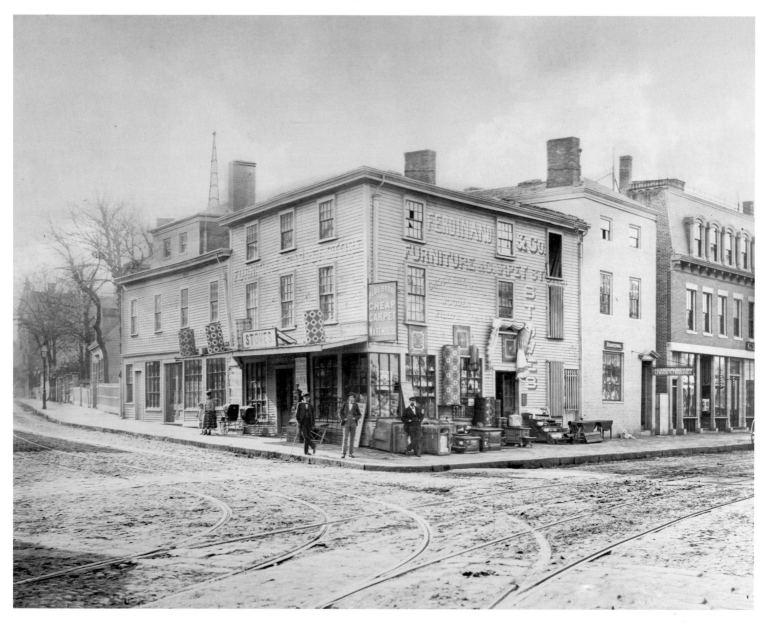

Shown shortly after it opened in 1884, the Cyclorama was designed to show a painting of the Battle of Gettysburg, 50 feet high by 400 feet long, in a full circle. Despite later additions, the building remains a landmark in the South End, part of the Boston Center for the Arts.

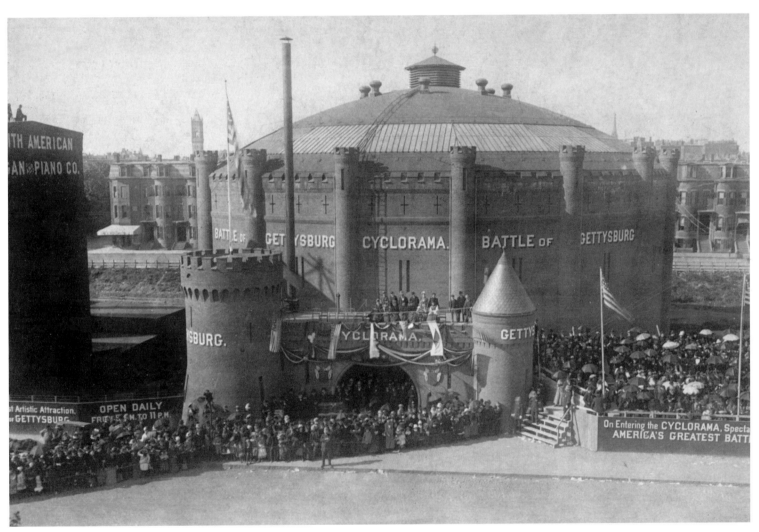

City Square in Charlestown, shown here in 1884, was dominated by the City Hall (1868) designed by William Washburn in French Second Empire style. In 1874, Charlestown was annexed to Boston, and eventually much of City Square was obliterated by Boston highways.

Taken about 1885, this photograph shows the Old State House (1712), at the head of State Street. The Old State House was restored in 1881, after Bostonians rallied to prevent Chicago from buying and moving it.

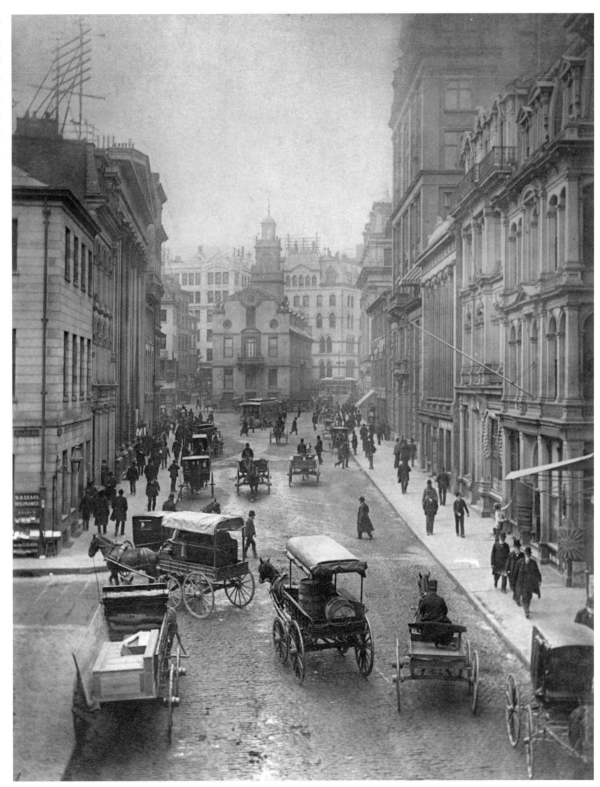

This early photograph shows the south side of the corner of Boylston and Tremont streets, with the home of John Quincy Adams (at left) and the Hotel Pelham (at right; 1857), the first apartment house in eastern America. They were eventually replaced with the Hotel Touraine (1897) and the Little Building (1916).

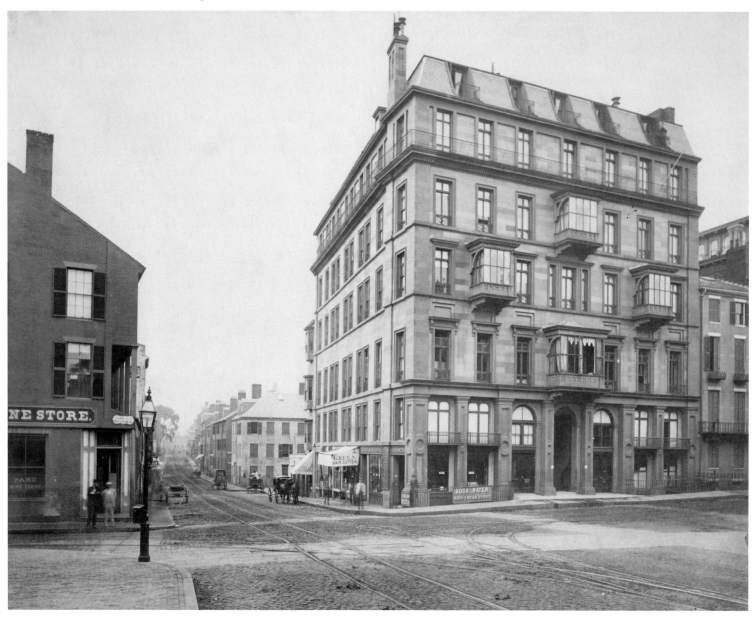

This remarkable rainy-day view of Arlington Street, ca. 1885, shows a crowd huddling under umbrellas outside Arlington Street Church. Built of New Jersey brownstone and completed in 1861, the church was the first building in the fashionable Back Bay district.

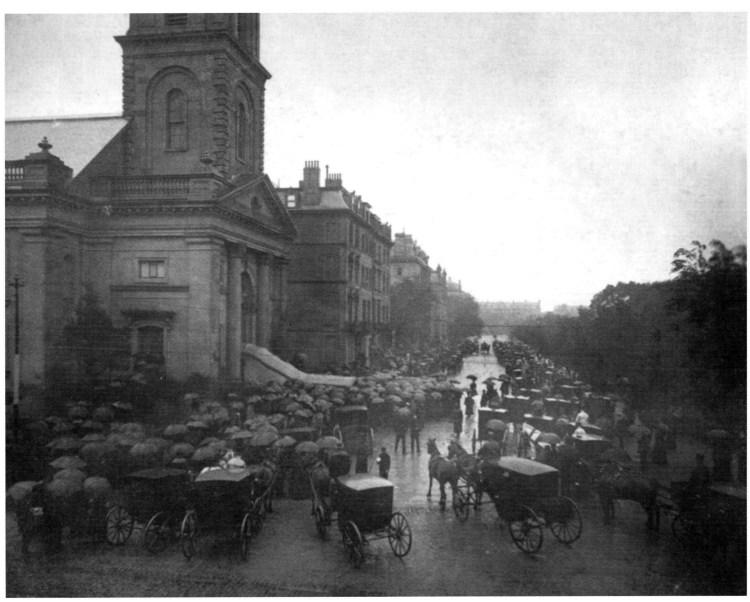

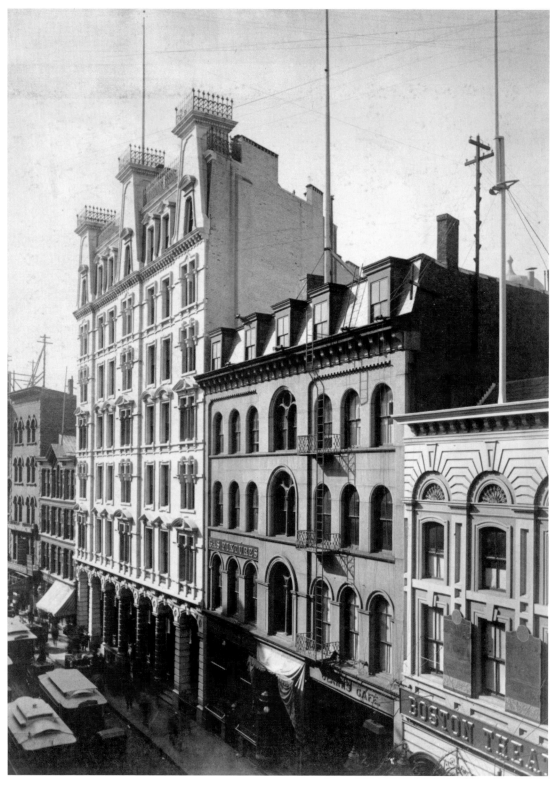

This section of Washington Street has long been the heart of Boston's theater district. The Boston Theater (1854), at right, was rebuilt in 1928 as the B. F. Keith–Savoy Theatre, then restored in 2004 as the Opera House. The middle building (1858) served as an annex to the 7-story Adams House Hotel (left). In 1885, about the time of this photograph, Keith began his vaudeville theater empire in the Annex in a second-floor auditorium.

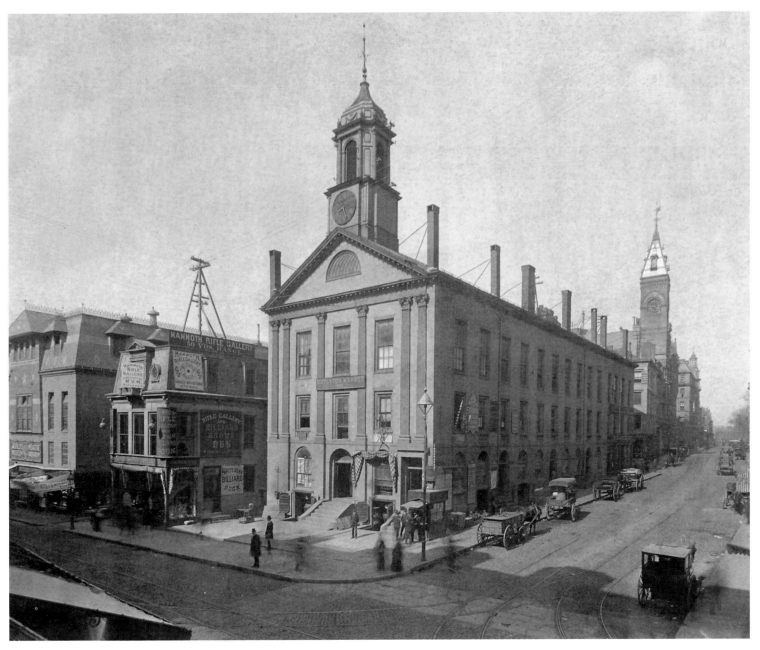

In 1809 John Quincy Adams laid the cornerstone for the Boylston Hall and Market on Boylston Street, shown here shortly before its 1888 demolition. All that survived of this building designed by Charles Bulfinch was the clock and cupola, which were incorporated into a church in Arlington, Massachusetts.

Scollay Square Station, with its four-sided clock and 1898 date block, shows Boston's civic pride in its subway system. This station and most of the surrounding buildings were leveled in the 1960s for Government Center.

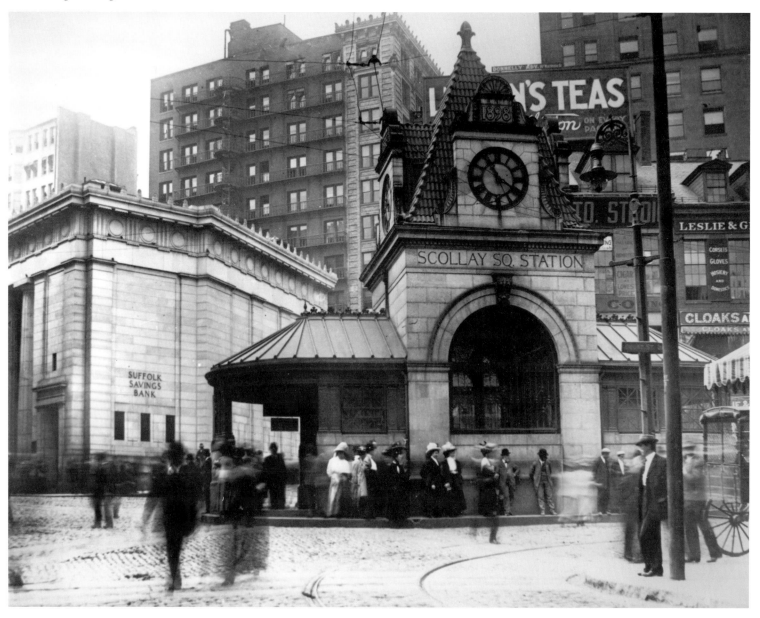

Washington Street was once the only connection between the mainland and the colonial city of Boston on the Shawmut peninsula. Shown here in the 1890s, it was Boston's "Main Street," its stone block surface bisected by streetcar tracks.

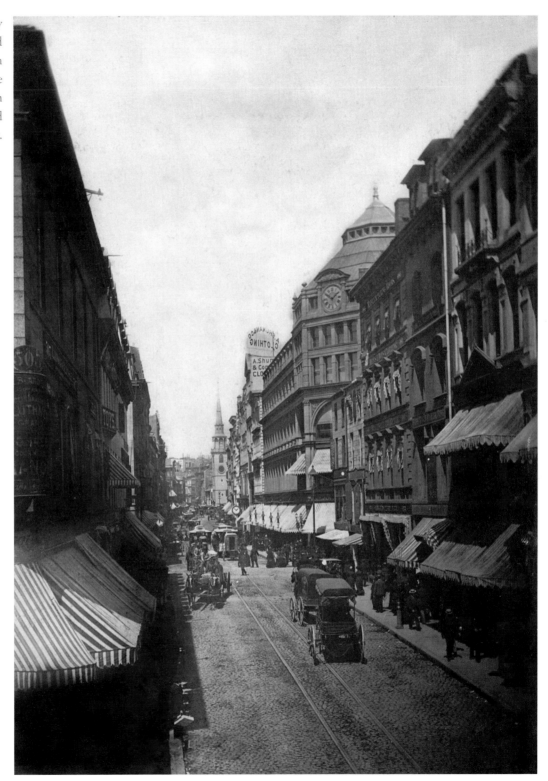

This image shows a Chinese funeral on Harrison Avenue ca. 1890.
Chinese immigrants began opening businesses along Harrison in 1875; by
1890 Boston's Chinatown extended from Kneeland to Essex streets.

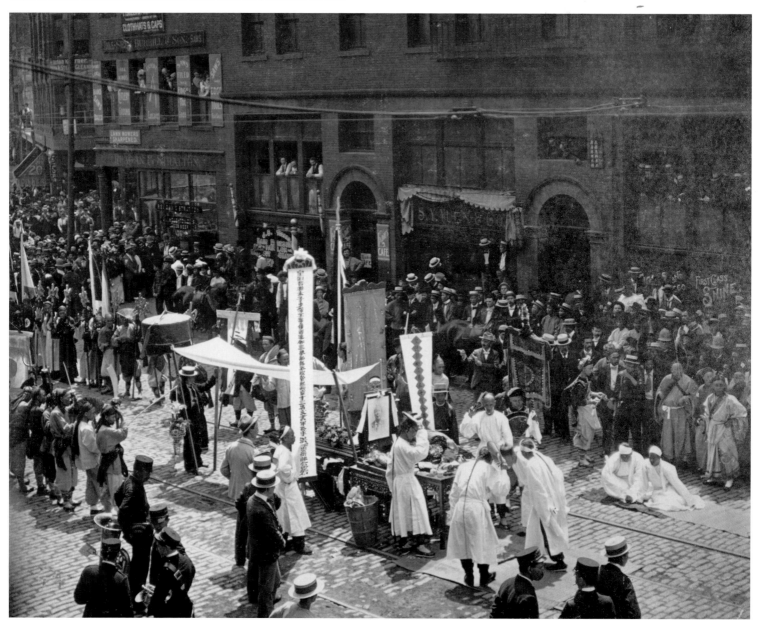

The Harvard College Medical School, founded in Cambridge in 1782 and moved to Boston in 1810, erected this building (designed by Ware and Van Brunt) on Boylston Street in 1881. After the medical school moved to the Longwood neighborhood, Boston University used the building for classes. The Boston Public Library built a large addition on the site in 1971.

Seen here ca. 1890, Copley Square is dominated by the Romanesque-revival tower of Trinity Church (1872-77), designed by H. H. Richardson (shown from the rear, at the corner of Clarendon and St. James). To the right of the church is its attached cloister and parish house; to the left, across Copley Square, is the Boston Public Library.

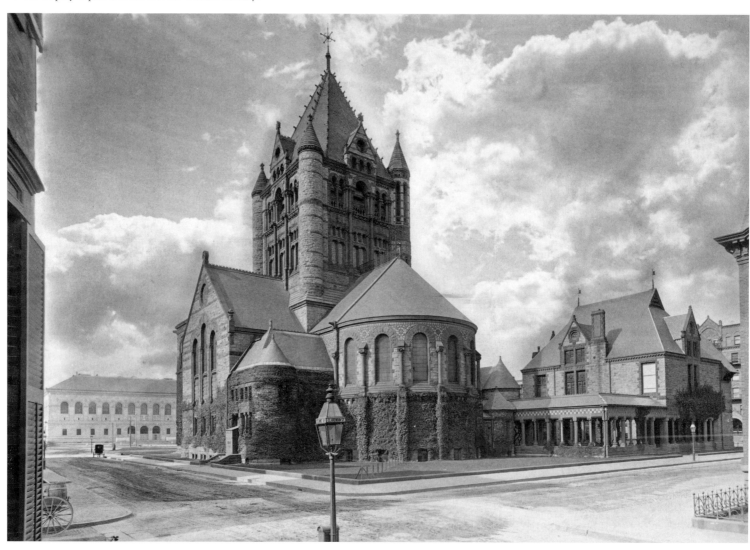

Faneuil Hall, shown here in the 1890s, with Quincy Market to the right. A gift to the city by Peter Faneuil in 1740, Faneuil Hall was designed by painter John Smibert. In 1804 Charles Bulfinch enlarged the building, doubling its width, adding a third story, and moving its cupola to the harbor end.

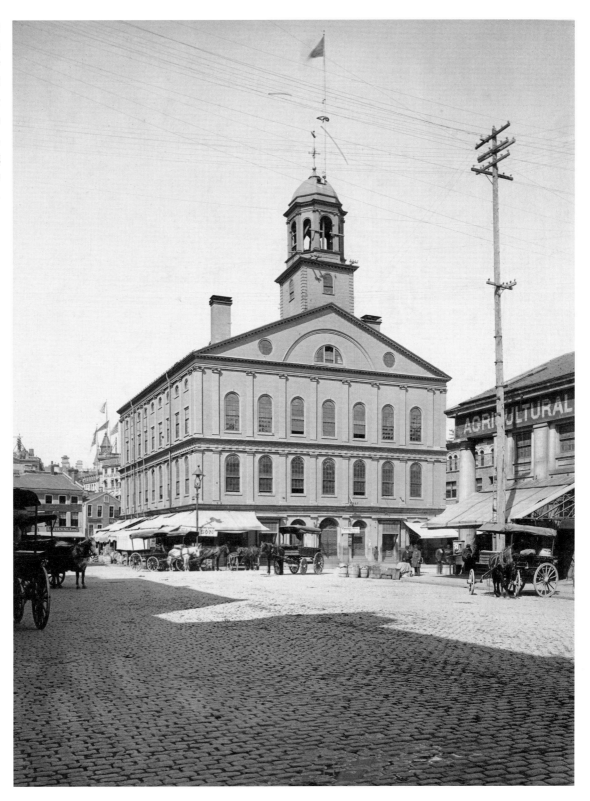

Following in the tradition of colonial militias, the Third Battalion, Boston School Regiment, of Boston Latin School poses on the Boston Common in 1892. A crowd has gathered at the base of the Soldiers and Sailors Monument in the background to witness the battalion's annual review.

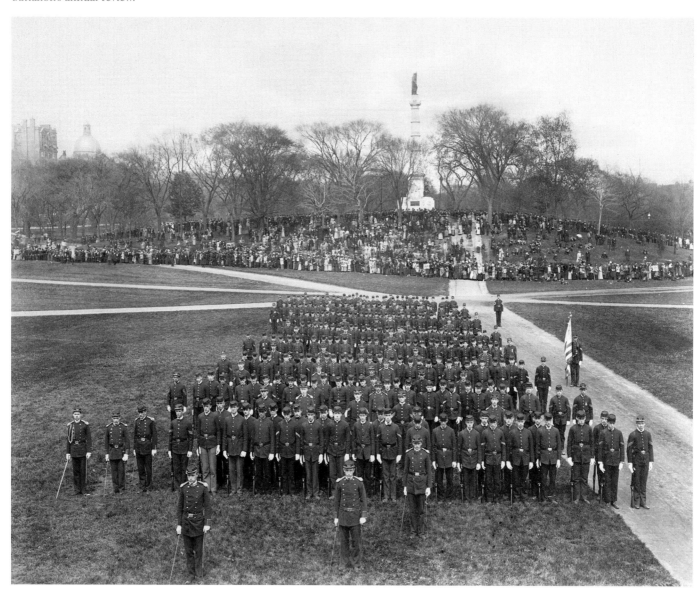

An 1893 work crew on Washington Street demonstrates how the granite block street surface was constructed. While one worker pours molten pitch in the open joints, a second sweeps gravel over the pitch. In summer, the pitch would partially melt and fill any cracks.

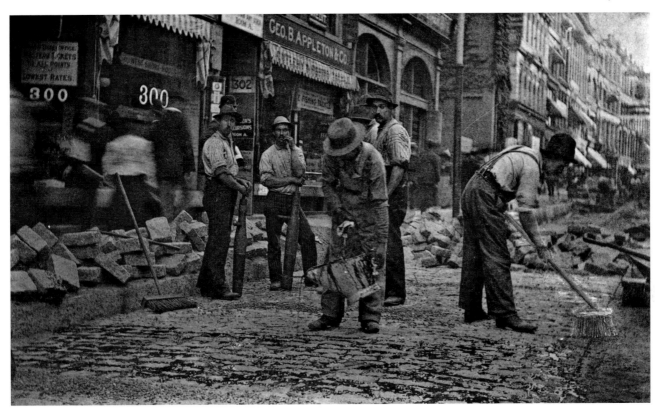

Shown here in 1893, the Wells-Adams House (ca. 1660) on Salem Street, with its overhanging second story, was a reminder of the North End's Colonial settlement. It reportedly served as a secret meetinghouse for early Baptists in Boston.

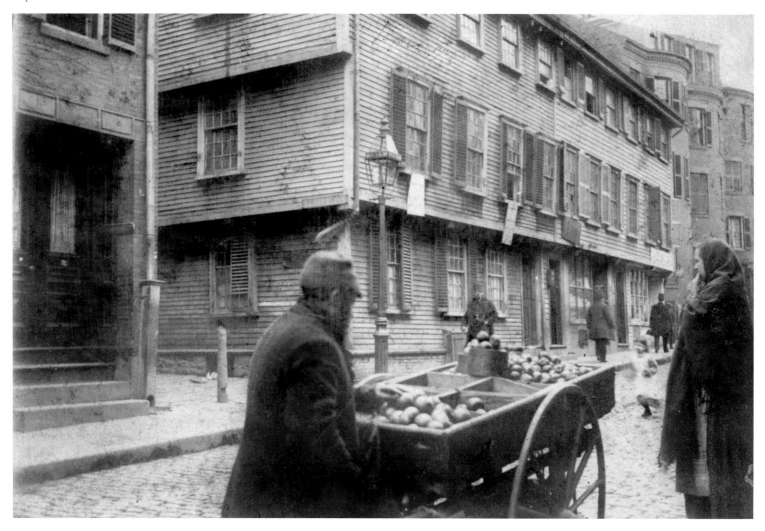

This 1893 photograph shows the newly completed Pilgrim Church at Upham's Corner in Dorchester. Designed in Romanesque Revival style by Worcester, Massachusetts, architect Stephen Earle, the church was the third home for a congregation formed in 1862.

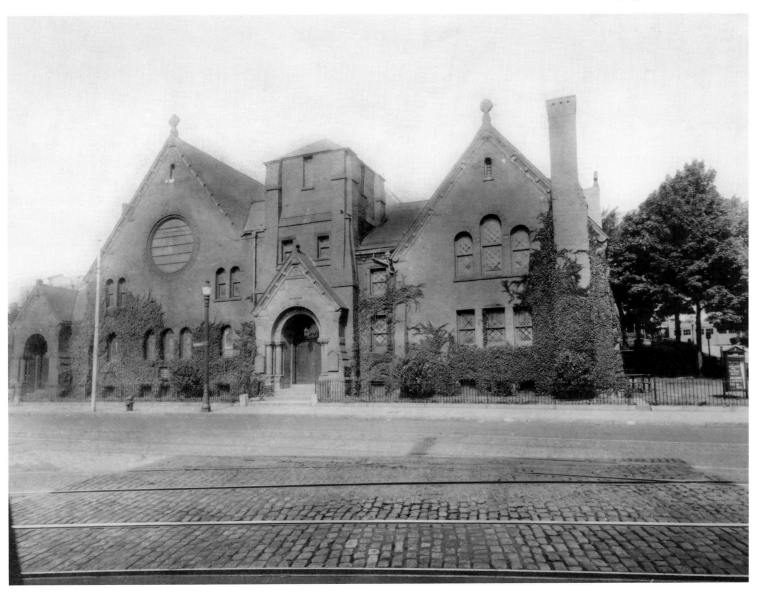

Narrow, winding Salem Street in the North End was home to successive
waves of Irish, Jewish, and Italian immigrants. This 1893 photograph
shows a laundry at Prince Street, where Salem begins a steep climb toward
Old North Church (1723).

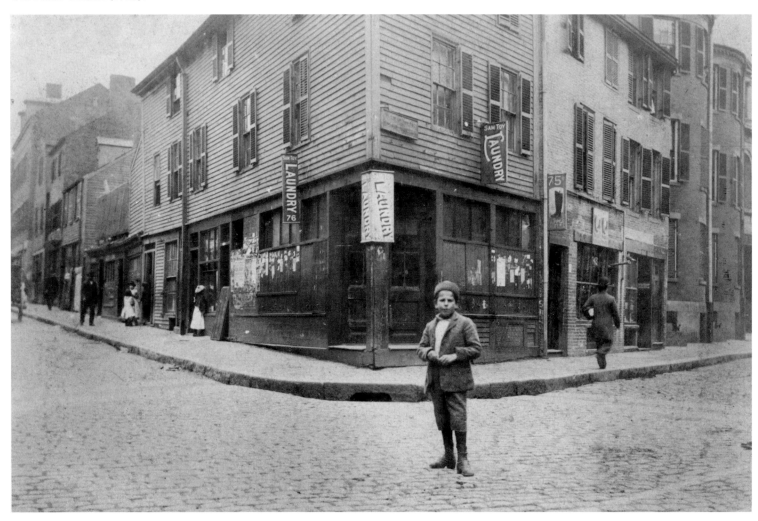

A view from August, 1897, shows the training trolley entering the
subway from Boylston Street, at the Public Garden. Gradually,
Boston expanded its subway system, but most trains outside
downtown still run on surface tracks.

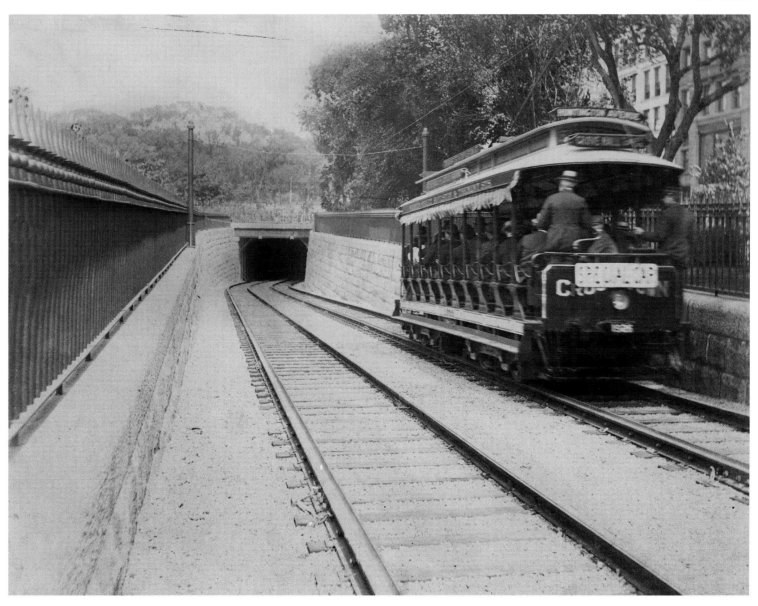

Boston opened the nation's first subway on September 1, 1897, to alleviate congestion on its crowded streets. This photograph shows conductors in training, crowded into a trolley at a bend near Park Street Station.

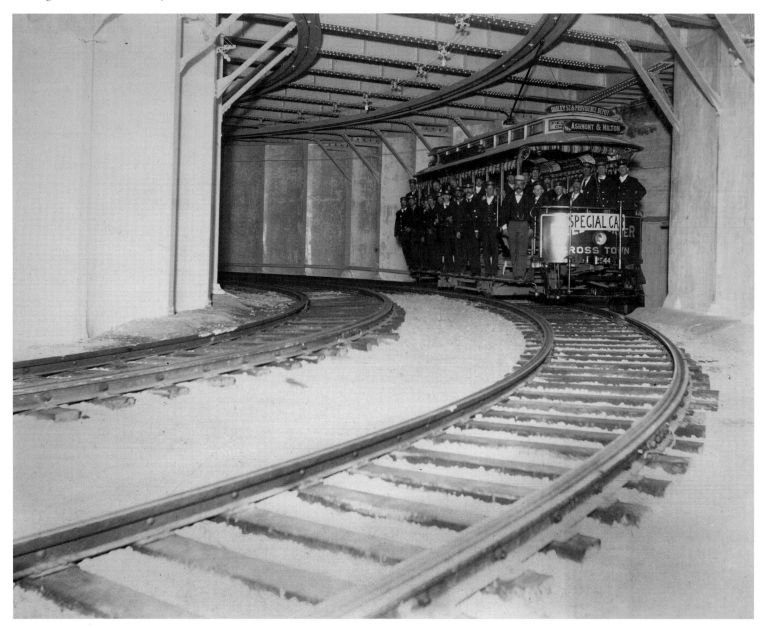

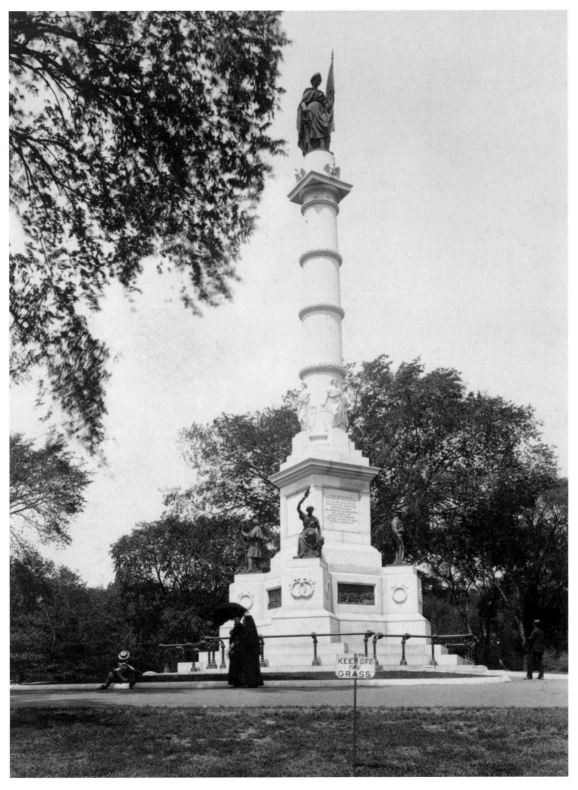

The Soldiers and Sailors Monument, atop Flagstaff Hill on the Boston Common, was dedicated to Boston's Civil War dead in 1877. Sculptor Martin Milmore's ambitious design includes bas-relief plaques, four statues at the base, and a figure representing the Genius of America atop a 70-foot granite shaft.

The second Suffolk County Court House (1836) stood on Court Street. This image from ca. 1880 shows the temple-like portico of this granite Greek-revival building designed by Solomon Willard. It was razed in 1912 for the City Hall Annex.

On a snowy day in 1899, electric trolleys vie with horse carriages for the cleared portion of Boylston Street near Arlington Street. Both would soon be displaced by subways and automobiles.

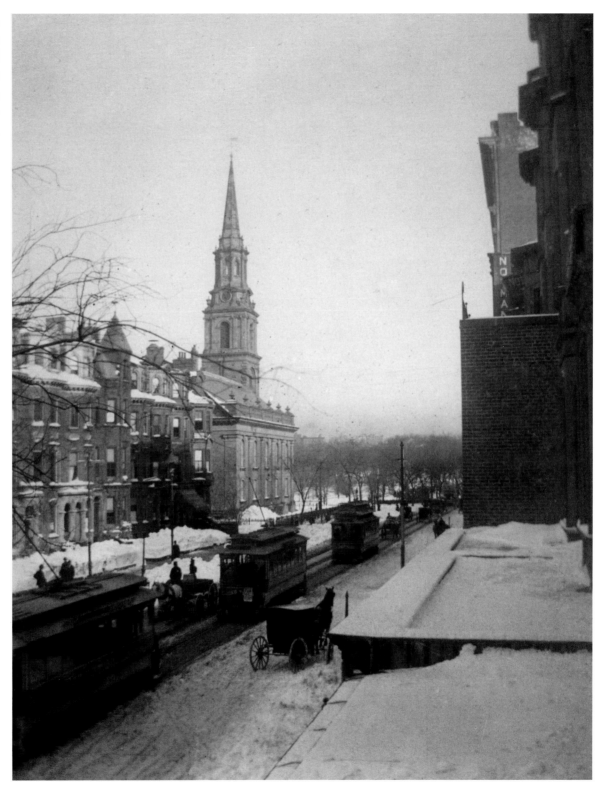

This view from ca. 1910 shows Copley Square from the roof of the Boston Public Library. Until 1969, Huntington Avenue cut diagonally across the square to join Boylston Street, preventing any substantial park development. The ivy-covered church to the extreme left, Second (Unitarian) Church, was replaced with an office building in 1914.

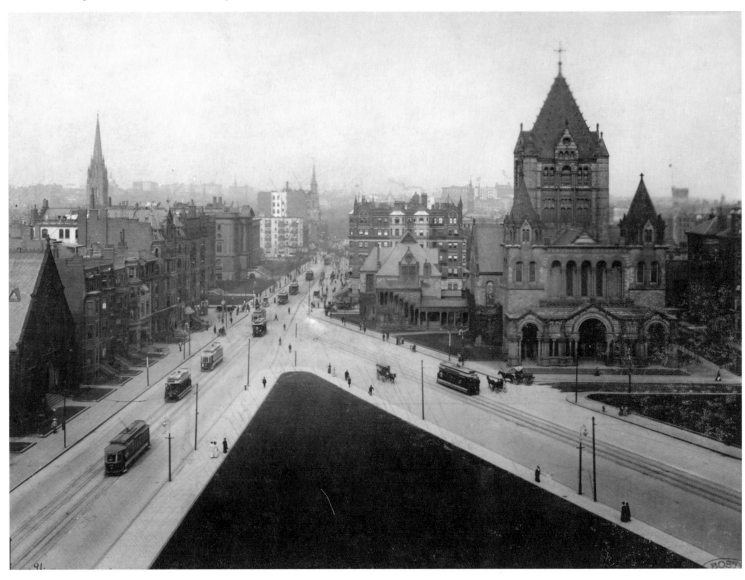

BOSTON IN THE NEW CENTURY

1900–1919

During the first two decades of the twentieth century, Boston was a prosperous, progressive city. Although the city's aging factories and mills began a long decline, its banking, finance, and service industries all boomed. From census to census, Boston's population continued to increase by double-digit percentages. Like other Americans, Bostonians began to gather in large stadiums to watch spectator sports like professional baseball, college football, and motorcycle racing, as shown in these images.

Beginning in the 1870s, ward bosses had arisen in immigrant neighborhoods, such as Martin Lomasney in the North End, giving assistance to new arrivals in exchange for political clout. Building a base in the Democratic Party, they governed the city with the Yankee Republicans in an uneasy balance. In 1906, ward boss John Francis Fitzgerald (grandfather of President John Fitzgerald Kennedy) became the first American-born ethnic Irish mayor of Boston. The excesses of his administration triggered reactions from Brahmin Boston. When the moderate Fitzgerald was ousted in 1914—by the confrontational South End ward boss James Michael Curley—Boston's political climate became one of open class warfare.

Boston photographs from these decades show the first signs of inventions that would redefine the city during the following century: the automobile and the airplane. Just as the railroad had replaced the canal boat before the Civil War, so these gas-powered innovations replaced horsepower and diminished the railroad, and would remake the city in their own image.

Four events brought this era of Boston history to a close, most importantly the entry of the United States into the First World War in 1917. In the fall of 1918, the global Spanish influenza epidemic killed thousands in Boston. Early in 1919, the Great Molasses Flood killed 21 people and injured 150 more, raising the specters of sabotage and corporate greed. Shaken Boston workers, like Americans elsewhere, were caught between rising prices and falling postwar wages, and went on strike. First fishermen, then transit workers, telephone operators, and finally policemen went on strike. After fires, vandalism, and looting broke out, Governor (later U.S. President) Calvin Coolidge had to call out the National Guard to restore order.

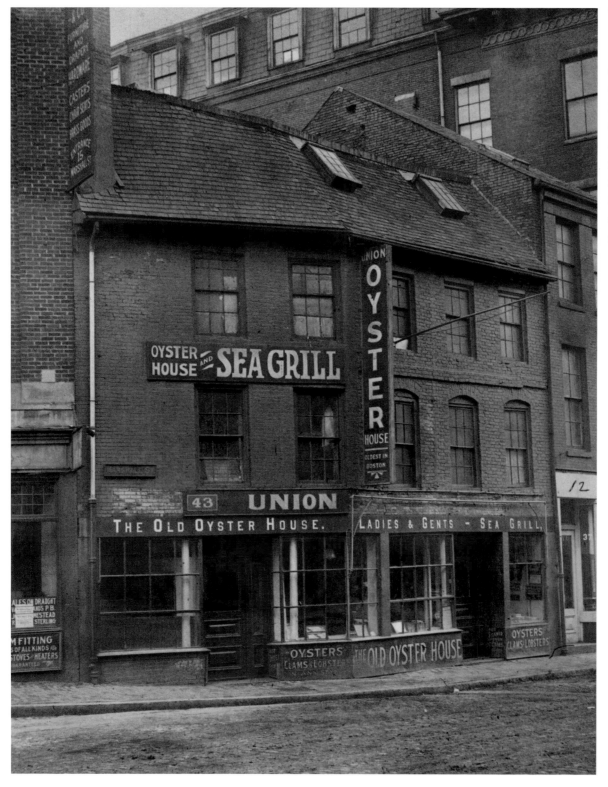

Though this photograph is thought to date to ca. 1900, the Union Oyster House is almost timeless. It was built ca. 1713-17 as the Capen House. An early anti-British newspaper, the *Massachusetts Spy,* was published upstairs in 1771. Opened downstairs in 1826, the Union Oyster House is the oldest continuously operating restaurant in the nation.

St. Peter's, on Meeting House Hill (shown ca. 1900), is the oldest and largest Roman Catholic church in Dorchester. Designed by Patrick Keeley and built from puddingstone quarried on its Bowdoin Street site, the building was begun in 1872. The tower and finials were finished in 1891.

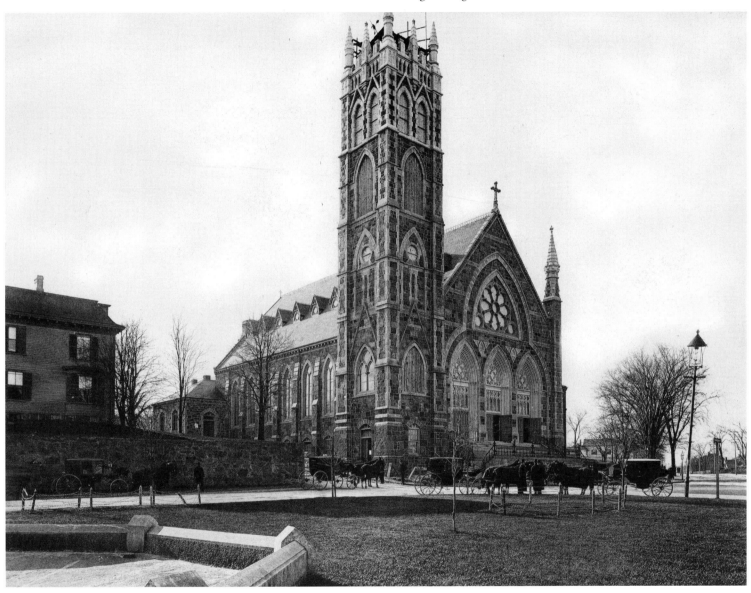

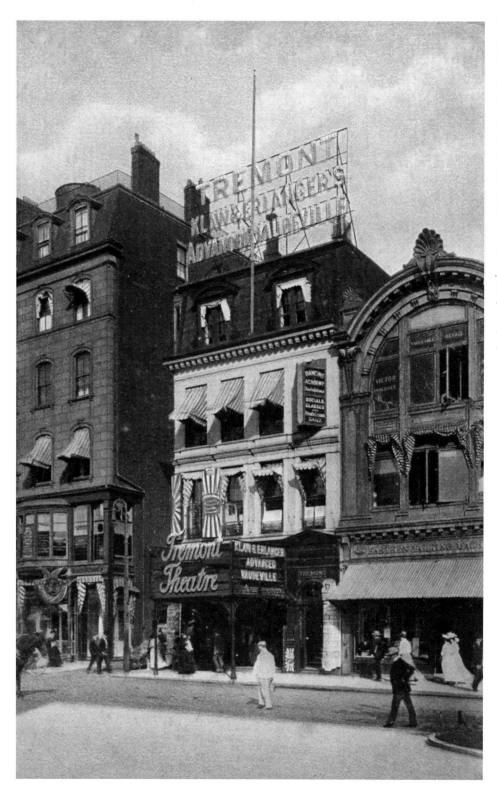

Tremont Street runs through the heart of the Theater District, and has lent its name to several theaters. The Tremont theater shown here stood near Avery Street from 1889 to 1949. Its important Boston premieres included Sarah Bernhardt in *La Tosca* (1891) and the first feature "talkie," *The Jazz Singer* (1927). Riots broke out during the Tremont Theatre's 1915 premiere of *Birth of a Nation*.

Park Square ca. 1900, looking straight down Columbus Street, with the tower of the Boston and Providence Railroad Station to the right. At left middle is the Thomas Ball statue *Emancipation Group* (1875).

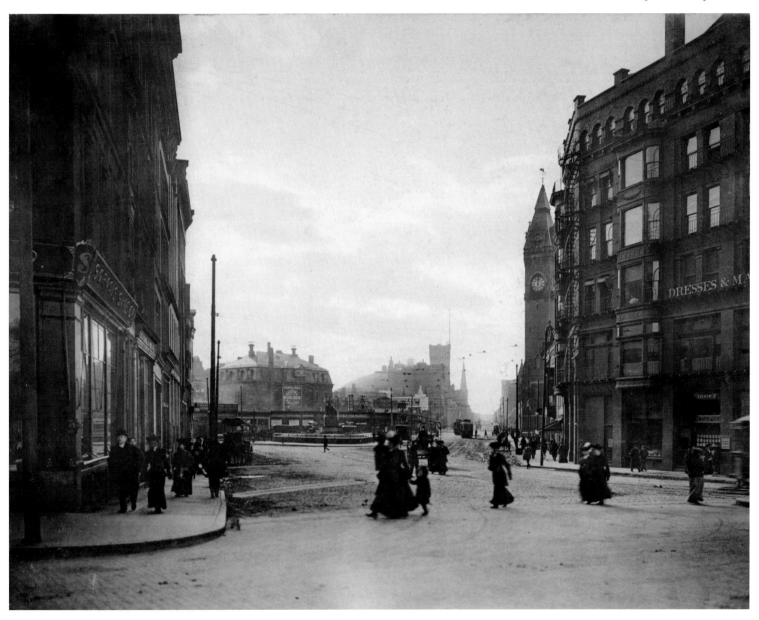

Boston began the first postal service in the colonies in 1639, with
Richard Fairbanks' Boston tavern designated the first post office. The
massive post office building to the left, in Post Office Square (shown
here ca. 1906), is one of its successors, built in 1869. The sharp-edged
Delta Building, to the right, was replaced in 1929.

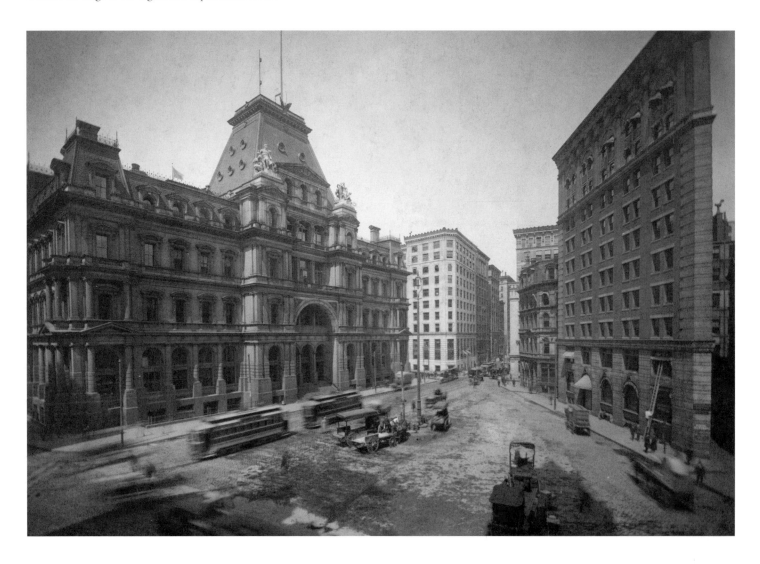

Merchant's Row (shown here ca. 1900) was the street which bisected Faneuil Hall and Quincy Market. The buildings of Joseph Breck and Sons, which stood at 47-54 North Market Street, show how merchants could turn every surface of a building into advertising space.

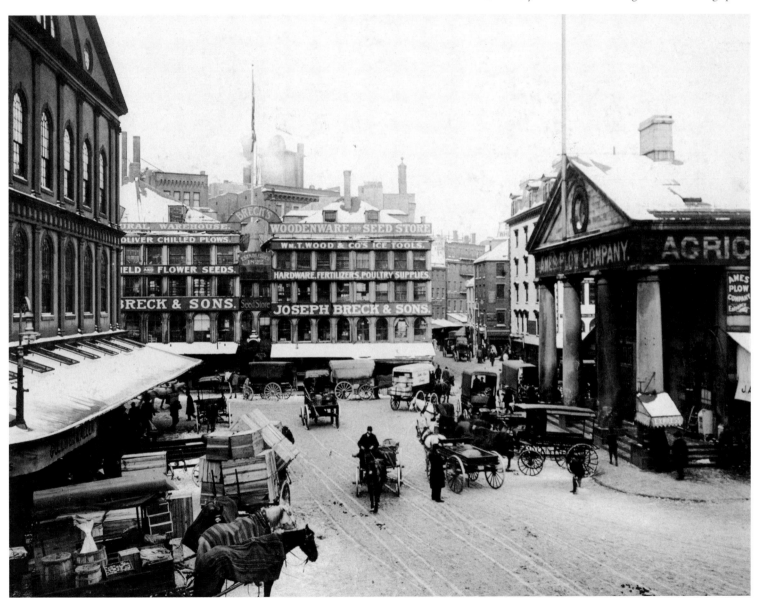

Castle Square Theatre (shown here ca. 1900) was on Tremont Street in the South End. Built in 1888 as a cyclorama to display a painting of the Battle of Bunker Hill, the theater was encased in a 500-room hotel in 1894. Besides opera and theater (Alfred Lunt was a member of its stock company), Castle Square hosted movies (beginning in 1917). Anchor of an immigrant neighborhood, the building was demolished in 1933.

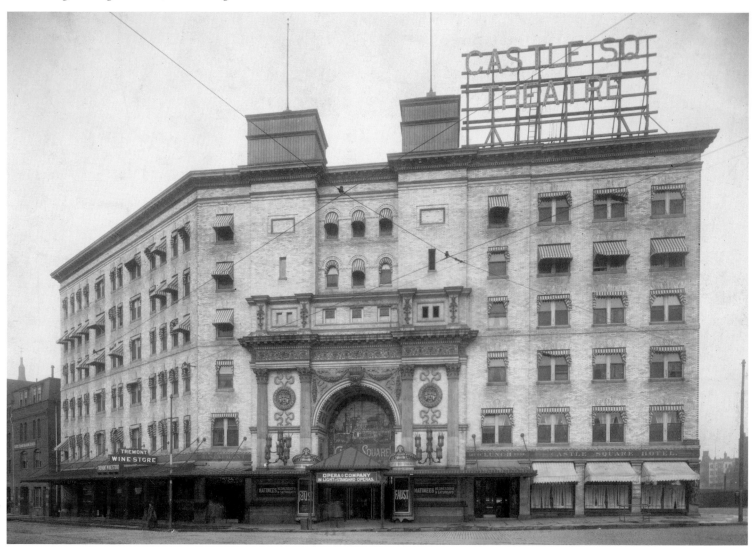

Just a block long, Park Street defines the eastern edge of the Boston Common and provides a dramatic view (ca. 1900) of the Massachusetts State House on Beacon Street. Its beginning has been marked since 1810 by the elegantly rounded front and telescoping spire of the Park Street Church (to the right), which graces Tremont Street.

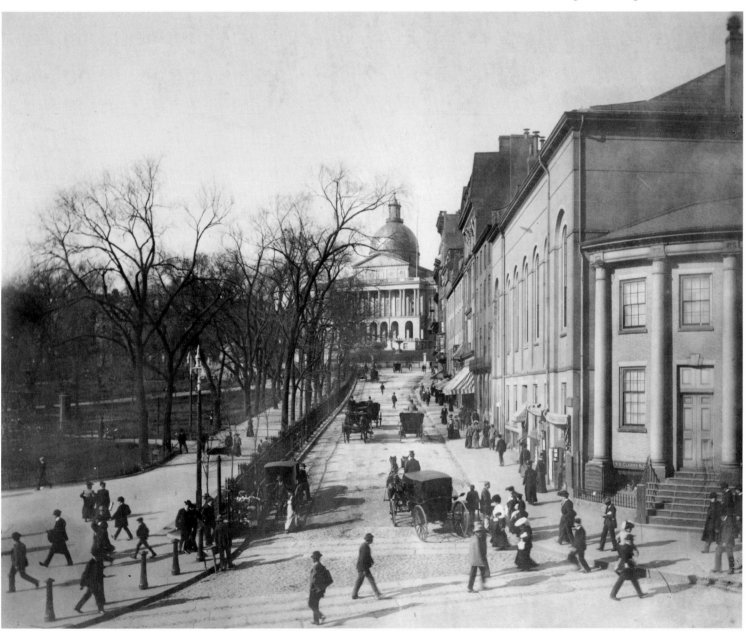

Temple Place in 1900, seen from the Common at Tremont Street. Named after Boston's first Masonic Temple, which stood on the left, the street changed from residential to business uses during the nineteenth century.

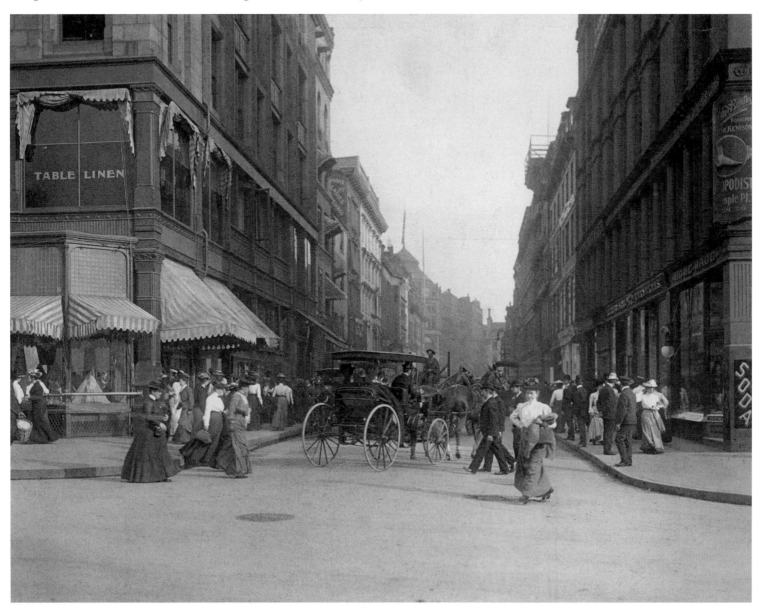

The Majestic Theatre (1903) has a history with many acts. Designed by John Galen Howard, who trained at the Massachusetts Institute of Technology and the Ecole des Beaux Arts in Paris, it was innovative and stylish. Built for opera, it hosted theater, then vaudeville, and then movies before closing. Restored in 1989 by Emerson College as the Cutler Majestic, it currently presents a variety of performing arts events.

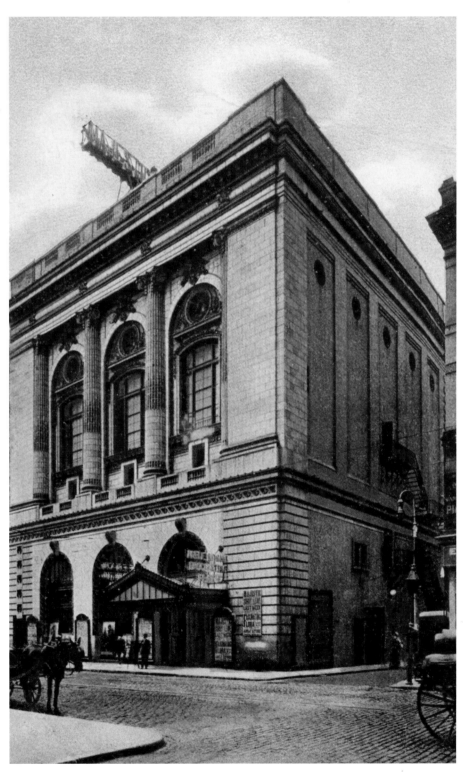

Tremont Street looks almost deserted in this early photograph, although the single automobile parked at the curb opposite the Boston Common foreshadows the course of the future. Mass production of automobiles began in the first decade of the twentieth century.

In view here ca. 1900, two horse-drawn carriages pass each other on Beacon Street, with the Massachusetts State House as a dramatic backdrop. Designed by Charles Bulfinch, the State House (1795-97) not only anchored the subsequent development of Beacon Hill, but provided a model for government buildings nationwide, especially through Bulfinch's redesign of the U.S. Capitol (1817-29).

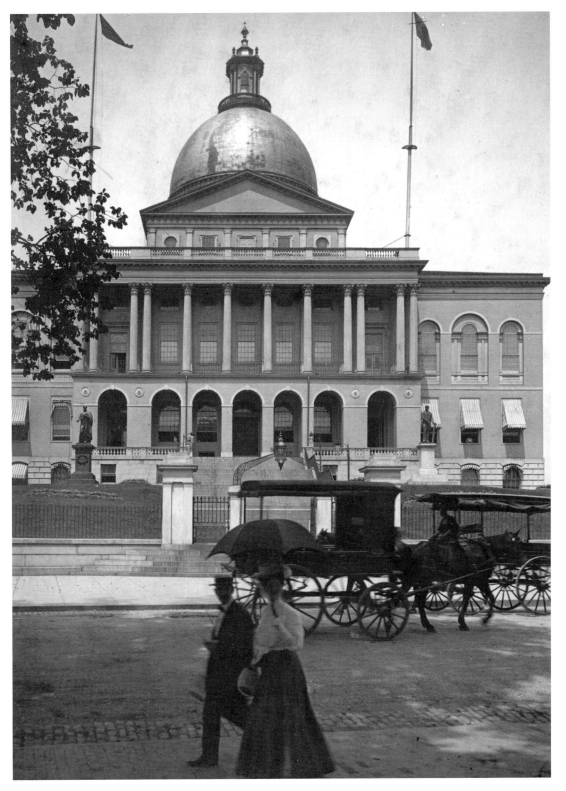

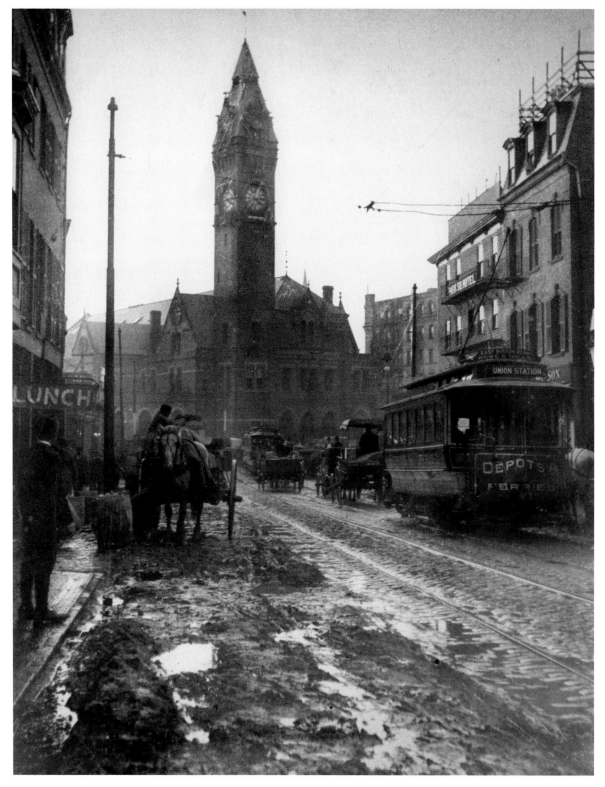

This view of Park Square (ca. 1900) gives little indication of the changes a new century has in store for Boston. Less than 30 years old, the Providence Railroad Depot is about to close, and its 150-ft. clock tower will disappear by 1925. By that year automobiles had displaced Park Square's horse carriages and electric trolleys.

Little distinguishes the red-brick buildings of the North Slope of Beacon Hill (foreground) from those of the West End (beyond) in this view from ca. 1900, while the Bunker Hill monument marks Charlestown in the distance, across the Charles River. The church tower to the right belongs to the Old West Church (1806, Asher Benjamin, architect) on Cambridge Street, which marked the line between the neighborhoods.

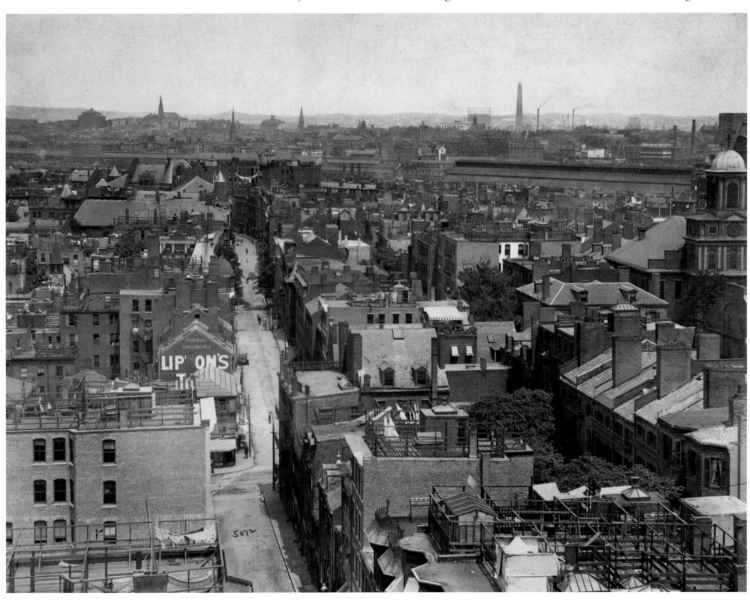

This 1901 photograph reveals only a portion of the massive Union Station (1894) by Shepley, Rutan, and Coolidge. Built between the old Lowell and Fitchburg stations, it linked them into a grand facade along Causeway Street. The entire complex was leveled in 1927, replaced by North Station and the Boston Garden.

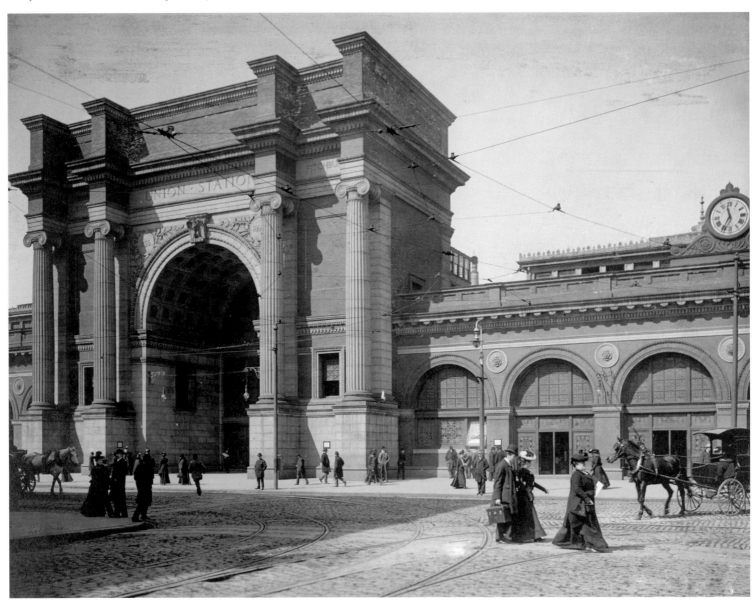

Shepley, Rutan, and Coolidge's South Station (1899) provides a suitable backdrop for a procession through Dewey Square honoring Vice President Theodore Roosevelt on April 29, 1901. In the carriage (at center) with Roosevelt, is George Draper, President of the Home Market Club, the group Roosevelt addressed the next evening. Roosevelt became president that September, when President McKinley was assassinated.

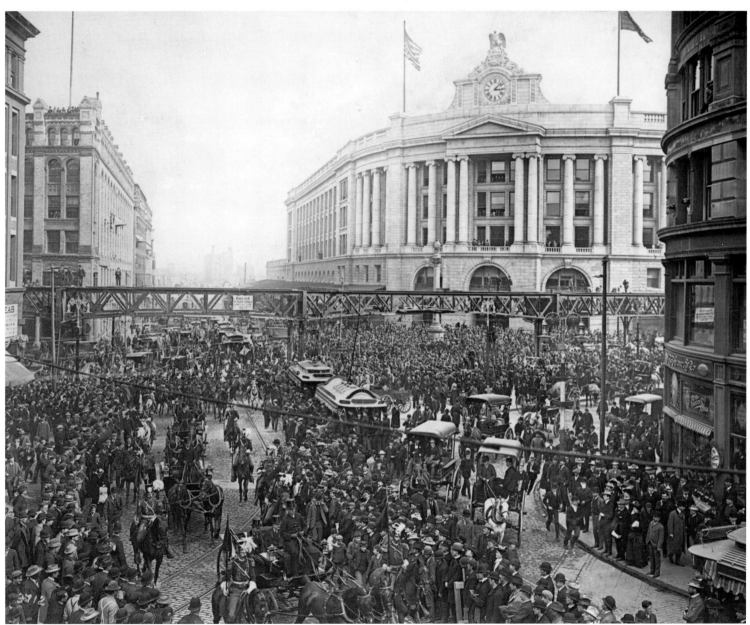

At 9:30 in the morning on June 25, 1903, Joseph Hooker Wood loosened a silk ribbon and unveiled the statue of his granduncle, General "Fighting Joe" Hooker. Though best known for his defeat at Chancellorsville, Hooker served bravely throughout the Civil War. The bronze statue of Hooker was sculptured by Daniel Chester French and the horse by Edward C. Potter.

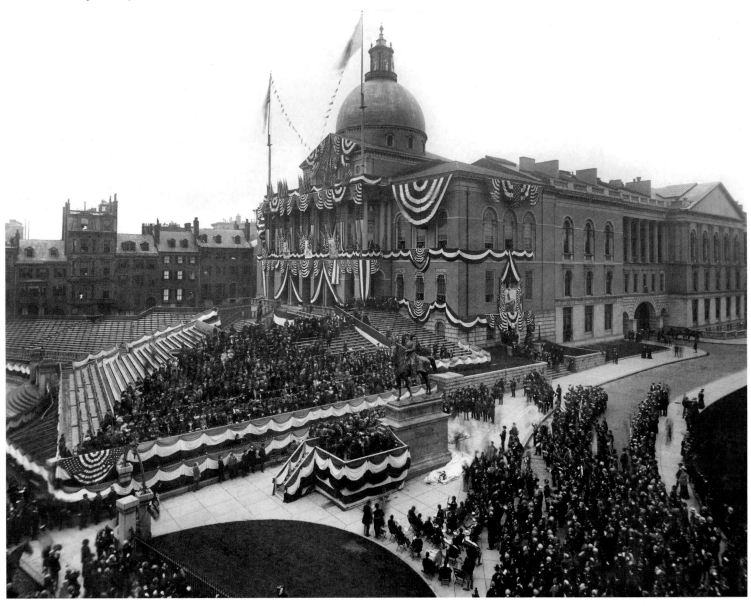

The 1902 Boston visit of Prince Heinrich of Prussia, brother of Emperor Wilhelm II, included an honorary doctorate from Harvard and a visit to the State House on March 6. The latter was comic. Both houses of the legislature had gathered for a state address, but no one had actually invited Prince Henry to speak. After awkward silence, the puzzled prince sat down. Governor Winthrop Crane quickly escorted him back to his carriage.

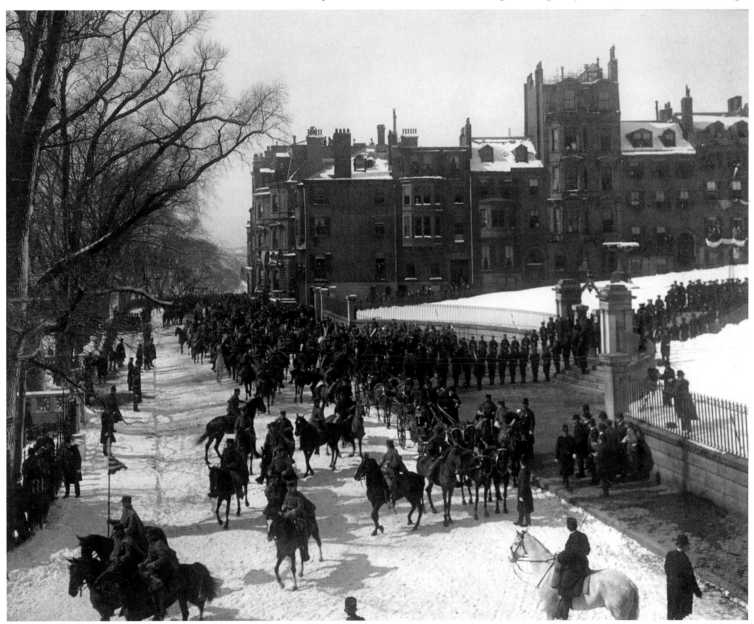

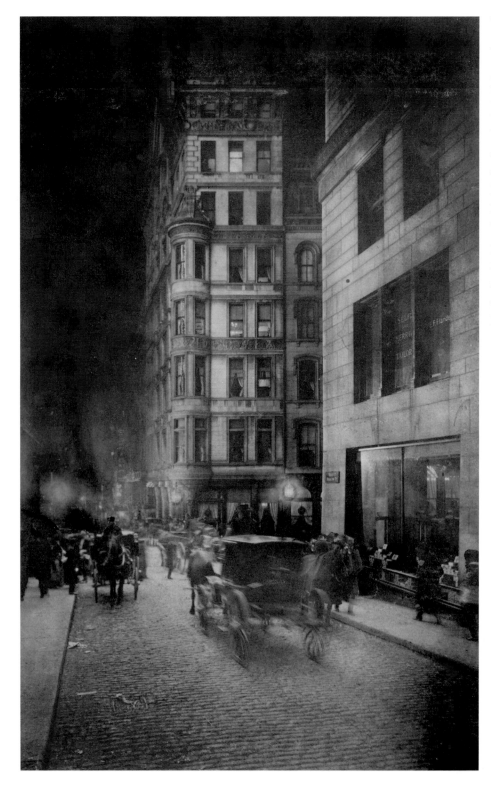

This rare night photograph (ca. 1904-10) by Boston Globe photographer E. E. Bond looks down Beacon Street to the Parker House Hotel at Tremont. Billed as "America's longest continuously operating hotel" (since 1855), the Parker House originated "scrod," Boston cream pie, and the Parker House roll. Its employees have included Ho Chi Minh as a pastry chef and Malcolm X as a busboy.

On August 9, 1904, a horse-drawn steam fire engine gallops by an open electric trolley on Washington Street. In the background, on either side of Milk Street, are the Old South Meeting House (1729), and, covered with bunting, the Boston Transcript building. All the buildings this side of Milk Street were built after the Great Fire of 1872.

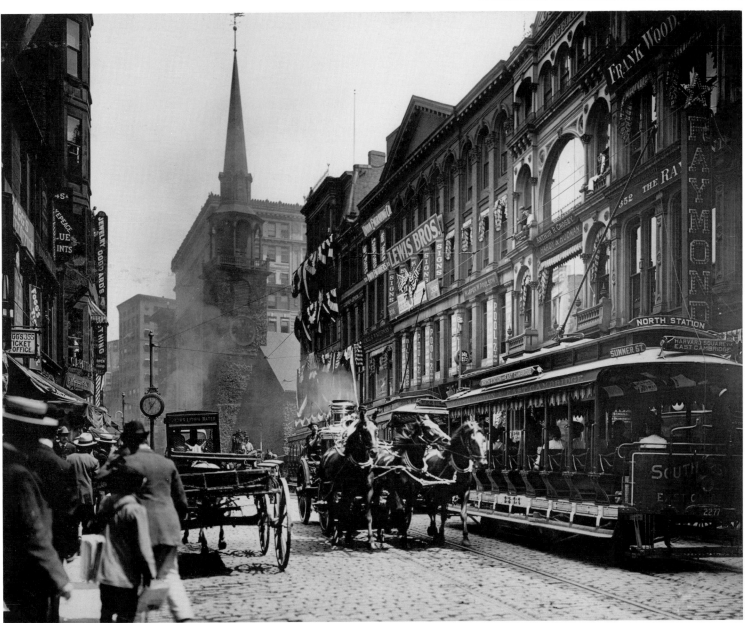

Shown here ca. 1905 is the shop of Lally Brothers, Blacksmiths and Wheelwrights, in the industrial Fort Point Channel neighborhood. A cart for Frank Jones Brewing Company is up on blocks for repairs. In 1893, more than 500 carriage workers went on strike against Lally Brothers and other Boston firms, successfully securing a 9-hour workday.

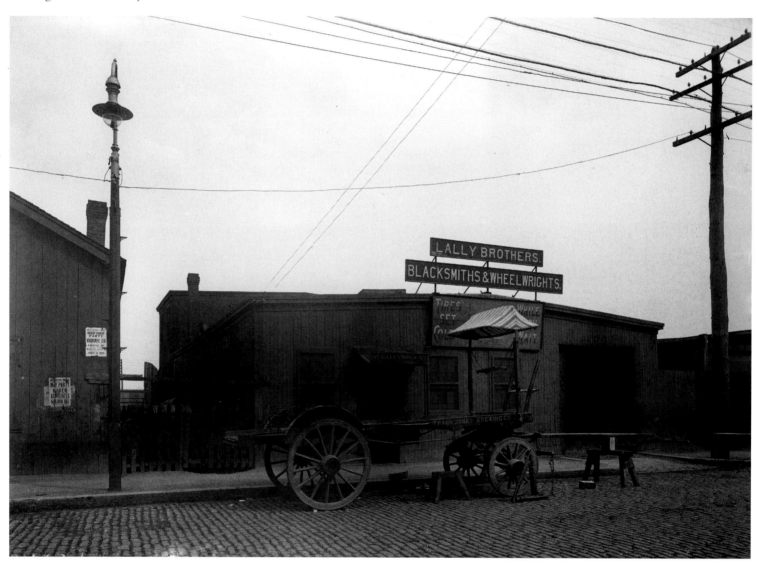

Lou Criger and Cy Young of the Boston Americans, ca. 1905, at the Huntington Avenue Grounds. Denton True "Cyclone" Young set a pitching record of 511 major league baseball wins, now commemorated with the prestigious annual pitching award. Criger became Young's catcher in 1896 when they played for the Cleveland Spiders, and followed him to Boston.

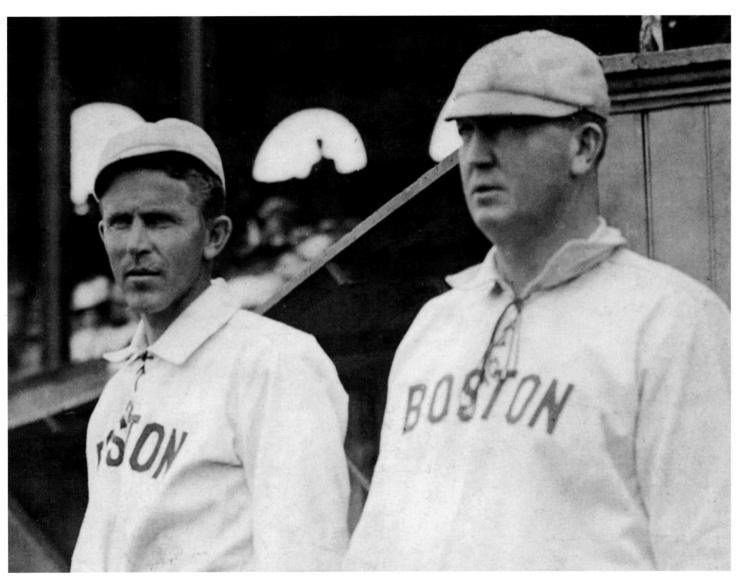

Third baseman Jimmy Collins jumps for the ball in a posed action shot, ca. 1905. Collins began his major league career with the Boston Beaneaters in 1895. He joined the Boston Americans as player-manager when they formed in 1901, and led them to the 1903 World Championship. He left for the Philadelphia Athletics in 1907, the year the Americans became the Boston Red Sox.

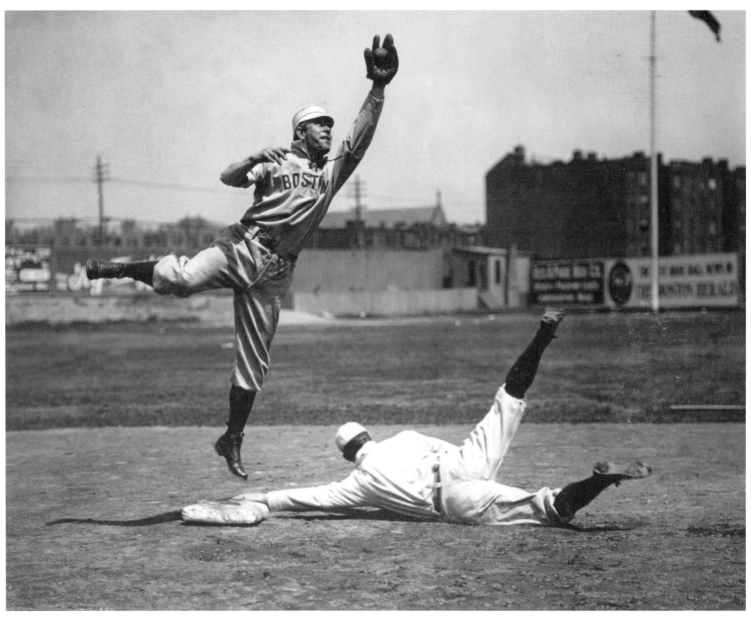

The ferry *Governor Russell* plies the waters in June 1905, carrying passengers and horse carts across the Boston Harbor. The *Governor Russell* was a propeller ferryboat built by William McKee in 1899, on the same lines as his *Noddle Island,* which set a record 14 miles per hour when first launched.

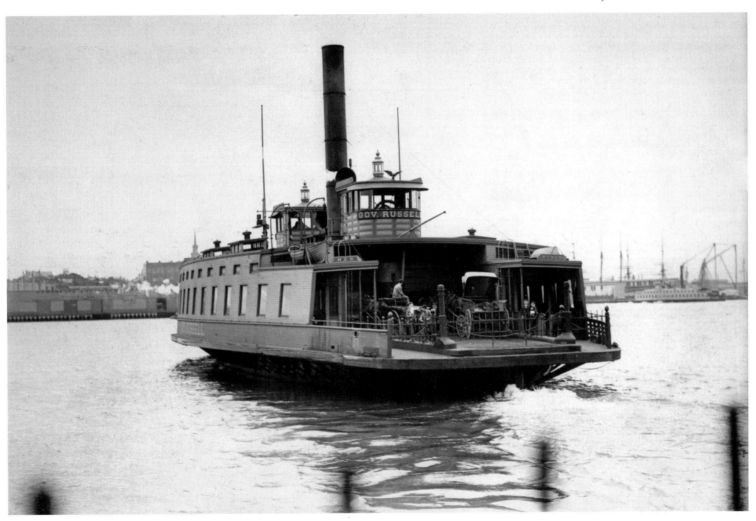

The Sherwin Williams Company (which adopted the "Cover the Earth" logo in 1906) had a distribution center on Purchase Street. Beginning in 1906 its New England employees gathered at Canobie Lake Park in New Hampshire for annual company outings.

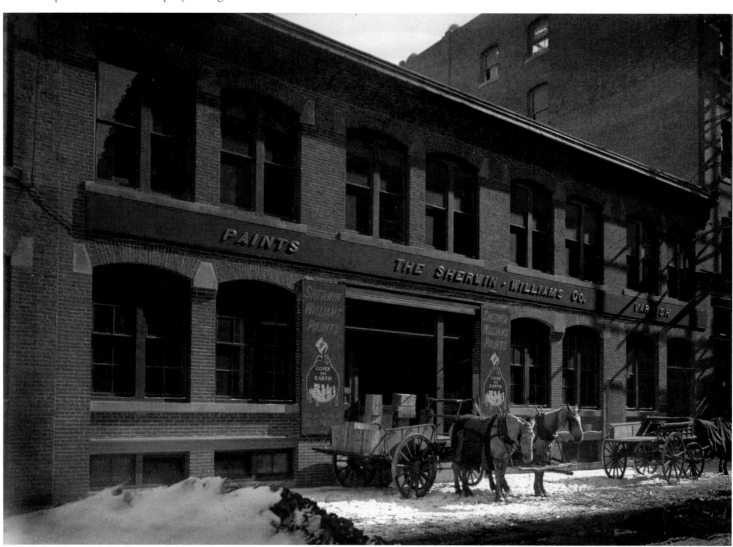

This 1907 photograph shows Spring Street and Poplar Street in the West End. Early in the 1800s the West End had been a fashionable upper-class neighborhood. A century later, it was a remarkable working-class neighborhood of African Americans, immigrants from Ireland, Poland, and Italy, and Jews from the Pale of Russia.

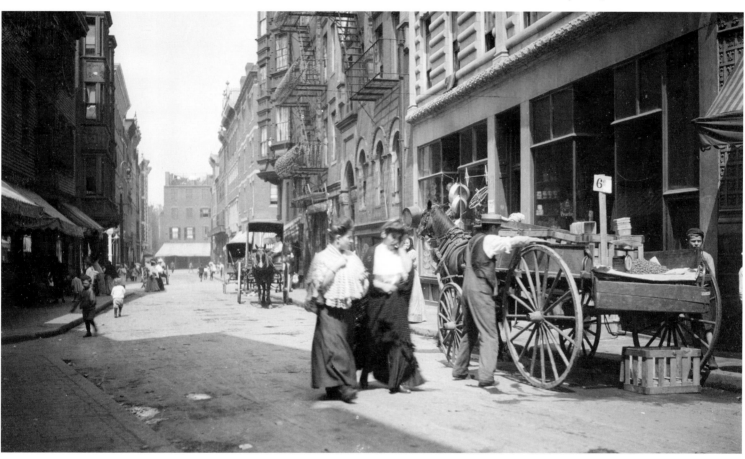

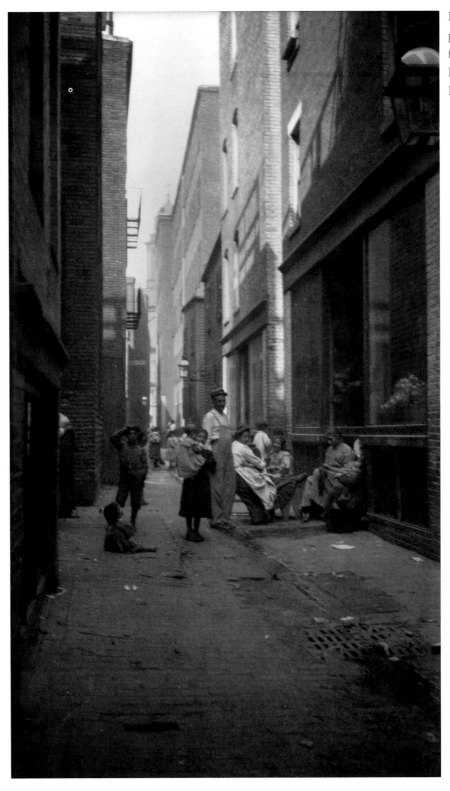

Interrupted by Boston Globe photographer E. E. Bond, a family relaxes in an alley off Hanover Street in the North End ca. 1907.

Automobiles are gradually displacing horse-drawn vehicles amid the electric trolleys on Washington Street on August 19, 1908. Houston and Henderson Co., a dry-goods store at Temple Place, used the advertising slogan "the Busiest Corner on Boston's Busiest Street."

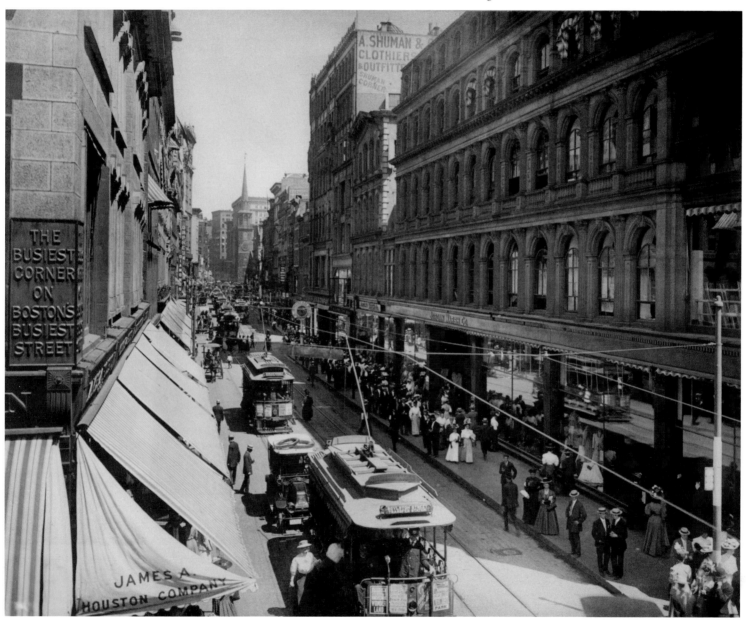

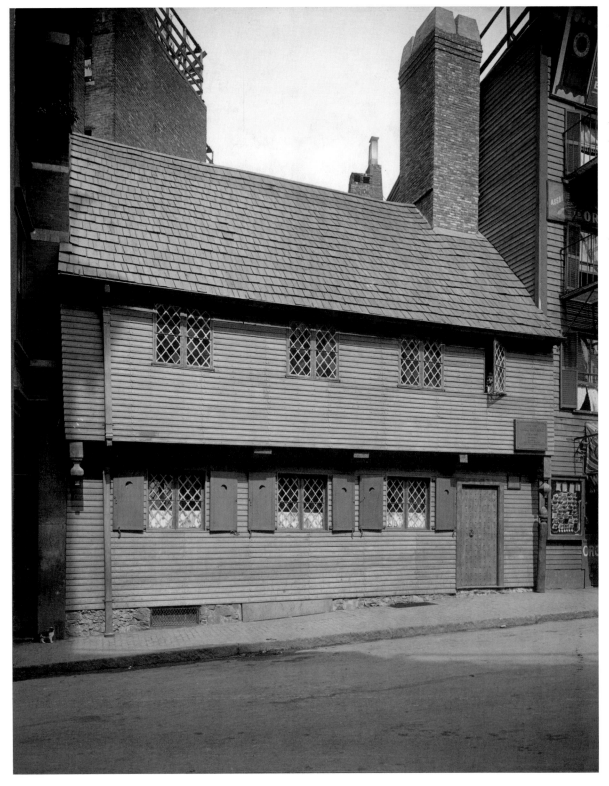

Paul Revere's House, on North Square in the North End (shown here in 1909), is the oldest surviving building in downtown Boston. Built about 1680, it was already ninety years old when Paul Revere moved in (1770). On the night of April 18, 1775, Revere left this house and rode to Lexington to warn Samuel Adams and John Hancock that British troops were coming to arrest them, a ride later immortalized by poet Henry Wadsworth Longfellow.

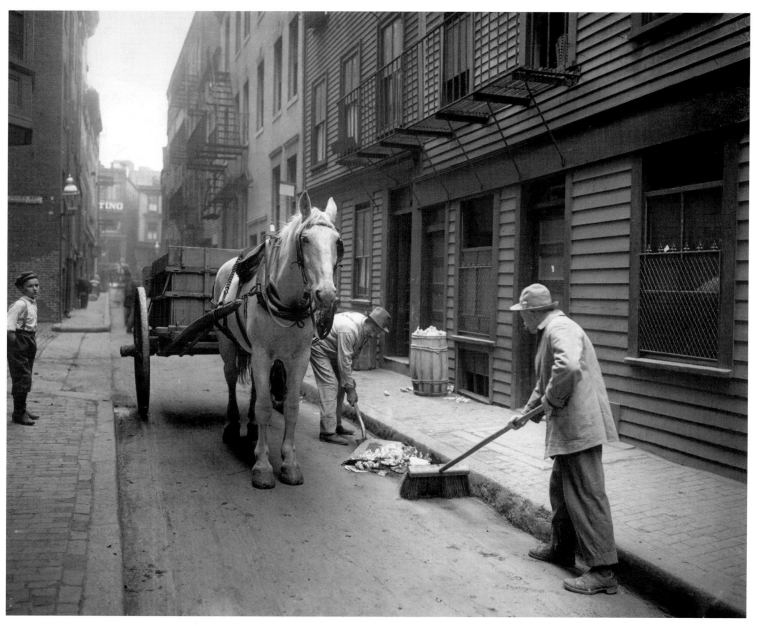

A schoolboy in suspenders watches as city workers sweep up trash in the North End in 1909.

Tourists are a long-standing Boston tradition. This photograph from ca. 1910 shows the Boston Palace Car, with its driver and bullhorn-wielding guide. The sign on the side of the open car advertises that the tour "starts opposite Hotel Touraine at 10-2-4."

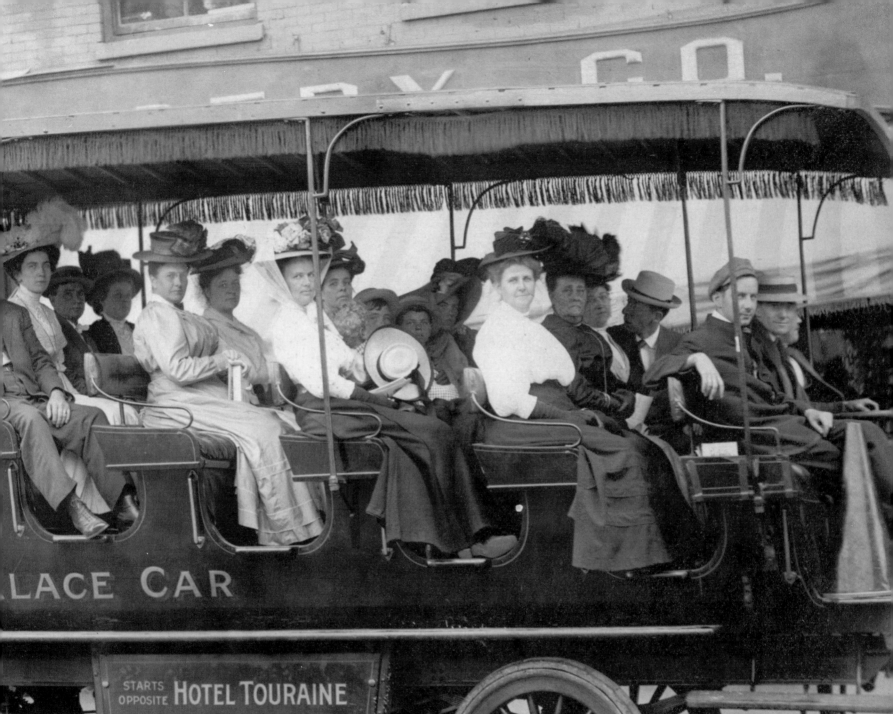

The third Suffolk County Court House (1896; designed by George A. Clough) obliterated half of Pemberton Square, an 1830s park-centered neighborhood much like Louisburg Square on Beacon Hill. This view shows the courthouse before a tall mansard roof was added in 1906-9.

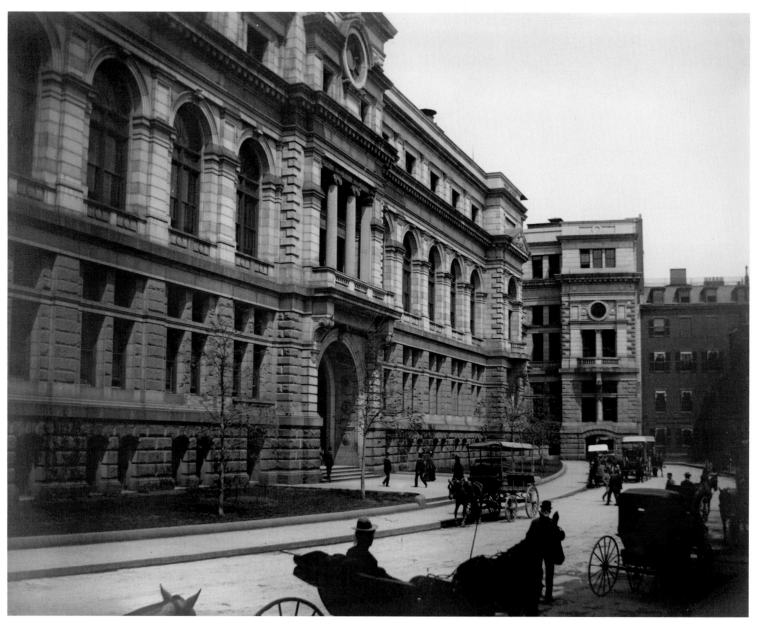

The Hemenway Building (1883, center) by Bradlee, Winslow, and Wetherell, in view here ca. 1910, is unremarkable except for its whimsical 7th-floor corner turret. Most of the rest of the surrounding Scollay Square, including the statue of Governor John Winthrop, was removed in the 1960s for Government Center.

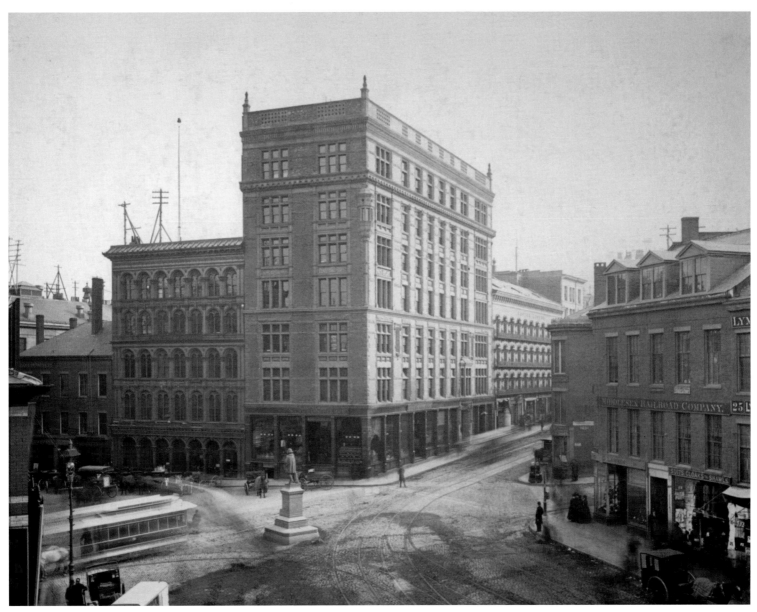

In September 1910, at Squantum Field in Quincy, "birdman" Walter Brookins took off in a Wright Brothers biplane. The Harvard-Boston Aero Meet included a flight over Soldier Field and the Boston Light (lighthouse). In the years after Kitty Hawk, the Wrights employed Brookins and other pilots, who traveled the country setting records. Earlier in 1910, Brookins was first to fly a mile high above the earth.

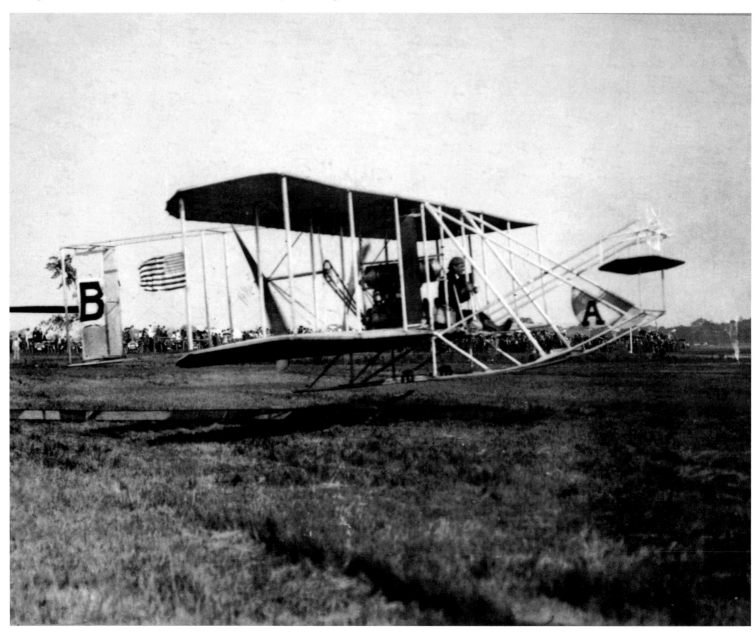

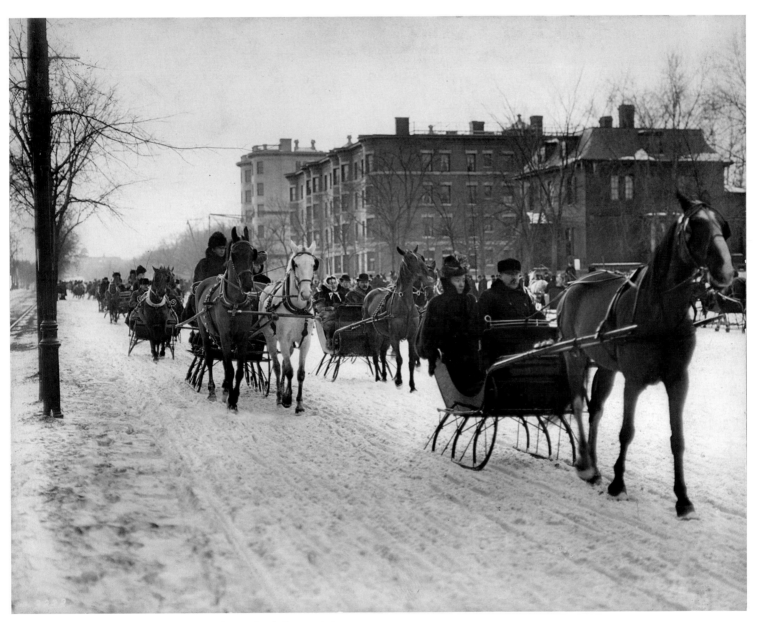

Automobiles had not displaced horse travel completely by 1910, in
evidence in this view of sleighs parading along Beacon Street.

This picture shows the West End in 1910. This is the corner of Chambers and Spring streets, looking toward Leverett Street. The West End, sandwiched between Beacon Hill and the Bulfinch Triangle, held as many as 7,000 inhabitants.

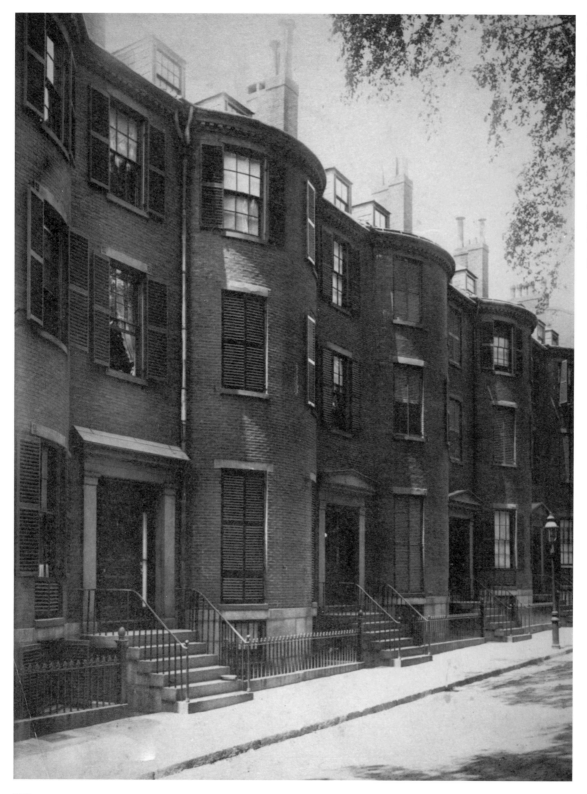

Louisburg Square was built in the 1830s and 1840s, a block of 22 townhouses around a jointly owned park. Shown ca. 1910 is 10 Louisburg Square, the bowfront townhouse Louisa May Alcott purchased for her family with the profits from *Little Women.* Novelist William Dean Howells lived at No. 4, and visitors to the square included authors Charles Dickens, Ralph Waldo Emerson, and Edgar Allan Poe.

Unlike New York or Chicago, Boston in 1913 was a city without skyscrapers. This view looks over Scollay Square (the clocktower in the foreground is part of Quincy House, an old hotel) toward Charlestown and the Bunker Hill Monument. The view was recorded from atop the 14-story Ames Building (1886), Boston's tallest building at that time.

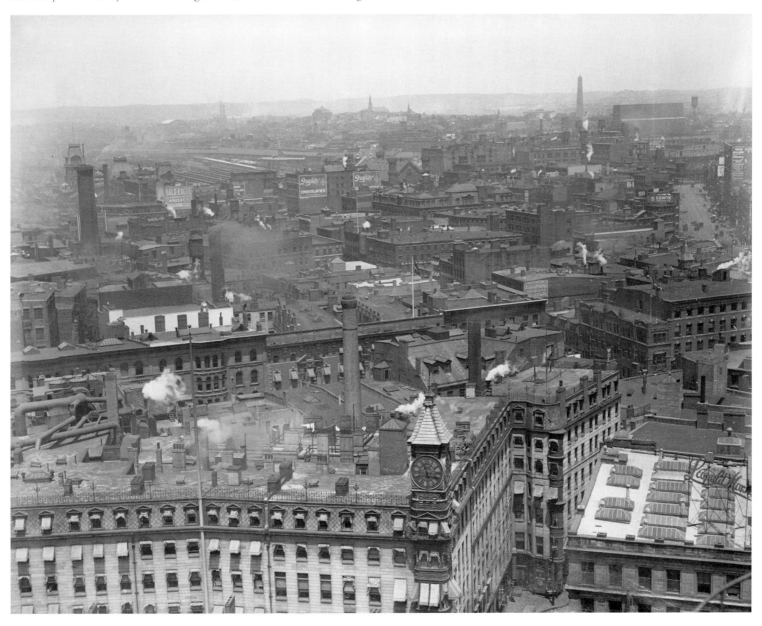

Following Spread: Spectators fill Harvard Stadium in 1914 for "the Game," the annual November competition between the Harvard Crimson and the Yale Bulldogs. The rivalry began in 1875. Harvard's "flying wedge" of 1892 caused both injuries on the Yale team and early attention to regularizing rules. Ivy League football made popular such college traditions as pennants, mascots, fight songs, and pranking.

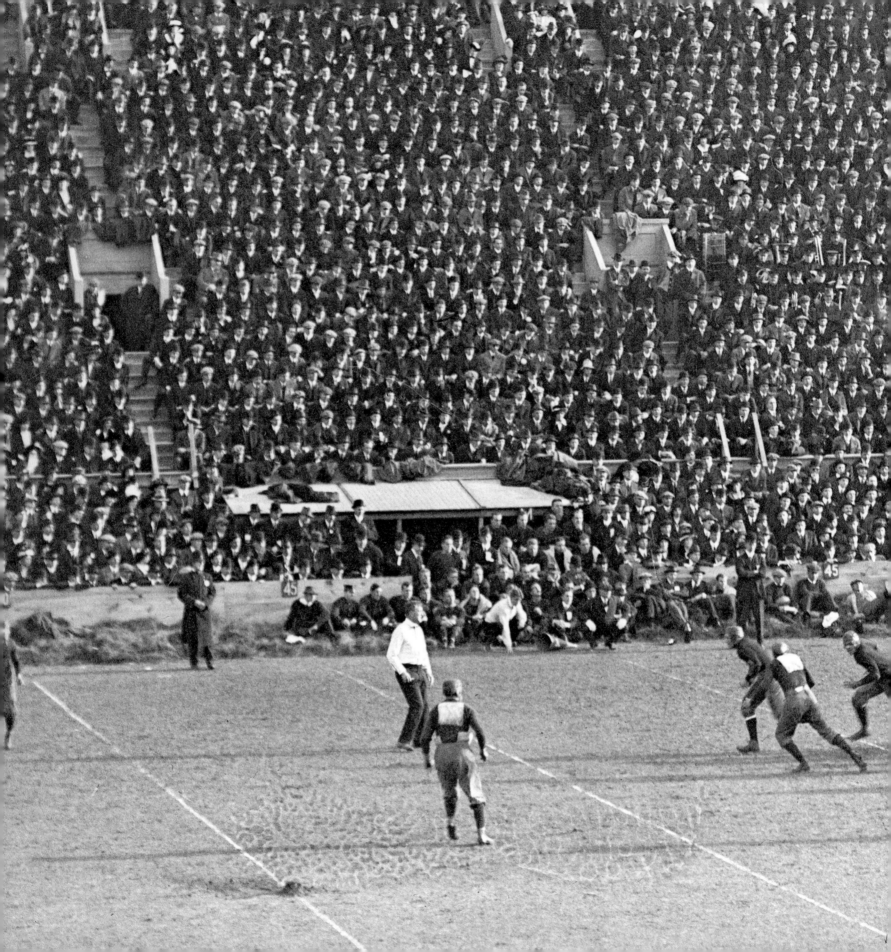

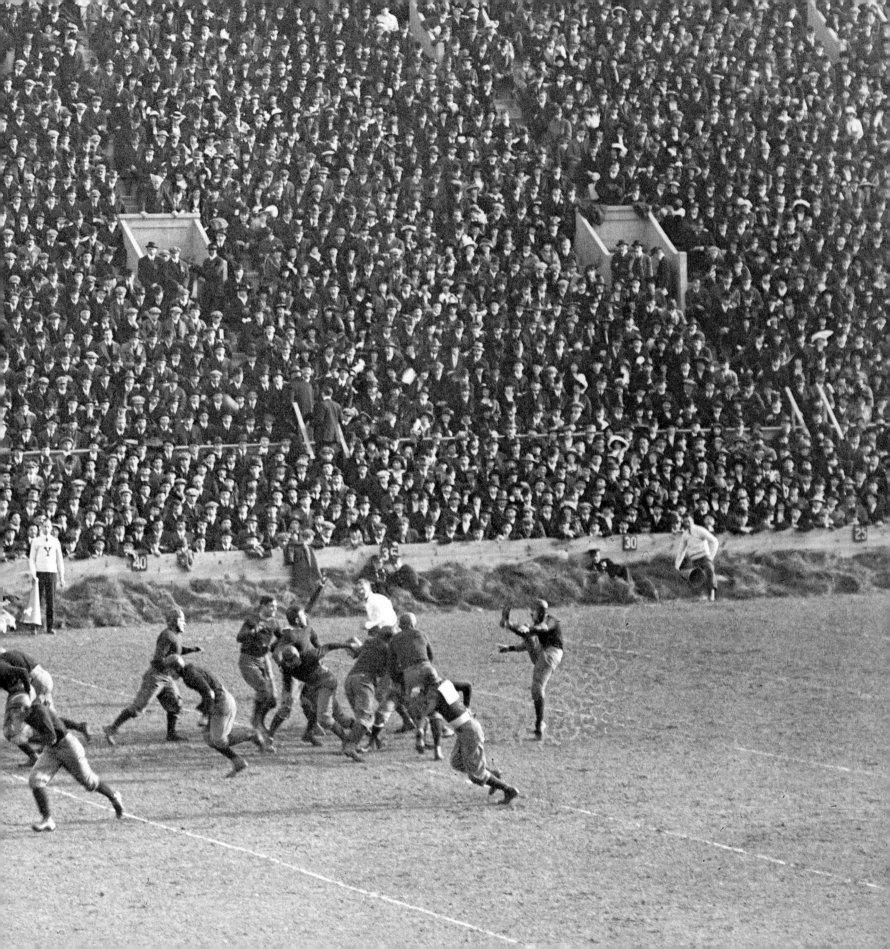

This 1915 aerial shot shows Harvard Stadium, in Boston's Allston neighborhood. Designed by McKim, Mead, and White and opened in 1903, the first permanent college stadium was also a pioneering use of reinforced concrete. The horseshoe shape evoked Greek amphitheaters and Roman stadia.

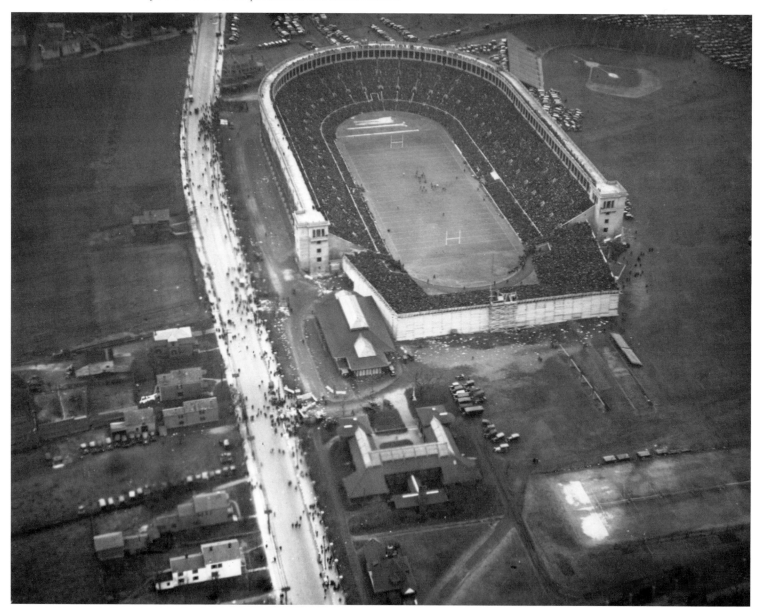

This photograph shows granite works behind the State House, presumably part of the extension of the State House. The Massachusetts State House was significantly expanded from 1914 to 1917, with two large wings (designed by Chapman, Sturgis, and Andrews) bracketing the original 1795-97 building.

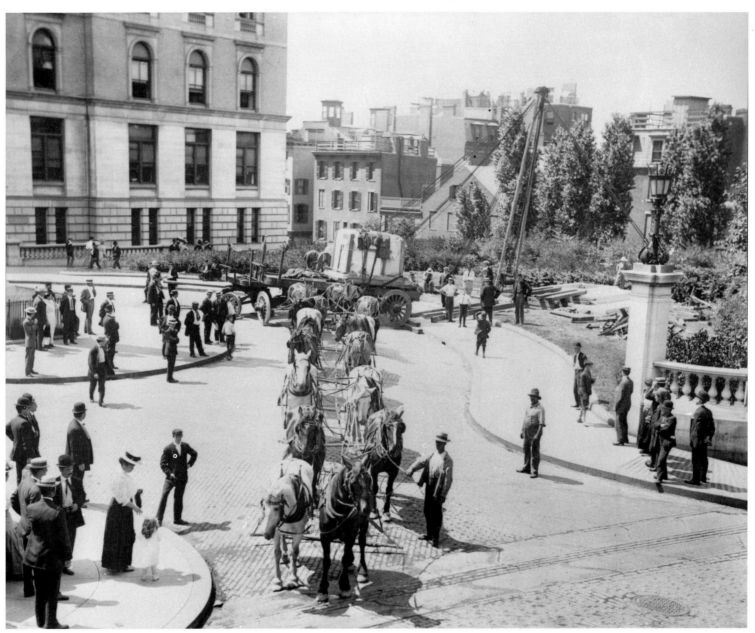

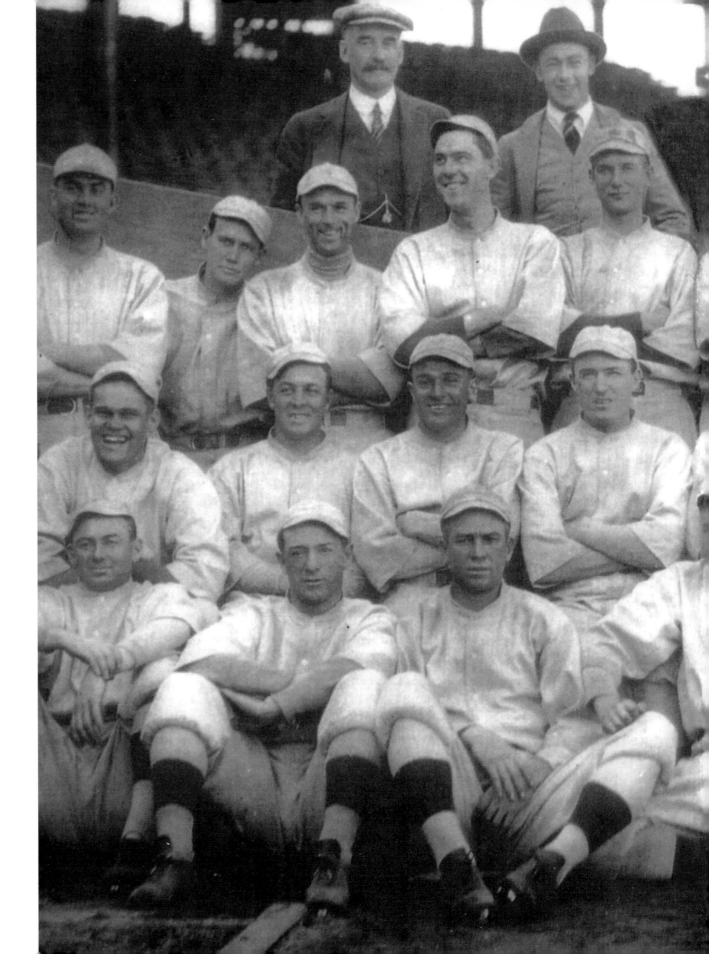

94

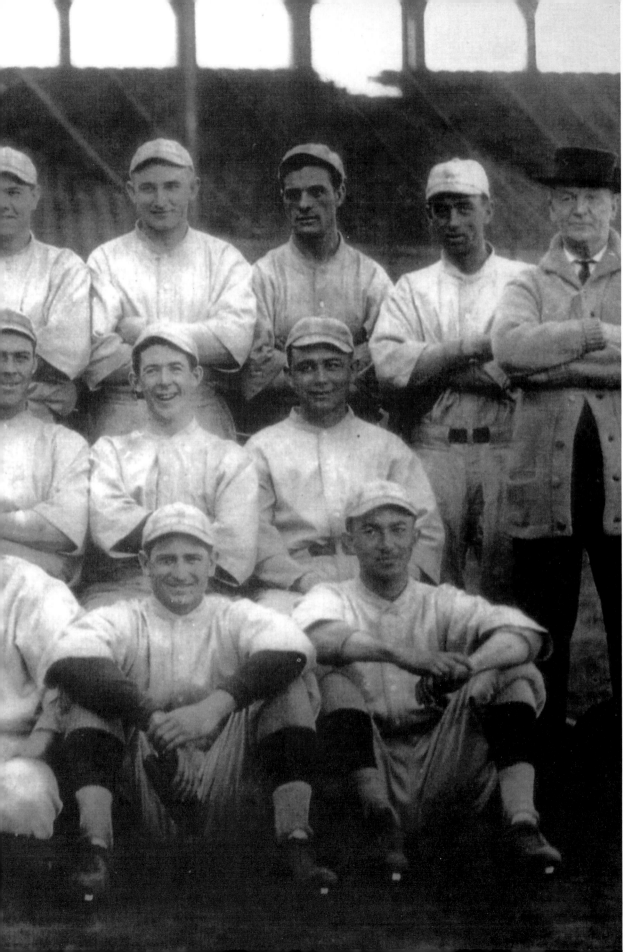

The 1915 Boston Red Sox team won the World Series by beating the Philadelphia Phillies 4 to 1. Rookie lefty George Herman "Babe" Ruth played in the series, but only as a pinch-hitter in the first game. Woodrow Wilson attended Game 2, the first president to do so, symbolizing baseball's growing popularity.

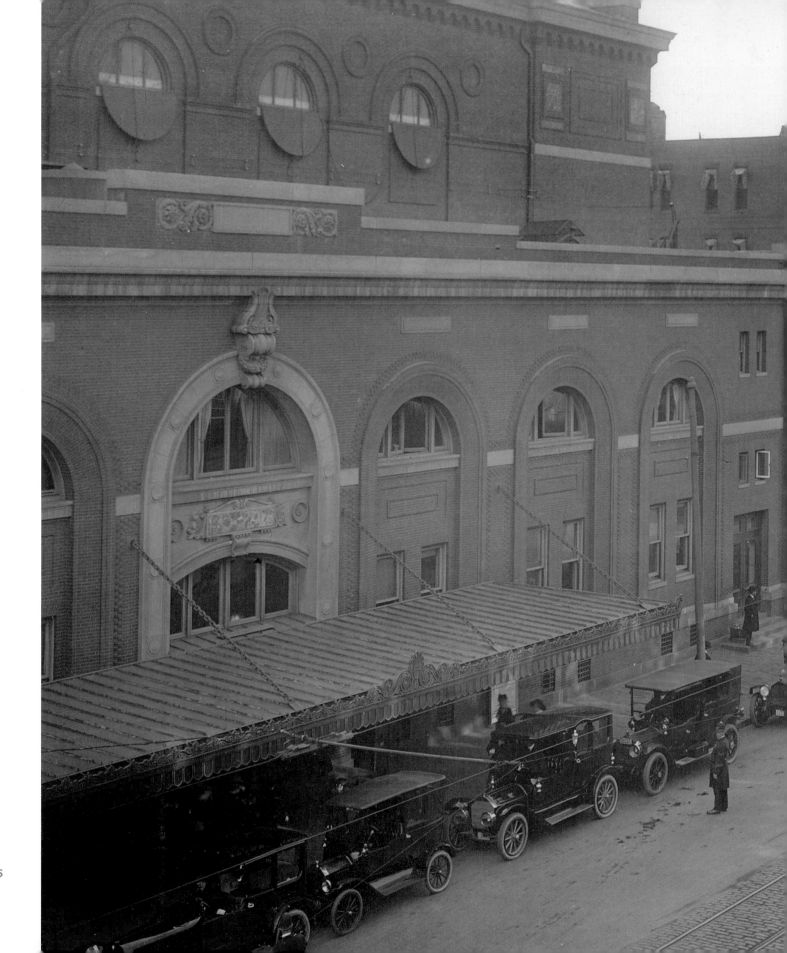

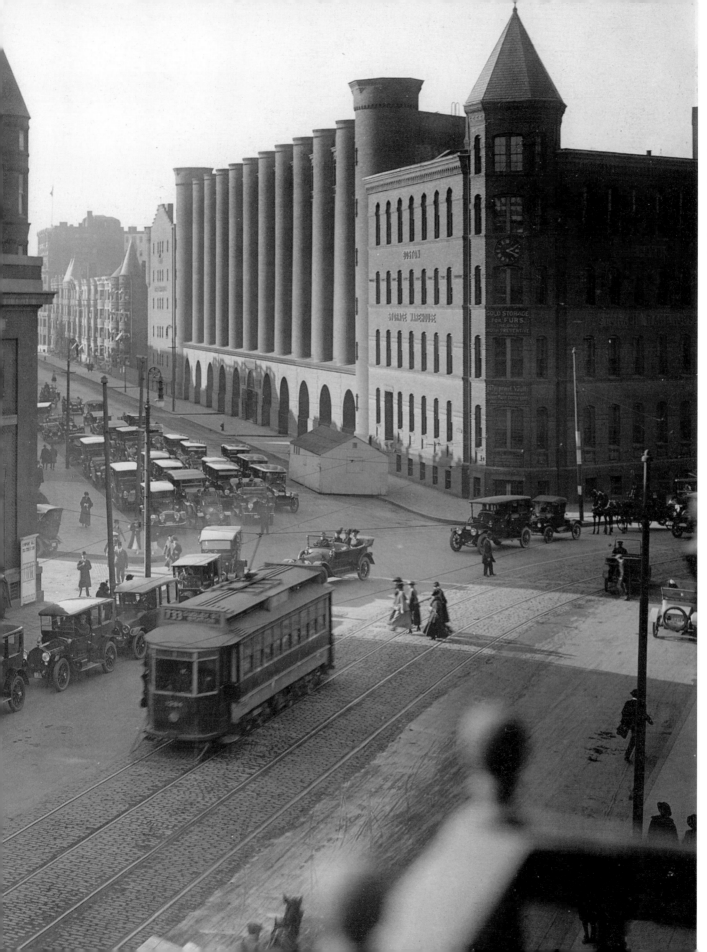

Most Bostonians would immediately recognize Symphony Hall (1900; McKim, Mead, and White), to the left in this 1916 photograph. Receding into the distance along Westland Avenue is the castle-like form of the less-known Boston Storage Warehouse, reduced to a parking lot in 1955.

97

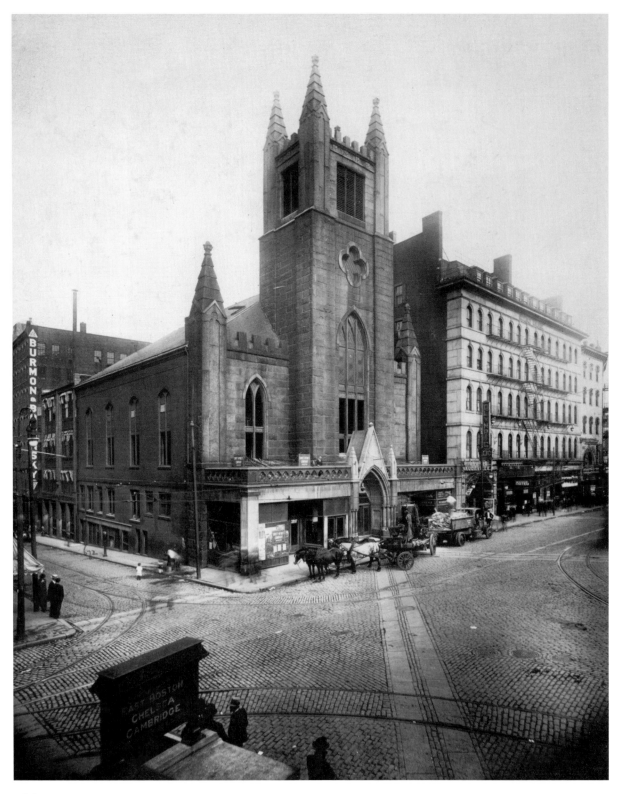

Bowdoin Square Baptist Church (1840), designed by Richard Bond, in view here ca. 1915. The church was built of brick, with an unhammered granite front that included a 110-foot gothic tower. It was razed for the New England Telephone Building (1930).

The Northern Avenue Bridge across the Fort Point Channel is congested with horses and carts laden with goods in 1916. Built 1904-8, the Northern Avenue Bridge is a Pratt triple-barreled truss swing span. Fort Point Channel today is almost a museum of bridges, all built as moveable-truss bridges that allowed traffic to go through the channel.

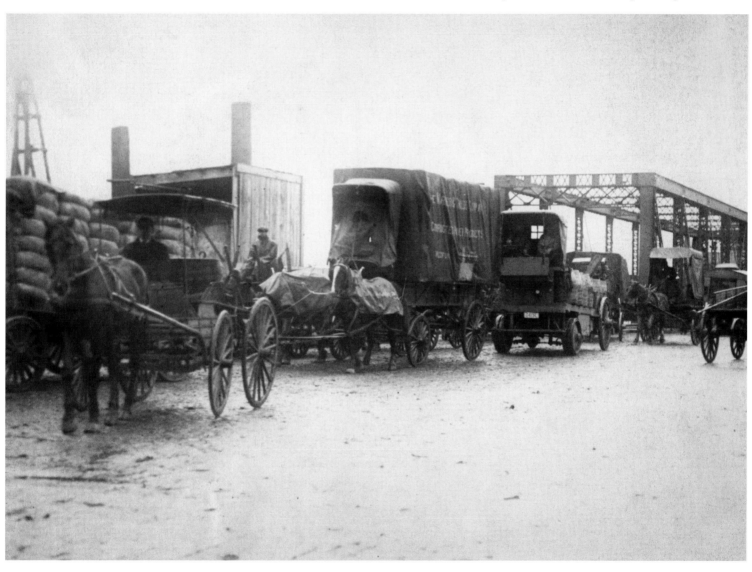

The United States remained neutral for almost 3 years before entering the First World War in April of 1917. As part of the mobilization, the Massachusetts State Militia came under federal control. This image, dated July 28, 1917, shows the first muster of the Massachusetts militia under federal orders, marching up Beacon Street and down Park Street.

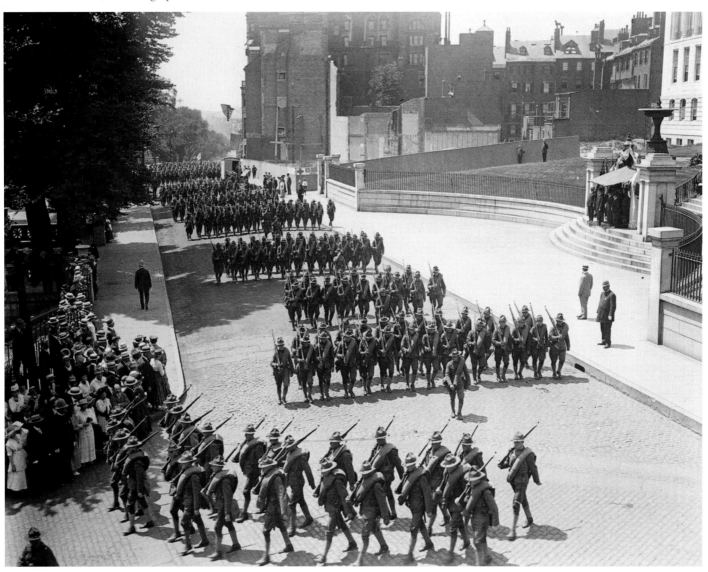

Despite its timeless air, the Massachusetts State House has gone through many changes, including two rear extensions in the 1800s, and these new marble wings, completed in 1917. The red-brick center section, known as the Bulfinch front (after its architect Charles Bulfinch), survived an 1890s effort to replace it. Long painted yellow, it was painted white in 1918 to match the marble wings. The paint was finally removed in 1928.

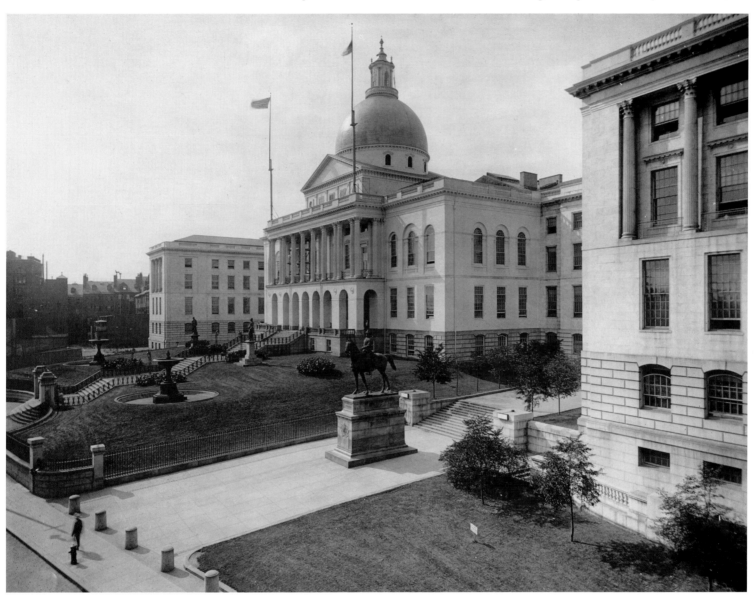

In 1918, children stricken with infantile paralysis (poliomyelitis) were transferred to a clinic by the Children's Ambulance Service. A rare condition until the 1890s, polio was feared as a mysterious crippler of children throughout the first half of the century, until the Salk and Sabin vaccines were devised in the 1950s and 1960s.

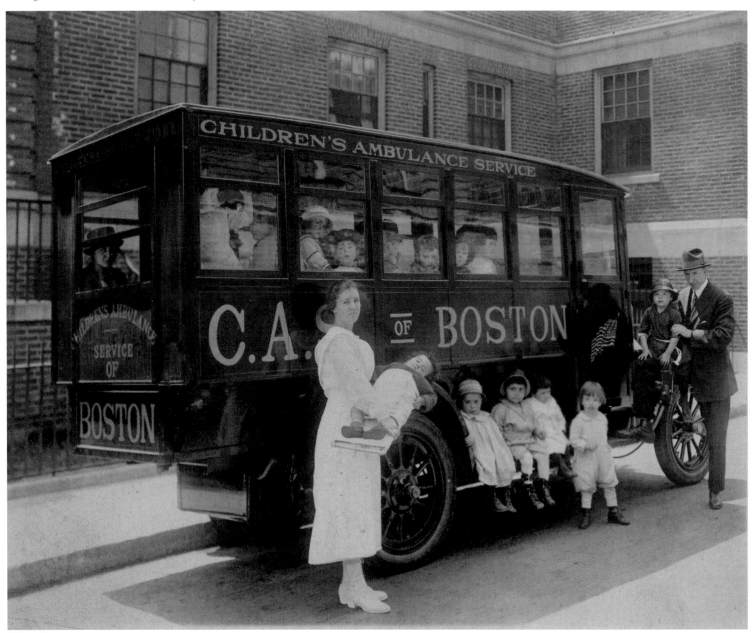

Shortly after noon on January 15, 1919, a storage tank on Commercial Street in the North End ruptured, and an 8-foot wave of molasses, moving at 35 miles per hour, engulfed an entire neighborhood. It buckled the metal supports of the Atlantic Avenue elevated railway and knocked a train off the rails. The wave killed 21 people and injured 150.

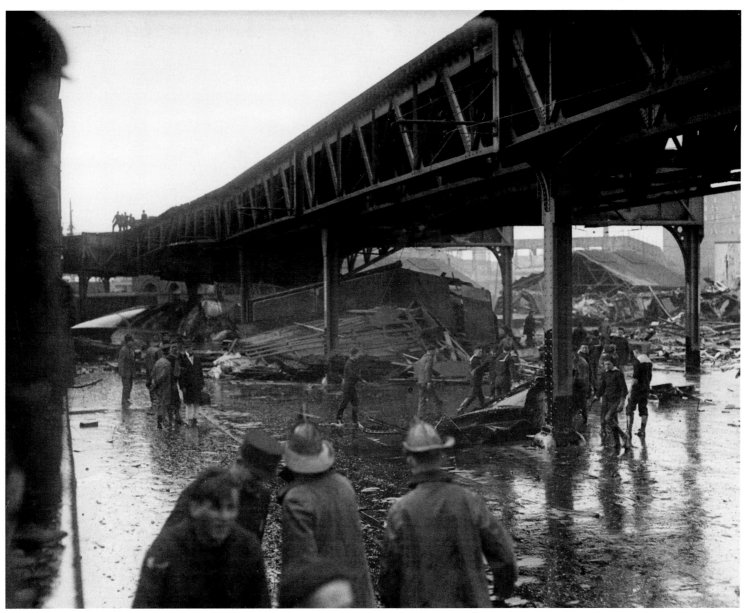

The circular pile of debris just in front of the light-colored warehouse is all that remains of the tank that held more than two million gallons of molasses. Used as a sweetener, molasses was also an ingredient in alcohol and munitions. Rather than repair the leaks in the tank, the company had painted it brown to hide them. It initially blamed anarchists for the disaster.

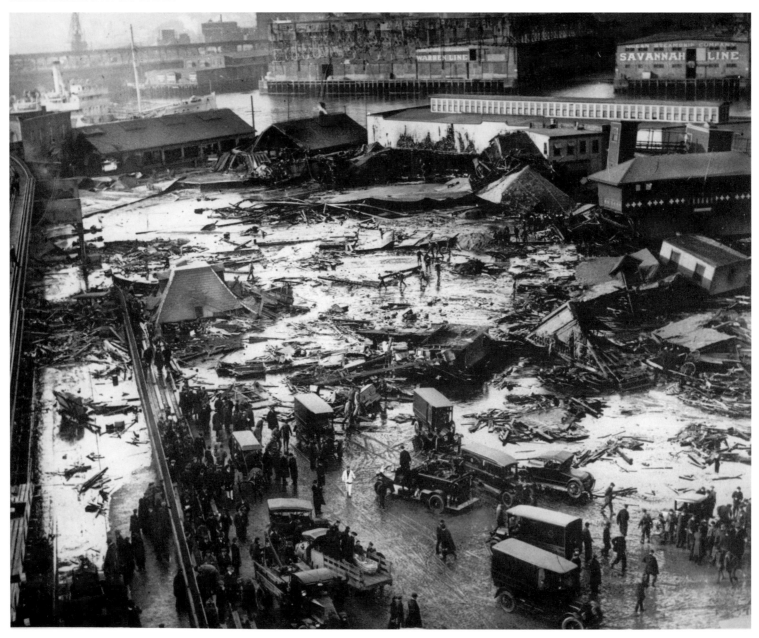

Copley Square as it appeared in 1919, from the tower of Trinity Church (its roof is visible at lower-left). Across Boylston Street, to the right of the Boston Public Library, rises the tower of the New Old South Church (1874-75). All of Copley Square is built on unstable fill. The 246-foot tower of this Congregational church began tilting, and had to be dismantled in 1931. By 1940, a shorter—but stable—tower rose in its place.

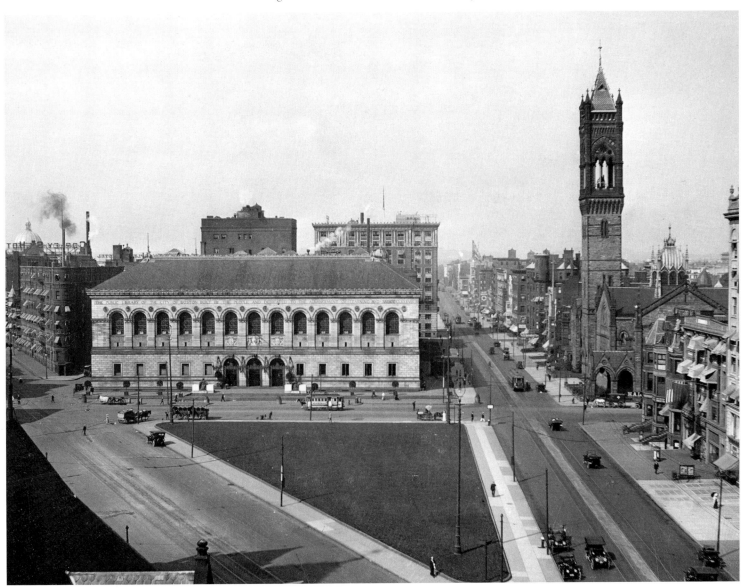

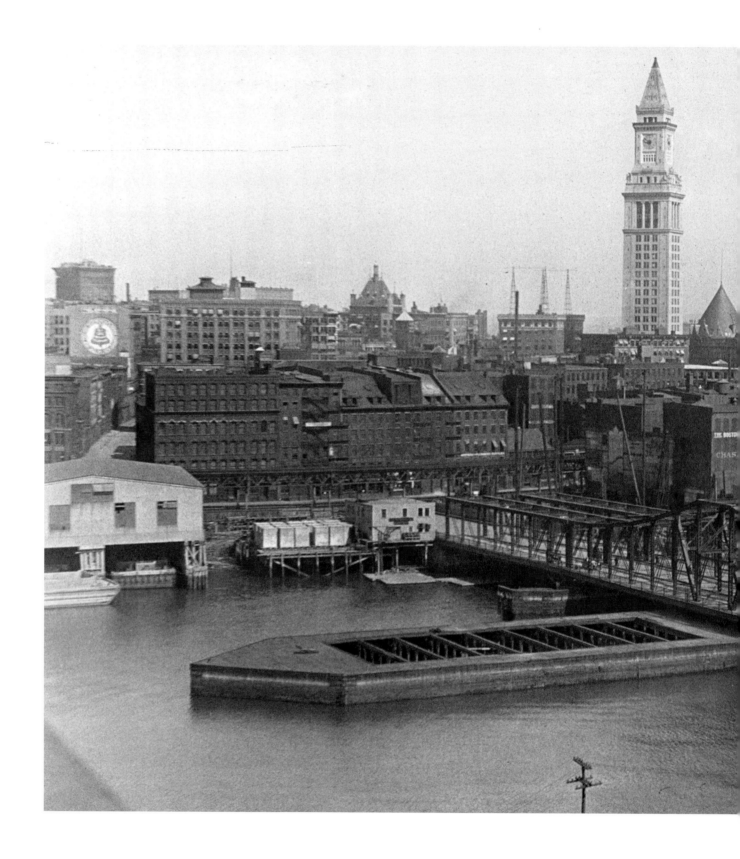

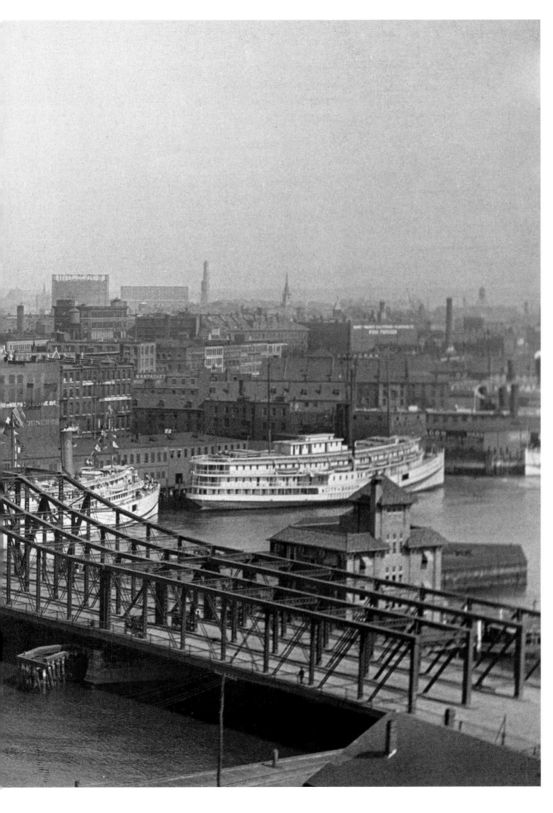

From the vantage point of the Boston Wharf buildings, this photograph shows downtown Boston in 1919, just beyond the Northern Avenue Bridge over the Fort Point Channel. The single skyscraper is the tower of the Custom House. Completed in 1915, this tower circumvented downtown Boston's 125-foot height restriction because it was federally owned.

On May 27, 1921, Boston kids try out a new "sprinkling device" for keeping cool in the summer. On the sidewalk behind them, social classes are clearly delineated, as those in ties and hats keep a safe distance from the splashing, while workmen in cloth caps enjoy the revelry.

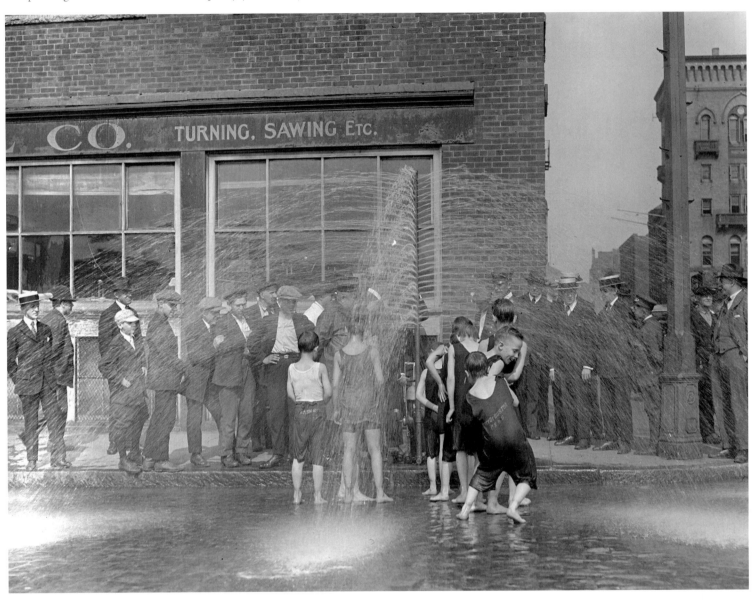

BOSTON BETWEEN THE WARS

1920–1939

Boston between the World Wars was a city of contrasts and divisions. Prohibition destroyed Boston's rum industry by outlawing the production and sale of alcohol. Yet the consumption of alcohol remained legal, leading to rum-running, an increase in organized crime and federal enforcement bureaucracy, and a general disregard for the laws. For more than a decade—until the repeal of Prohibition—Bostonians covertly, and sometimes openly, flouted the law.

The greatest of the divisions was between the financial and social upper classes and the political machine of James Michael Curley. Beginning in 1914, Curley served four terms as Boston mayor, one per decade, interspersed with time served as governor, as congressman, and as convict. "The People's Mayor," Curley taxed the rich and let downtown Boston rot, but poured city money into improving long-neglected poor neighborhoods. Curley's divisive politics, and the reactions against Curley, strengthened ethnic and neighborhood ties—but on opposing sides of a social, ethnic, and religious gulf.

Boston missed the first round of skyscraper building, which transformed New York, Chicago, and other leading cities. With the sole exception of the 29-story Custom House Tower (1913-15), Bostonians held on to height restrictions and built shorter, human-scaled classical buildings until the middle of the 1920s. Before the Great Depression stopped most large-scale construction, Bostonians added a few conservative art deco towers to their skyline.

Boston's population continued to grow, though more slowly, during these decades. In 1920, Boston's women gained the right to vote, with the passage of the 19th Amendment. Like other cities, Boston faced breadlines and bank runs during the early 1930s, but got relief through the programs of the New Deal. Radio (1920) and regularly scheduled airline service (1927) linked Boston more closely to the rest of the nation. Whatever the political or economic climate, though, Bostonians filled their theaters to watch stage plays, vaudeville, and increasingly, moving pictures.

Trotters at Readville Park, ca. 1920. Located in the Hyde Park neighborhood of Boston on the Dedham town line, Readville began as a Union training camp during the Civil War, and then a county fairgrounds. The mile-long Readville Trotting Park that opened there in 1896 became the premier site for harness racing in New England through the 1920s.

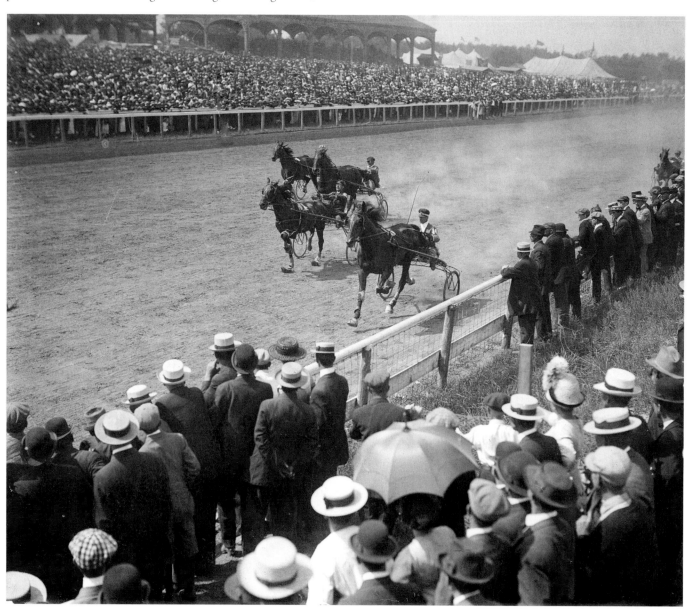

On a tour of Boston, General John J. Pershing meets with Governor Calvin Coolidge outside the Massachusetts State House on February 25, 1920. Hero of the Spanish-American War and campaigns in Mexico and the Philippines, Pershing served as the leader of U.S. forces in Europe in the First World War. Coolidge, who had gained national attention by breaking a Boston police strike in 1919, became Vice President in 1921 and President in 1923.

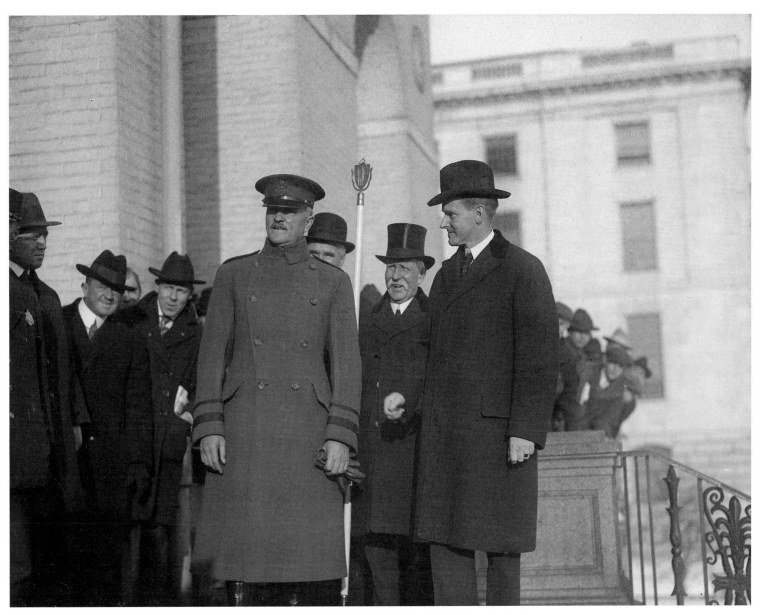

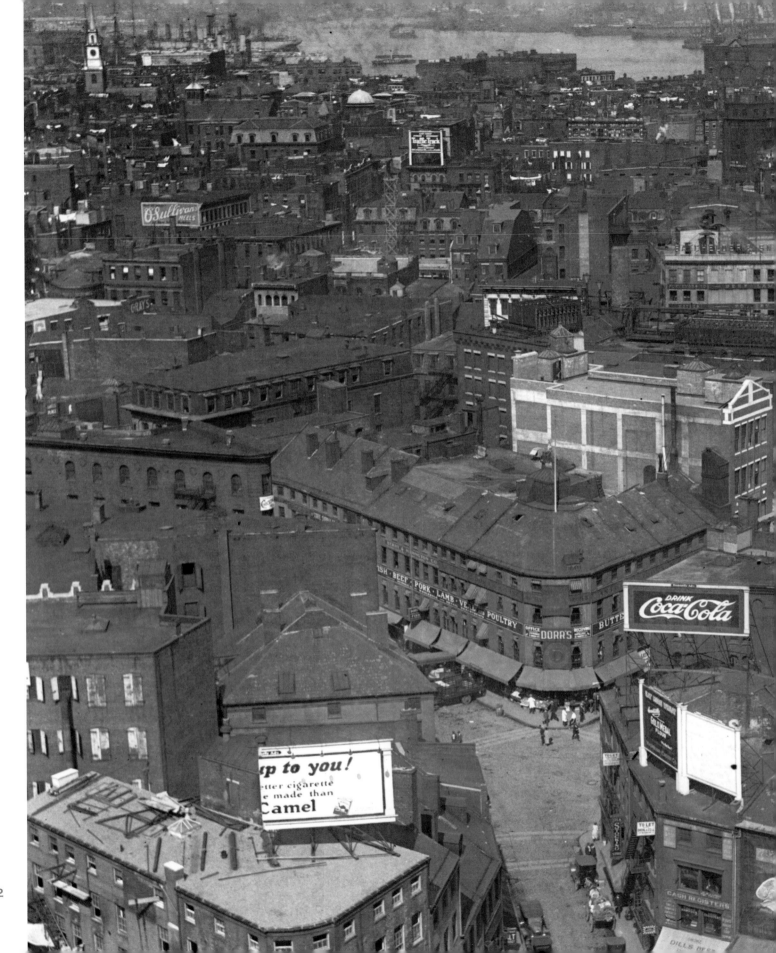

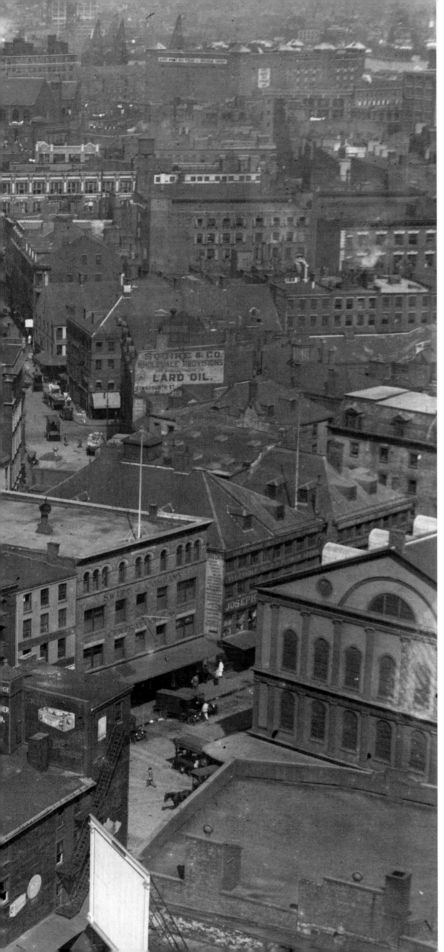

This view from ca. 1920 looks from the top of the Ames Building toward old Dock Square, and the North End beyond. To the right is Faneuil Hall. The neighborhood in the foreground disappeared for the Boston City Hall and Government Center, and the neighborhood beyond for the Central Artery elevated highway.

113

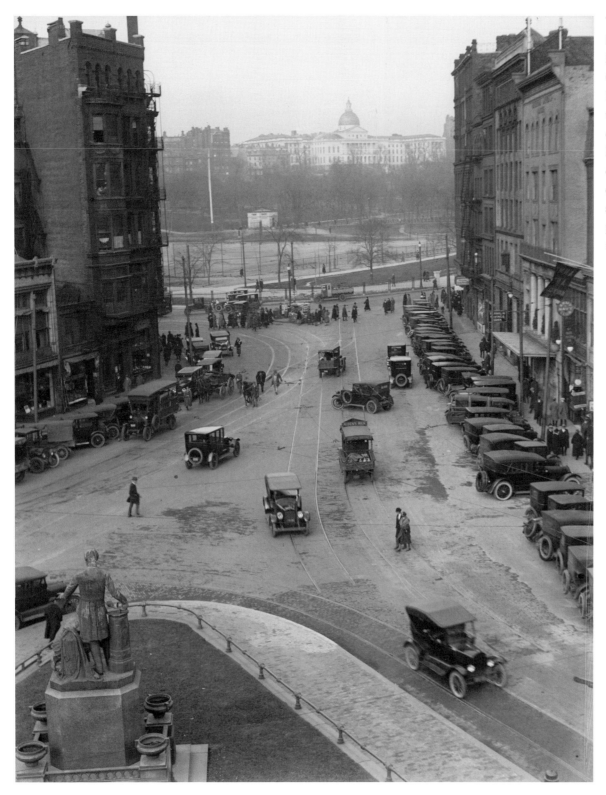

The State House is visible from Park Square, at the far corner of the Boston Common, ca. 1920. Bostonians so treasured their views of the State House dome that they enacted height restrictions and other laws at the turn of the century. These laws became a basis for preservation, planning, and zoning codes nationwide.

Looking down Commonwealth Avenue at the Hotel Somerset, on September 6, 1920. Designed by architect Arthur Bowditch in 1897, it was one of several apartment buildings along the Charlesgate Fens that attracted wealthy Social-Register residents to the western Back Bay in the 1920s.

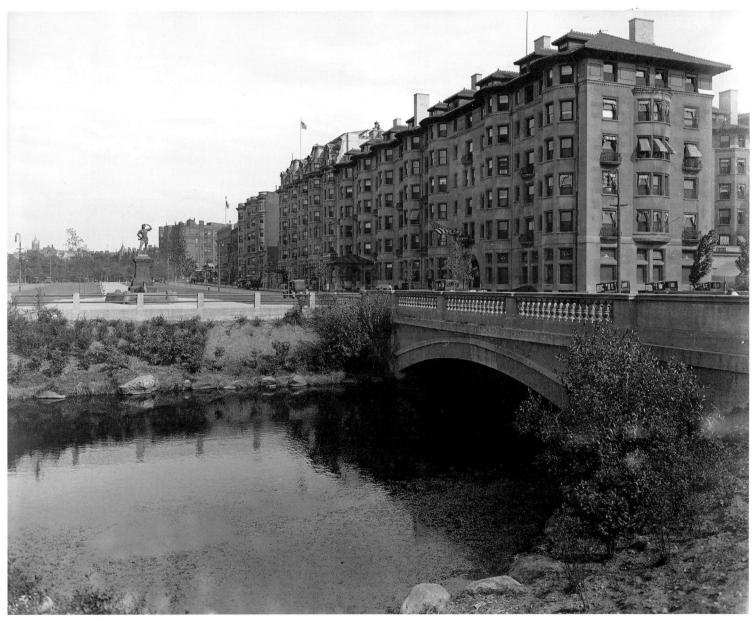

Charles Ponzi on his way to court, August 1920. An Italian immigrant, Ponzi hit upon a scheme of buying and selling international postal reply coupons and made a fortune in currency trading, mostly from gullible investors. Ponzi pled guilty to mail fraud in November 1920, and Bostonians lost millions of dollars. "Ponzi scheme" remains a term to describe a clever investment fraud.

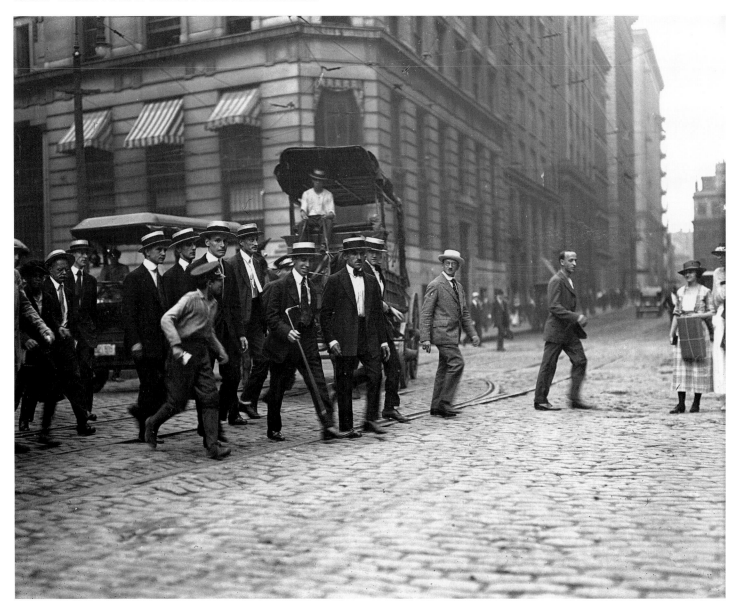

In the winter of 1920, workers unload fish at a South Boston pier. Originally a peninsula off Dorchester, South Boston was annexed to Boston in 1804. Its pastures were overlaid with a regular grid of streets. South Boston became an industrial engine for Boston, with foundries, machine shops, refineries, and shipyards employing a large immigrant work force.

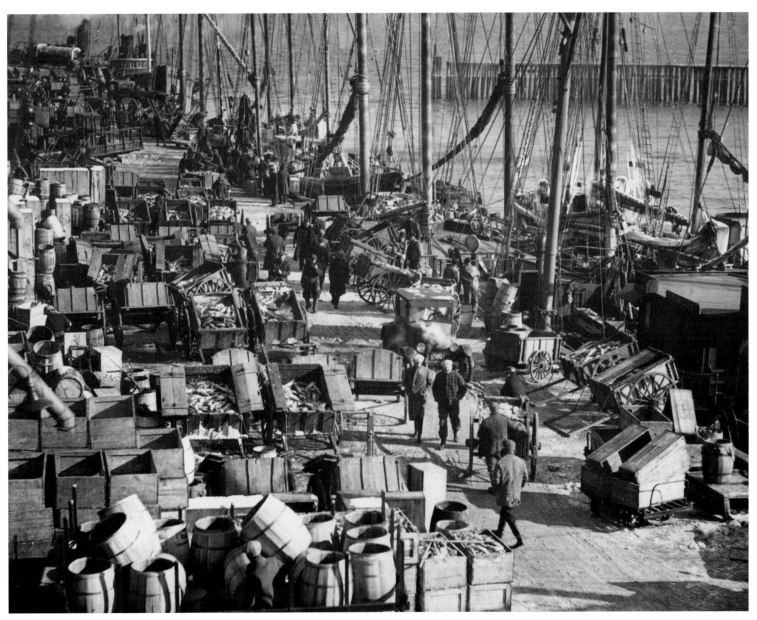

Firemen pose with their fire engine in East Boston, possibly Saratoga Street, ca. 1920. With its shipyards, warehouses, and wharves, East Boston attracted waves of workers from many nations, including Ireland, Canada, Italy, Greece, and Portugal. By 1905, the influx of Russian and Eastern European Jews made East Boston the largest Jewish community on the East Coast.

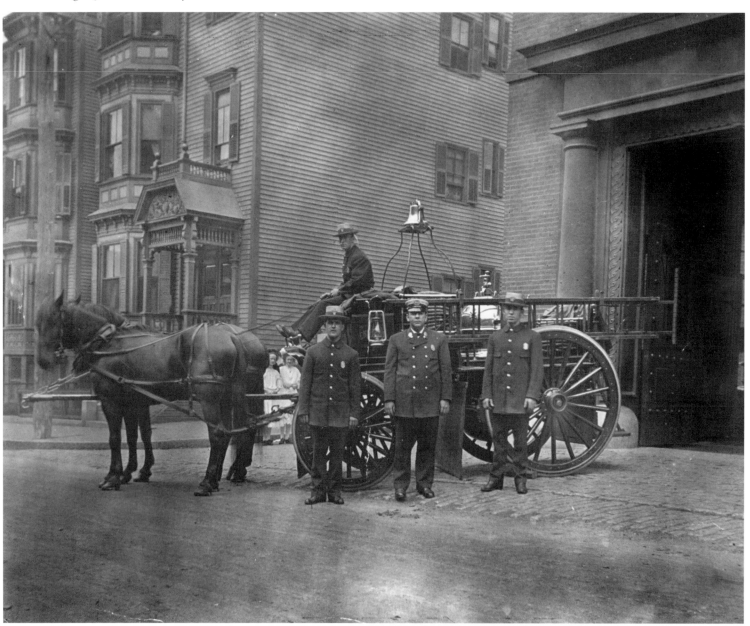

The Massachusetts Society for the Prevention of Cruelty to Animals (MSPCA) sponsored several fountains for watering horses in downtown Boston (shown here in 1922). Founded by Boston lawyer George Angell in 1868, the MSPCA sparked a national movement, which led to laws protecting animals from unnecessary abuse and established animal shelters and hospitals.

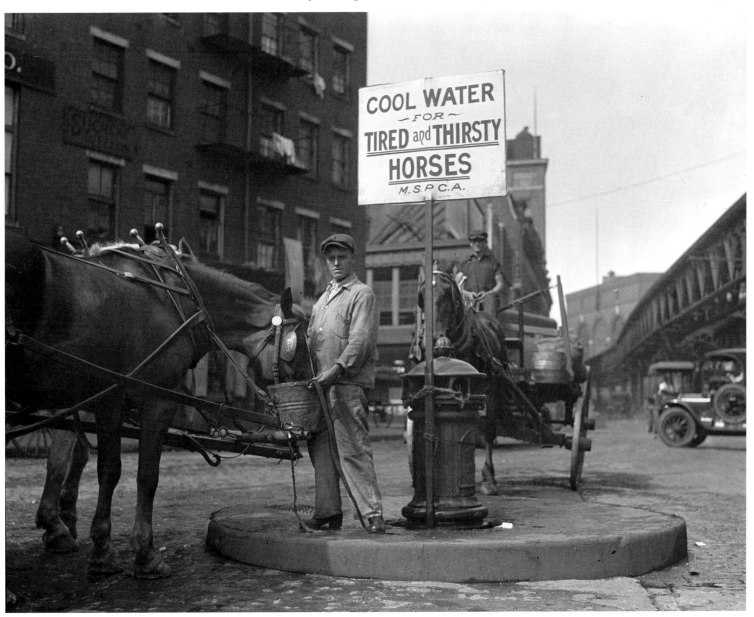

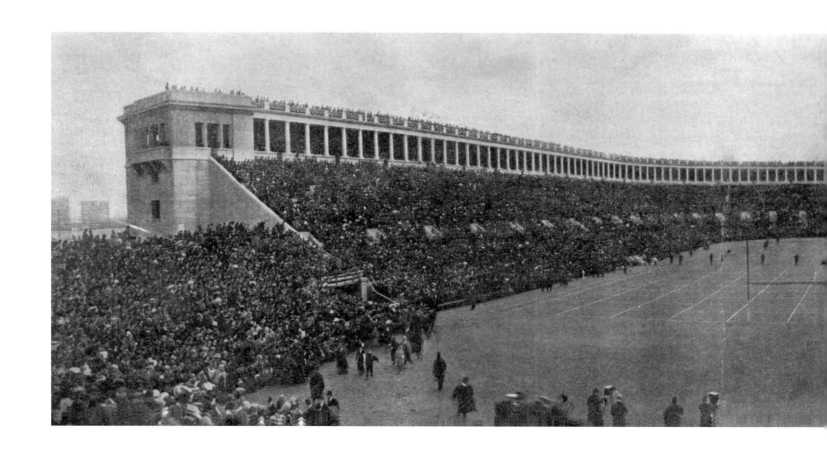

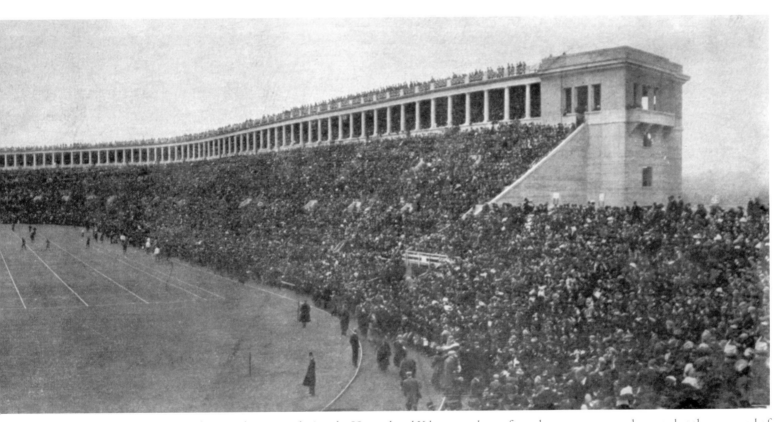

Harvard Stadium in the 1920s, during the Harvard and Yale game, shown from the temporary stands erected at the open end of the horseshoe. A steady increase in fan interest led Harvard to add open colonnade seating atop the stadium in 1910 and eventually to replace the temporary stands with steel bleachers, bringing its capacity to 57,000. As interest fell after World War II, Harvard removed the end bleachers and made it a horseshoe again.

This Back Bay view, looking down Stuart Street from Dartmouth Street, shows the first of the three John Hancock buildings in 1922, the year it was completed. Designed by Parker, Thomas, and Rice, the building still stands, although a subsequent addition stacked four more floors atop the original building, encasing its distinctive tower.

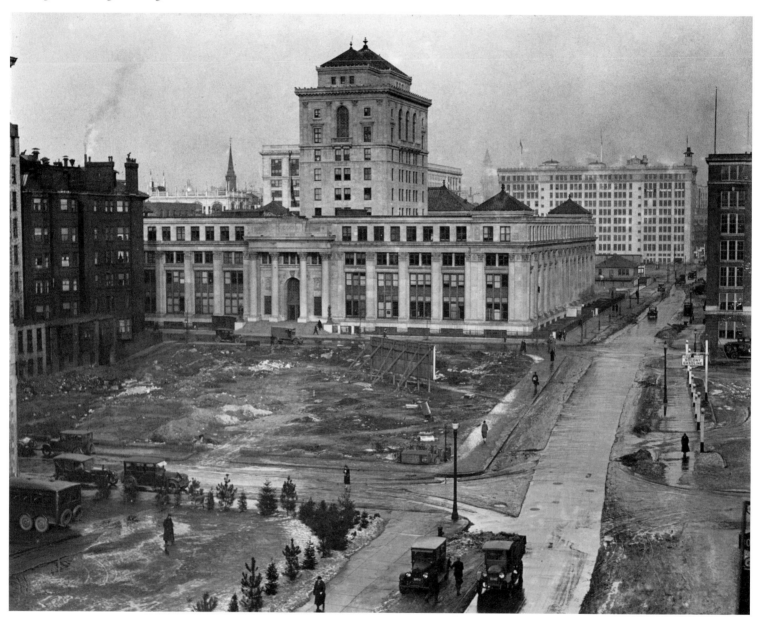

This view of Washington Street from ca. 1925 shows the Loews Orpheum Theatre's marquee, announcing a Lon Chaney film and a vaudeville act by Roscoe "Fatty" Arbuckle. Arbuckle's film acting career had ended in 1921 after he was charged with murder. Following his acquittal in a third trial in 1923, he toured in the vaudeville circuit, stopping in Boston.

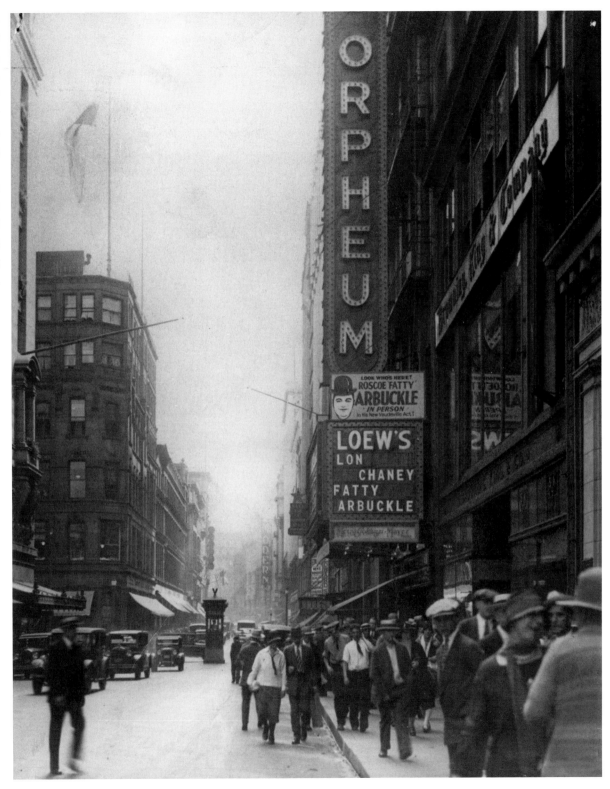

This aerial view of 1925 Boston shows Fan Pier to the lower right, with the Northern Avenue Bridge over the Fort Point Channel to the left. The single substantial tower downtown is the Custom House. Most of the land along the Boston Harbor has a complex history of centuries of dock construction, followed by harbor filling and building construction; today the original shoreline is often buried several blocks inland.

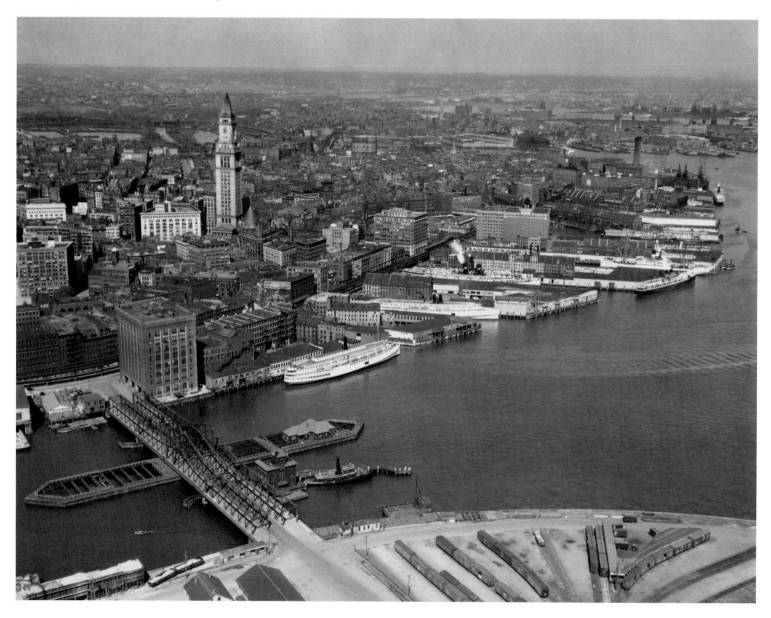

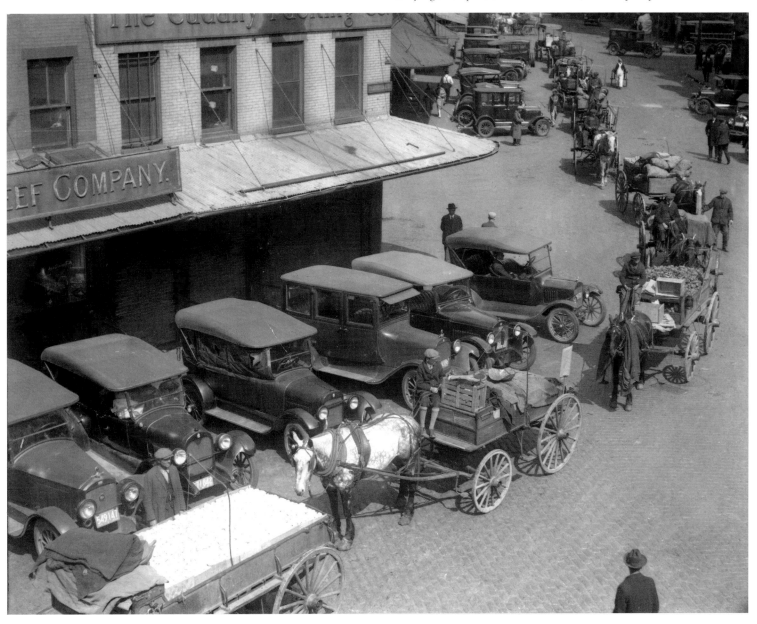

Rush hour at Quincy Market ca. 1925, as a line of horse-drawn wagons, most carrying fresh produce for the market, threads past parked automobiles.

This image from October 1925 shows Stuart Street, in Boston's Theater District, looking west from Washington Street toward Tremont. The district's oldest restaurant is on the right at 31-39 Stuart Street (its clock visible just below the "Hardware" sign). Jacob Wirth's, a German brew pub, opened in this block in 1868, moved to a bowfront Greek Revival house across the street in 1878, and expanded into its neighboring bowfront in 1891.

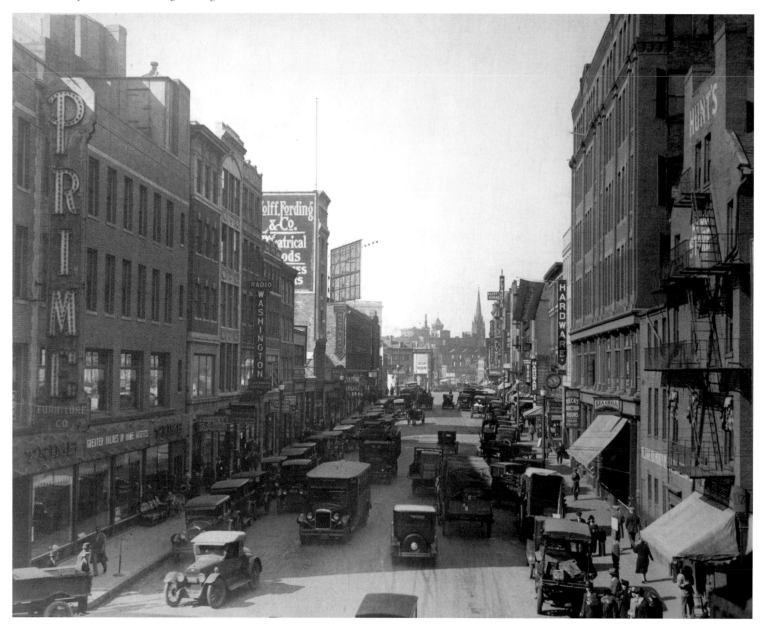

Perhaps no other landmark in Boston has been photographed as frequently as the Quincy Market. This 1926 view shows—through the billboards—the dome of Quincy Market and the cupola of Faneuil Hall. Atop the cupola is the famed grasshopper weathervane designed by Deacon Shem Drowne and erected above Faneuil Hall in 1742.

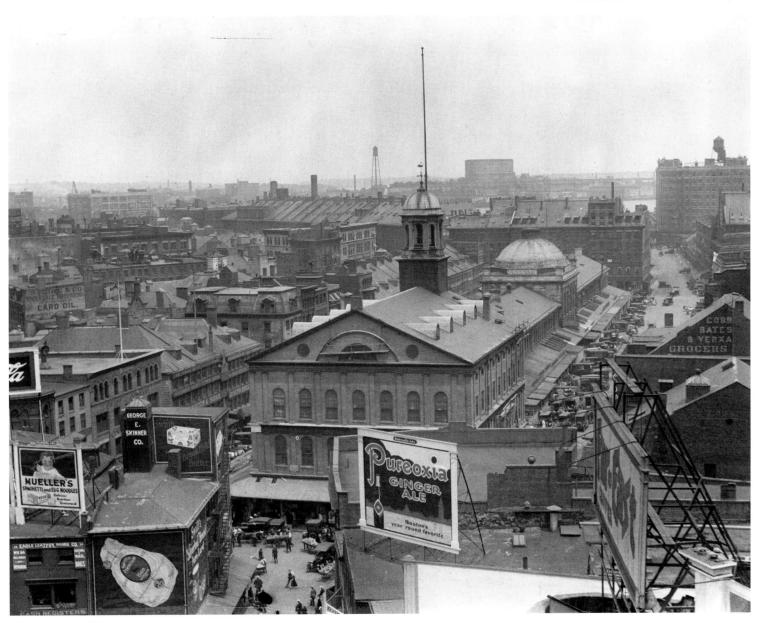

This 1927 photograph shows crowds mobbing fliers Charles "Lucky Lindy" Lindbergh, Clarence Chamberlin, and Richard Byrd in front of the Hotel Bellevue on Beacon Street in Boston. Lindbergh's fame, tragically, led to the kidnapping and murder of his son in 1932.

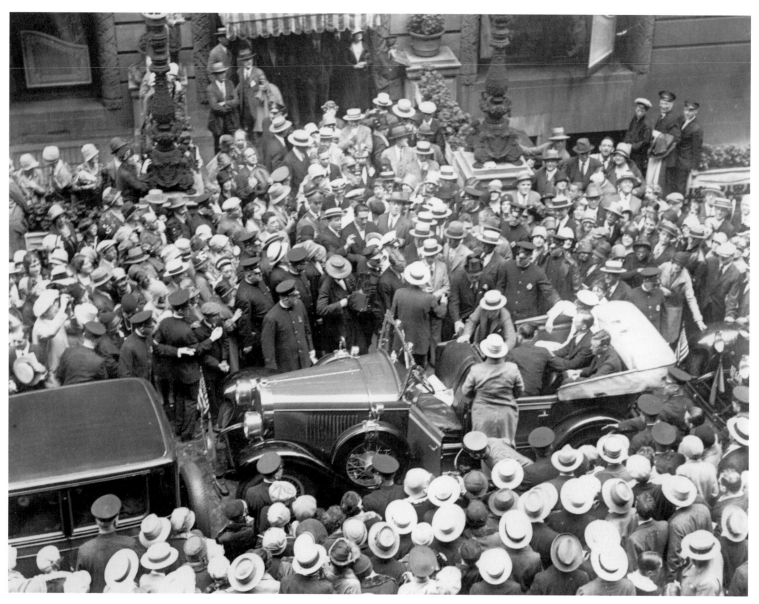

This March 1927 photograph shows busy Tremont Street from the Little Building on Boylston Street. On the left is the Boylston Street T Station, at the edge of the Boston Common. The Little Building (1916) was designed by Blackall, Clapp, and Whittemore, an architectural firm responsible for a number of theaters in the surrounding district.

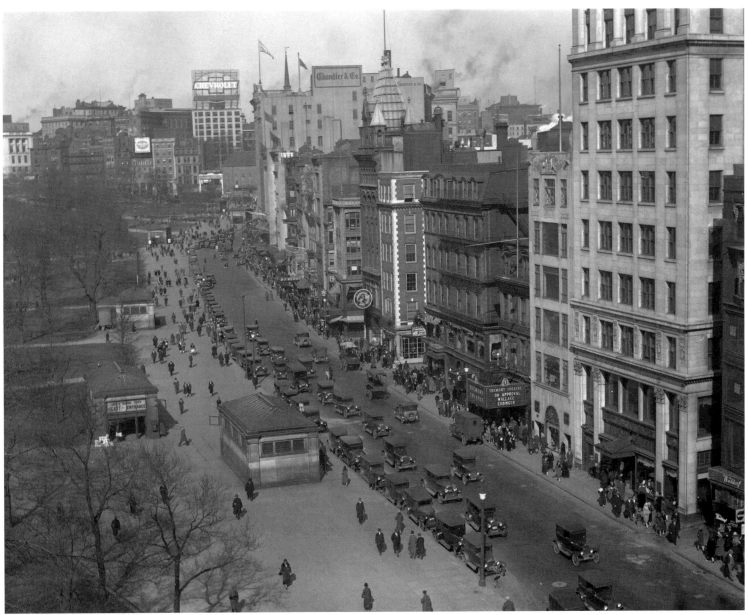

Governor Alvan T. Fuller presents Amelia Earhart with a bouquet of roses at the Massachusetts State House in July 1928. The month before, Earhart had been the first woman to copilot a transatlantic flight, followed by the second solo transatlantic flight in 1932. In 1937 Earhart attempted to be the first woman to fly around the world, but disappeared over the South Pacific.

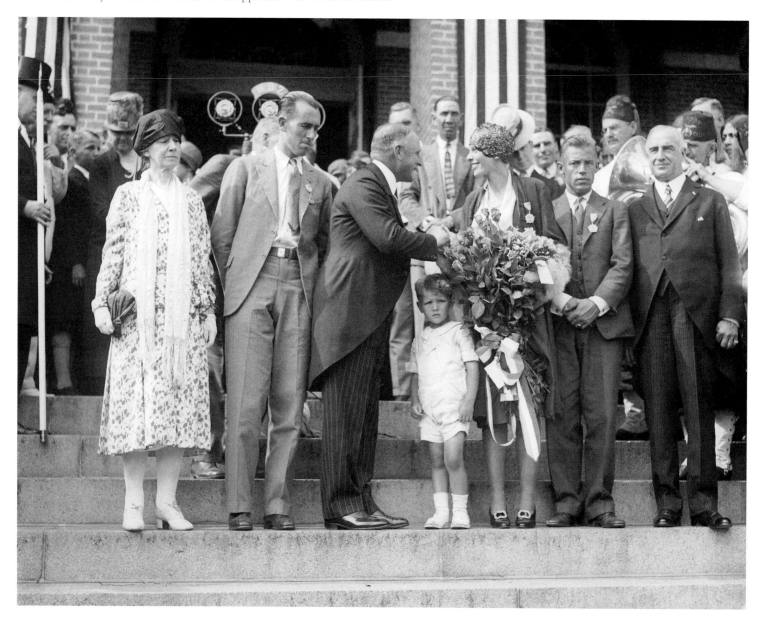

Boston Bruins General Manager Art Ross looks on as the team goalie shows a boy how to protect the net at the Boston Garden in 1929. The Boston Bruins hockey team debuted in 1924 and played its first season at the new Boston Garden in 1928-29. The city built the Boston Garden stadium on Causeway Street, above its new North Station.

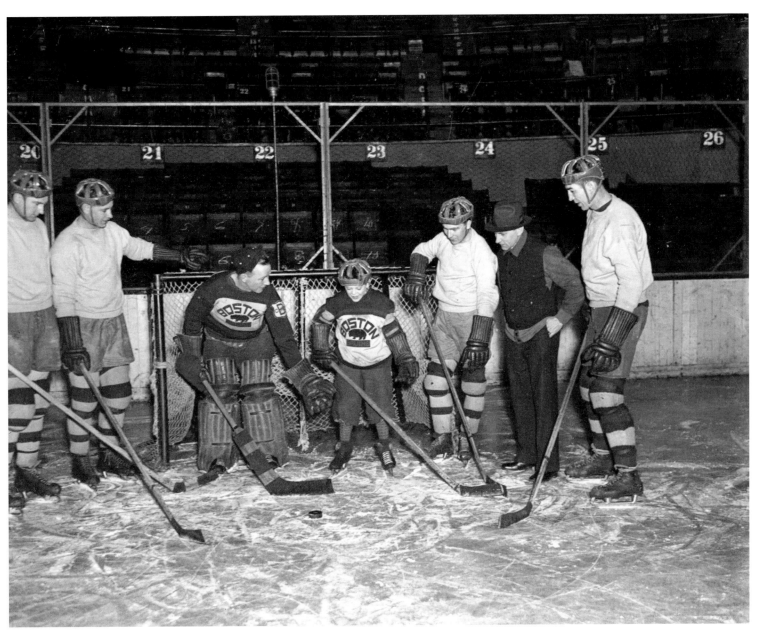

Haymarket Square on September 22, 1929, with the Custom House Tower and the cupola of Faneuil Hall (center) visible down the intersecting streets. This photograph was taken from the vantage point of the Haymarket Square Relief Hospital (1900), an emergency center designed to quickly treat those injured in industrial accidents: Boston's first ambulance station.

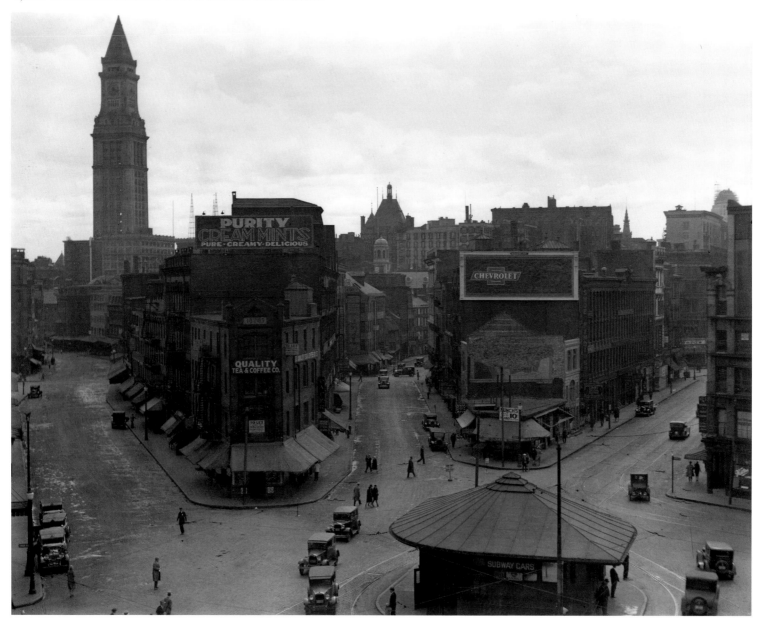

Christmas shoppers mill on Washington Street in 1929. With the
U.S. Stock Exchange collapse on October 28, 1929, and the overall
international economic crisis, which became known as the Great
Depression, the holiday might have been bittersweet for some.

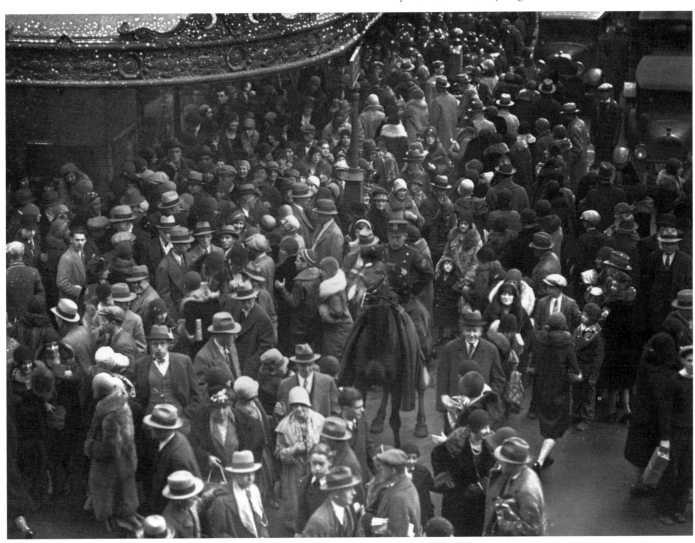

The *Spirit of St. Louis* in Boston, in 1927, probably July 22 or 23. On May 20, 1927, Charles Lindbergh became the first man to fly non-stop across the Atlantic, flying from New York to Paris, collecting a $25,000 prize. Lindbergh called his plane *Spirit of St. Louis* after city leaders there financed its purchase. Today the plane is in the Smithsonian Museum in Washington, D.C.

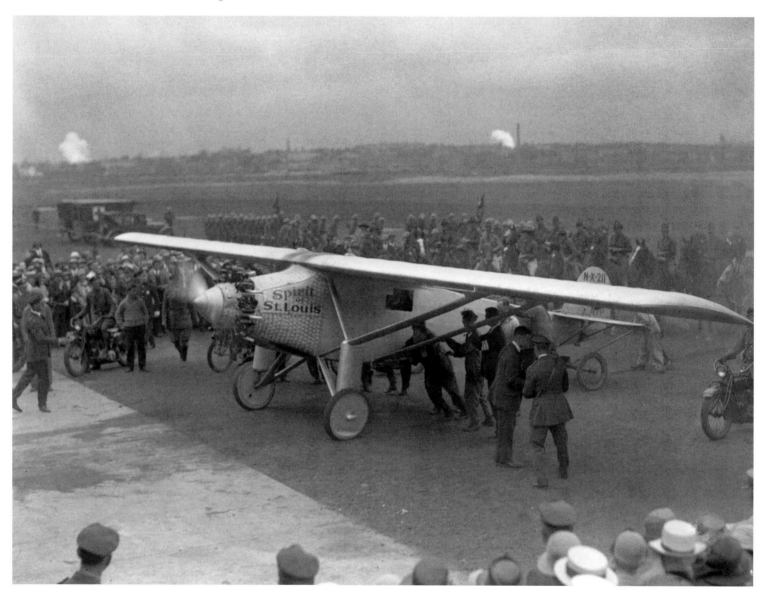

This view in May 1929 shows the Custom House Tower from the Boston waterfront, with the Eastern Packet Pier in the foreground.

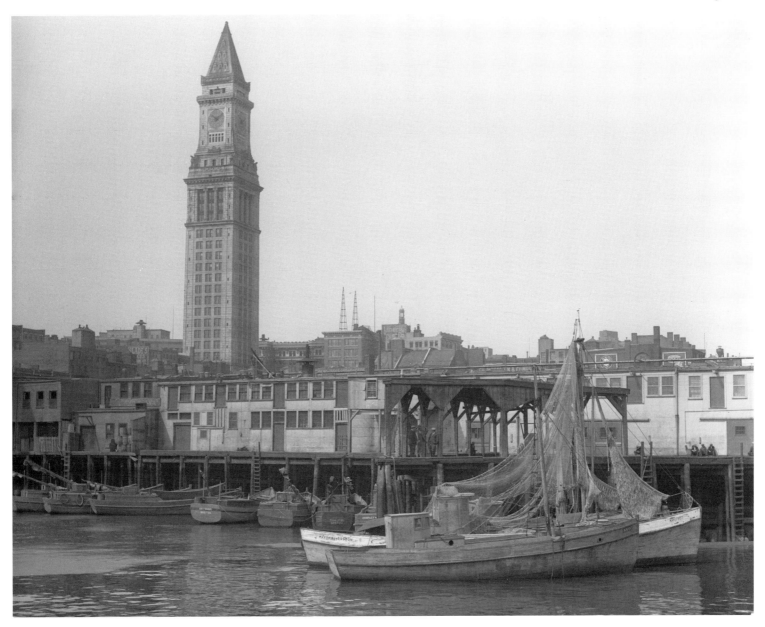

The first regularly scheduled passenger plane to run between Boston and New York left Boston (later Logan) Airport on April 14, 1927. The U.S. Army completed the airfield (for military flights) in 1923 on tidal flats on the south edge of East Boston. In 1925 the Boston Aircraft Corporation completed the first commercial hangar, and in 1927 Colonial Air Transport (later American Airlines) began passenger service.

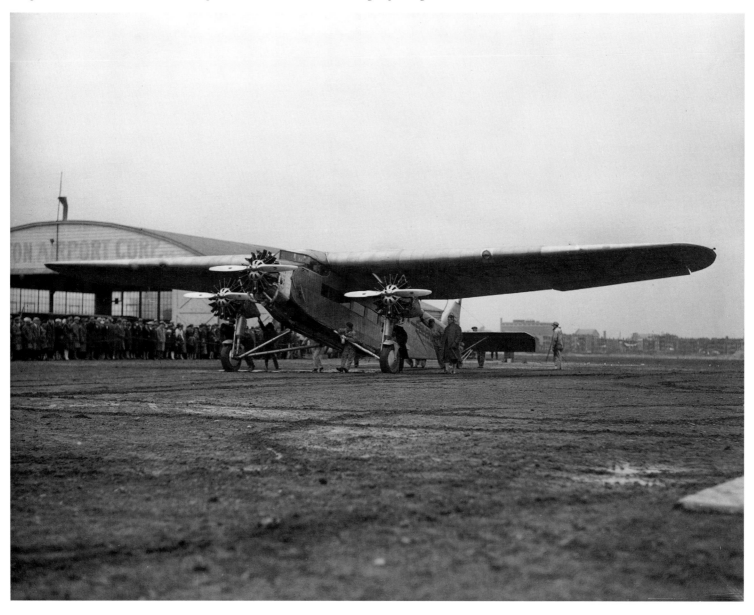

North Street in the North End (viewed from Fleet Street) is decorated for a feast day celebration on June 23, 1929. First organized by local Italian social clubs in the 1890s, feast day celebrations include public processions. Club members carry shrines with statues of their patron saints, and celebrants pin cash donations to ribbons hanging from the shrines.

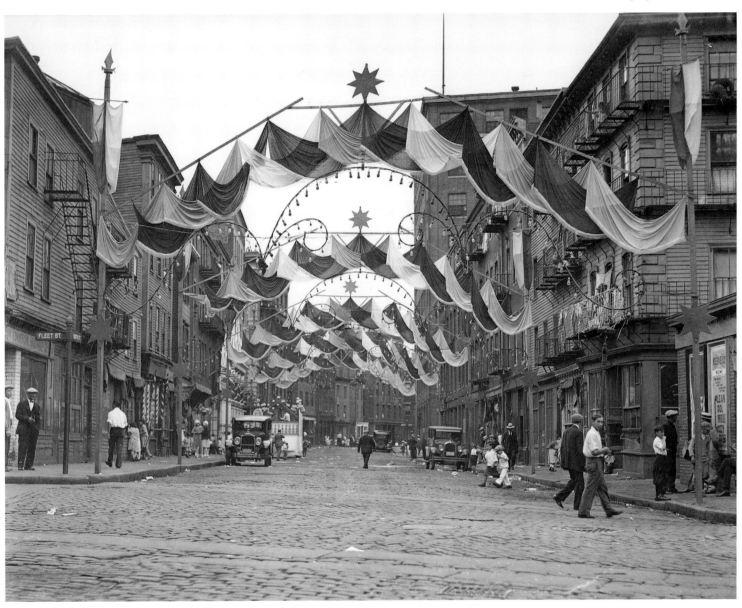

The Gillette factory in South Boston at night, ca. 1930. In 1901 King Camp Gillette, a traveling salesman and inventor, devised a disposable-blade safety razor in Boston. The South Boston factory opened in 1904, and by 1930 the complex of buildings along the Fort Point Channel covered 13 acres. A later sign christened the Gillette plant "World Shaving Headquarters."

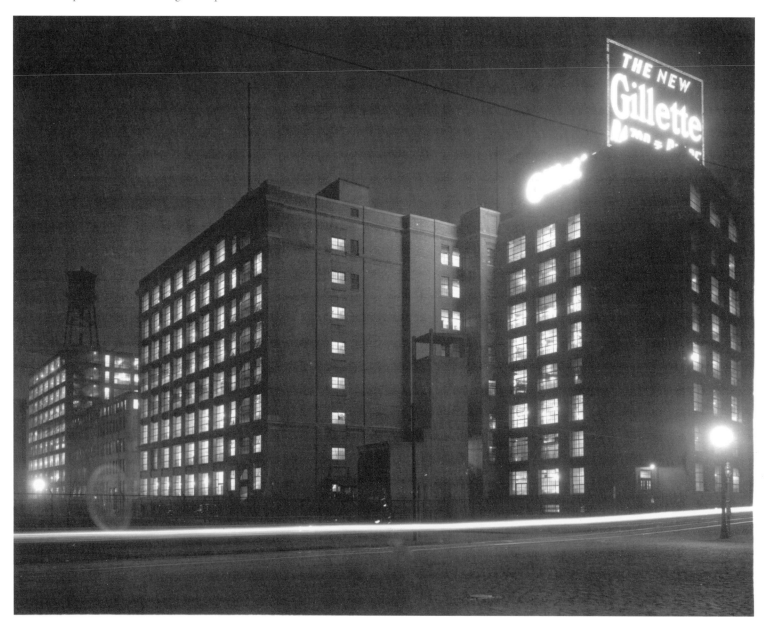

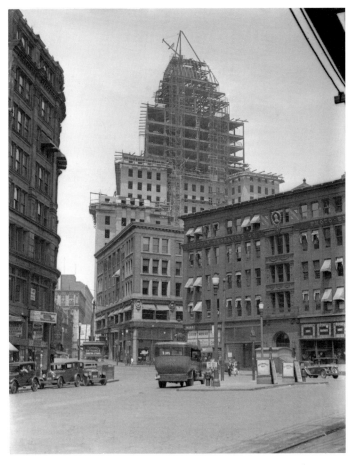

The United Shoe Machinery building, designed by Parker, Thomas, and Rice, shown during construction (ca. 1929). With its 34-story tower, elegant setbacks, tiled cap, and art deco styling, the building helped introduce the modern skyscraper to a hesitant, tradition-bound Boston.

The Public Garden (foreground), Boston Common, and Boston skyline from
the Ritz Carlton Hotel, 1930. The art deco–style Ritz Carlton (1927; designed
by Strickland, Blodget, and Law) broke the height limits of its Back Bay
neighborhood, but in return has provided spectacular views and service.

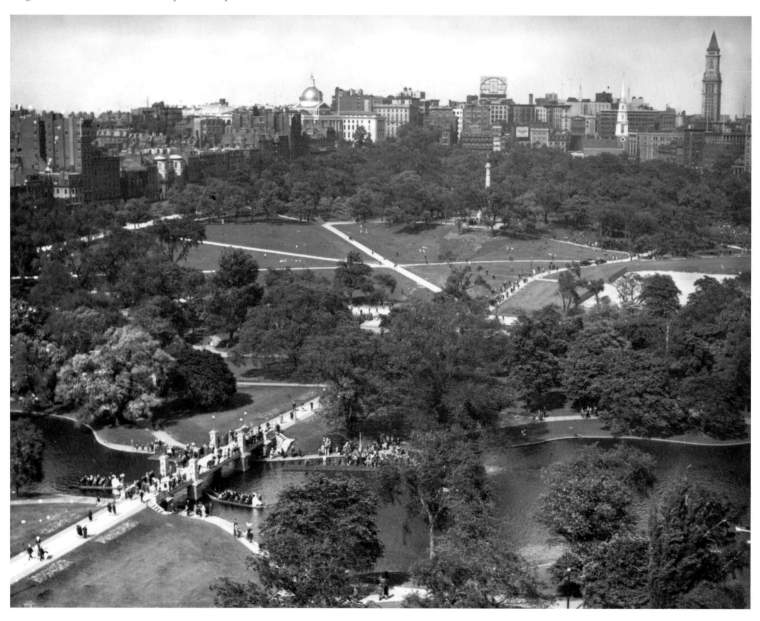

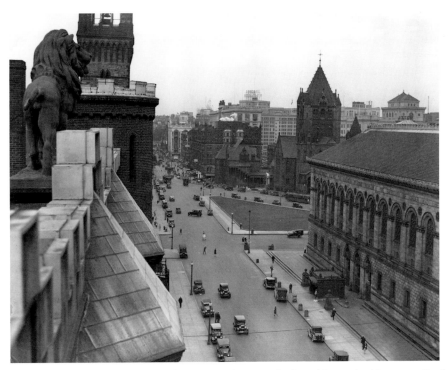

The Hotel Kensington was known for its stone lions, including this one looking over Copley Square, ca. 1930. Behind the lion, at left, is the tower of the New Old South Church. To the right is the beaux-arts-style Boston Public Library, with Trinity Church (Episcopal) and its parish house across Copley Square.

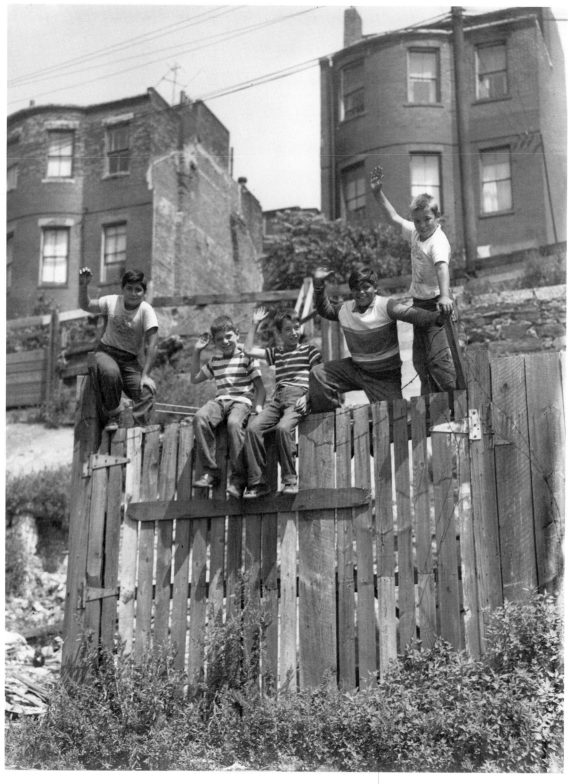

Five friends wave from atop a fence in one of Boston's residential neighborhoods.

Naval Commander Richard E. Byrd visits Boston, ca. 1930. Byrd was awarded the Congressional Medal of Honor by President Herbert Hoover for making the first flight over the North Pole in 1926. He received even greater acclaim (and his second ticker tape parade in New York City) in 1930 for the first of his five expeditions to the South Pole. Rear Admiral Byrd died at his home in Boston in 1957, and was buried in Arlington National Cemetery.

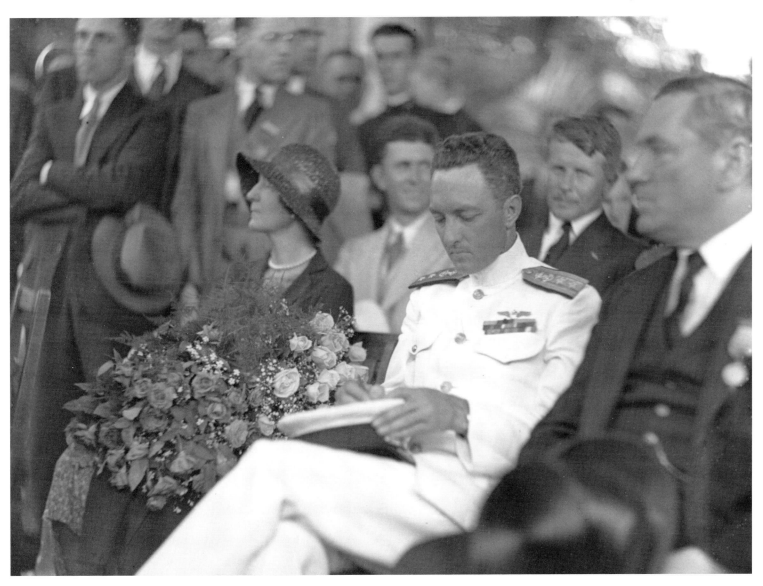

The view from atop a stable, corner of Canal and Traverse streets, ca. 1930. This neighborhood is known as the Bulfinch Triangle, for a delta of streets laid out by Charles Bulfinch in 1808, when filling began of the Mill Pond between the North End and the West End. Canal Street was named for a canal down the center of the triangle, replaced by railroads in 1845 (and later by North Station).

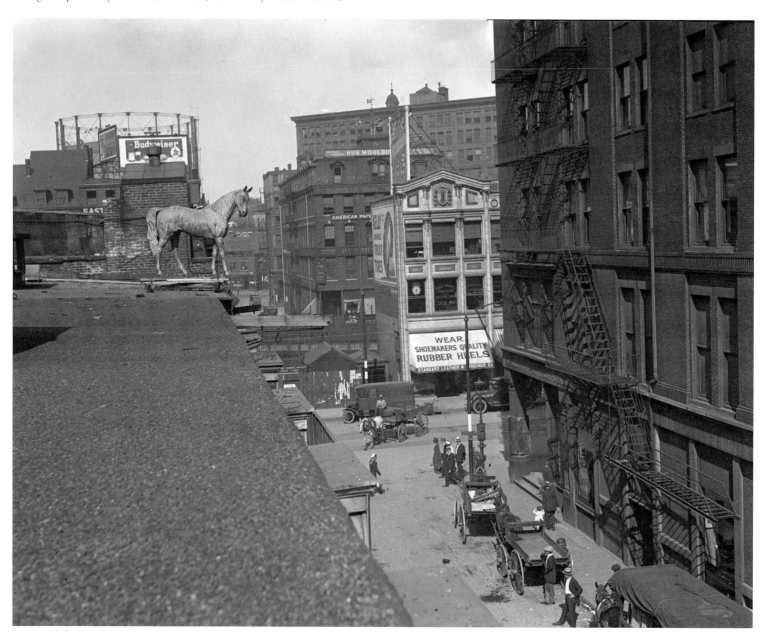

"Pushcart rush at Clinton Street in the Market District, 3 p.m." Pushcarts, shown here ca. 1930, were a way for poor immigrants to start careers in Boston. Several wealthy Boston merchants, such as bookseller and publisher Thomas O. H. P. Burnham, began careers with a Quincy Market pushcart.

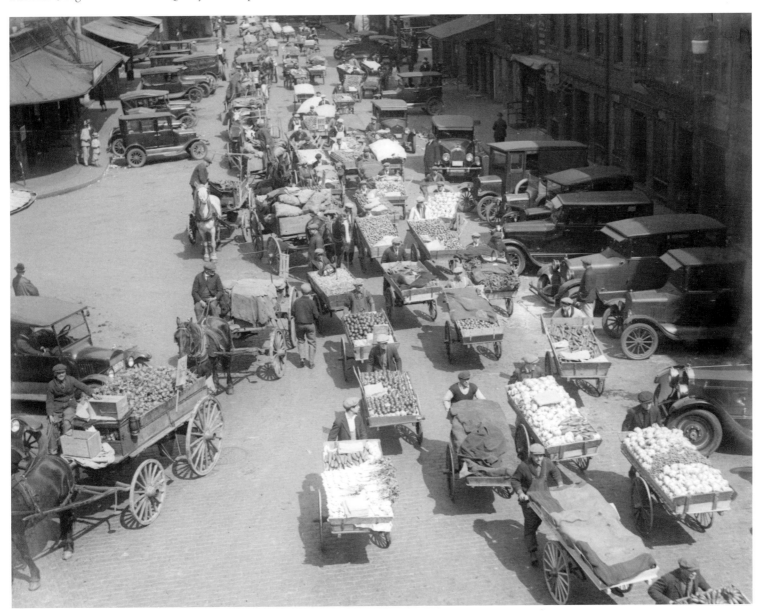

Bathing in the Frog Pond, on the Boston Common, ca. 1930. The last of three original ponds for watering cattle on the Boston Common, the Frog Pond was remade as a public fountain in 1848 to celebrate the opening of the Cochituate reservoir. Today it is popular year-round, for bathing, ice-skating, or as a reflecting pool, depending on the season.

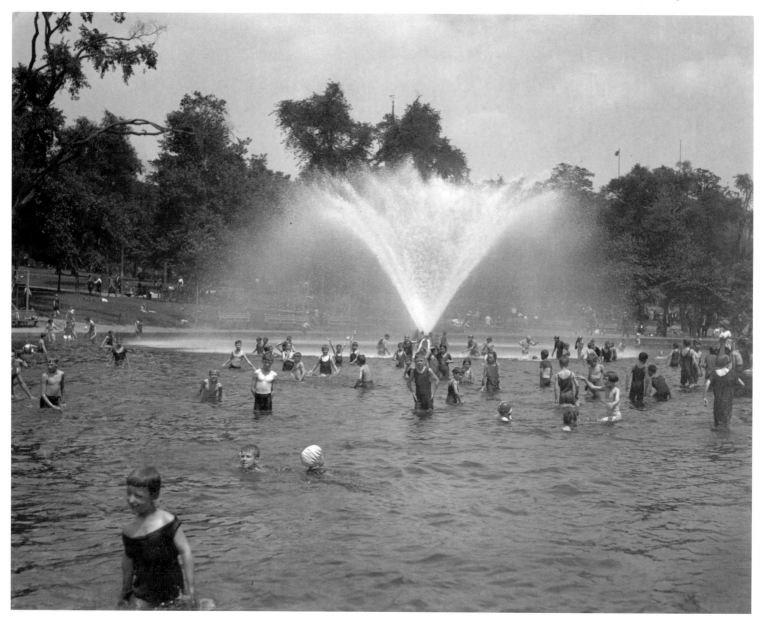

The American House, on
Hanover Street, in 1930.
Founded in 1835, the
American House absorbed
a number of neighboring
hotels. When Hanover Street
was widened in 1870, it
was rebuilt on the same site.
Hanover Street's origin as a
Colonial street is evident in
its royal name; today it is the
main thoroughfare for the
North End.

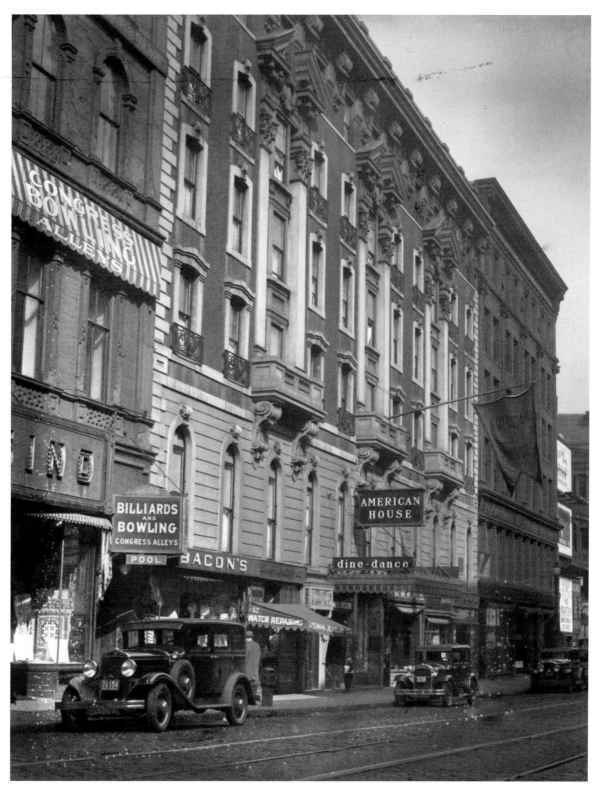

City Hospital in the South End, from Worcester Square, ca. 1930. Gridley J. F. Bryant designed Boston City Hospital (1862-64) so that its main pavilion was framed by Worcester Square, across Harrison Avenue. Laid out by the city in 1851 and developed a decade later, Worcester Square is characterized by its uniform rows of bowfront townhouses surrounding a long, narrow square.

A Roxbury theater used its sound truck to try to slow a run on neighborhood banks in December of 1931. The Federal National Bank and the Boston Continental Bank, like hundreds of others around the nation, were threatened with insolvency when a number of patrons withdrew their money at the same time.

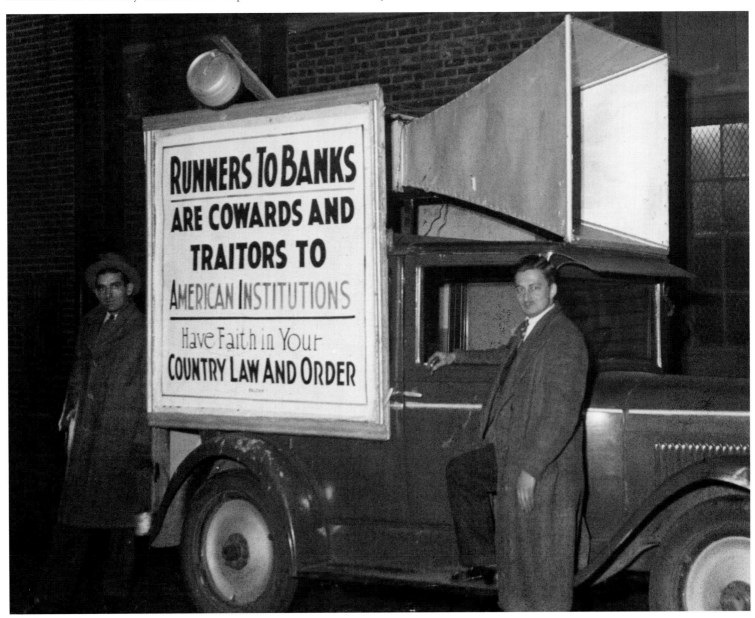

Boston Common in the winter, with the State House above, ca. 1930. Dating to 1634, Boston Common is sometimes called the nation's "oldest public park." Although used for grazing, military drills, whippings, public hangings, festivals, the "first" football game, concerts, papal visits, and protests, the Boston Common is mostly for relaxation. The cast-iron fence was removed during a World War II scrap metal drive.

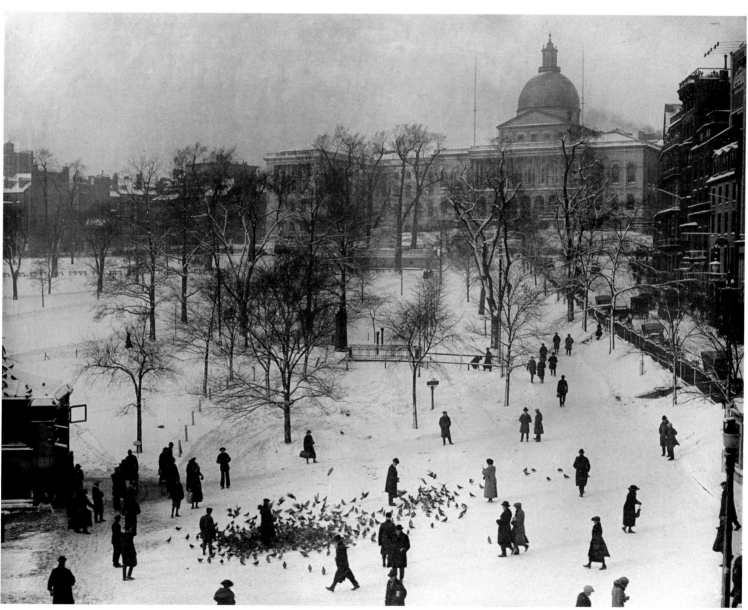

Guay's Bakery was at 786 Adams Street in Dorchester, ca. 1930, with Jos. Grevis Hardware to the right. Dorchester, founded a month before Boston in 1630, remained a country town almost until annexed by Boston in 1870. Adams Street was one of its earliest roads, and business centers formed around intersections like this one.

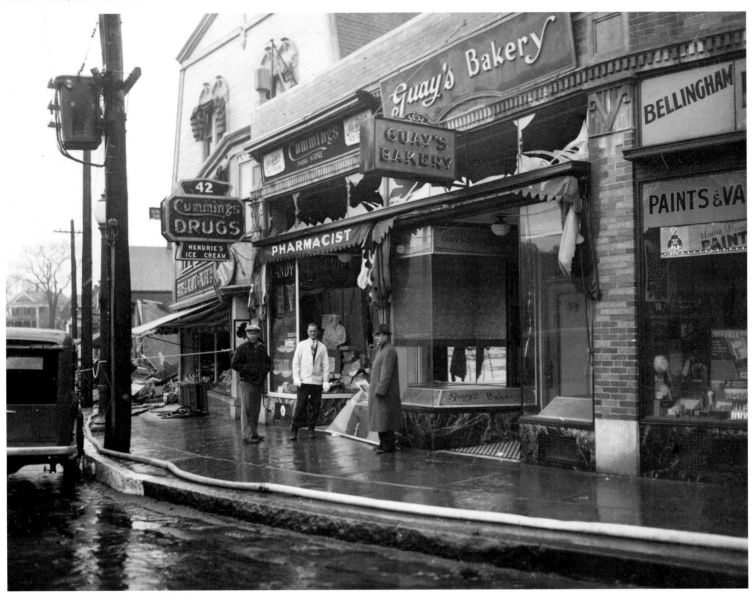

A jumble of automobiles, horse carts, and pushcarts crowds the portico of Quincy Market, ca. 1930. This block has been Boston's market district for nearly four centuries, beginning as the Town Dock in 1633. In 1740 the dock was replaced by Faneuil Hall, with Quincy Market added in 1826.

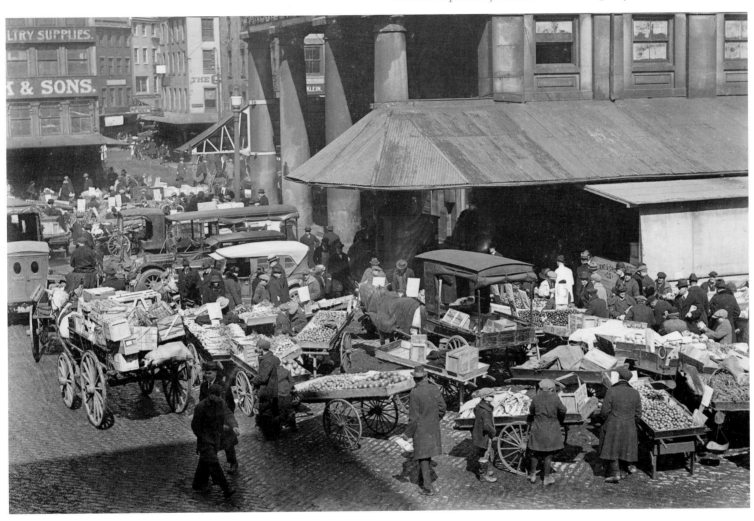

A policeman directs autos from a traffic box on Tremont Street, near Park Street. Park Street Church (1809), at Tremont and Park, was long known as "Brimstone Corner," reportedly both for the fiery rhetoric of its Congregational ministers and the gunpowder stored in its crypt during the War of 1812. It hosted the first antislavery speech in Boston by William Lloyd Garrison, Frederick Douglass, and the first public singing of "America."

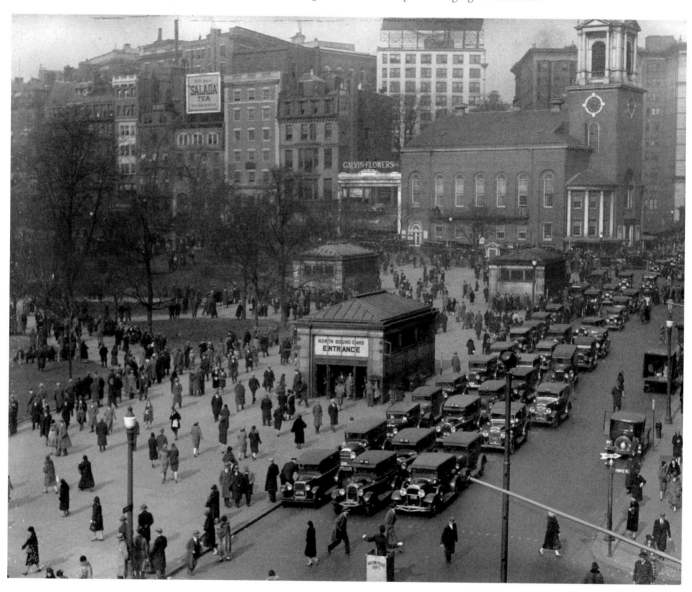

A blizzard lends an air of romance to Scollay Square, ca. 1930. Visible between the buildings at right is the famous steaming teakettle sign. Erected in 1873 by the Oriental Tea Co., the sign was a fixture of Scollay Square, moving several times before coming to rest (around 1960) on the Sears Block. Historic preservationists helped save the Sears Block and its sign during the Government Center redevelopment of the 1960s.

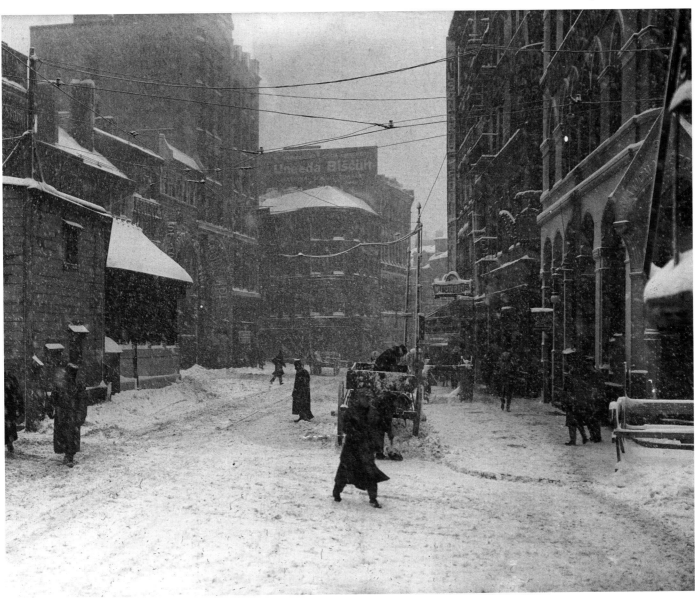

On June 3, 1931, the U.S.S. *Constitution* unfurls its sails at the Charlestown Navy Yard. The oldest commissioned vessel in the U.S. Navy, the frigate was designed by Joshua Humphrey and built in 1794-97 at Hartt's Shipyard in Boston. "Old Ironsides" fought pirates on the Barbary Coast and the British during the War of 1812. Restored in 1925, she began a tour of ninety port cities in 1931.

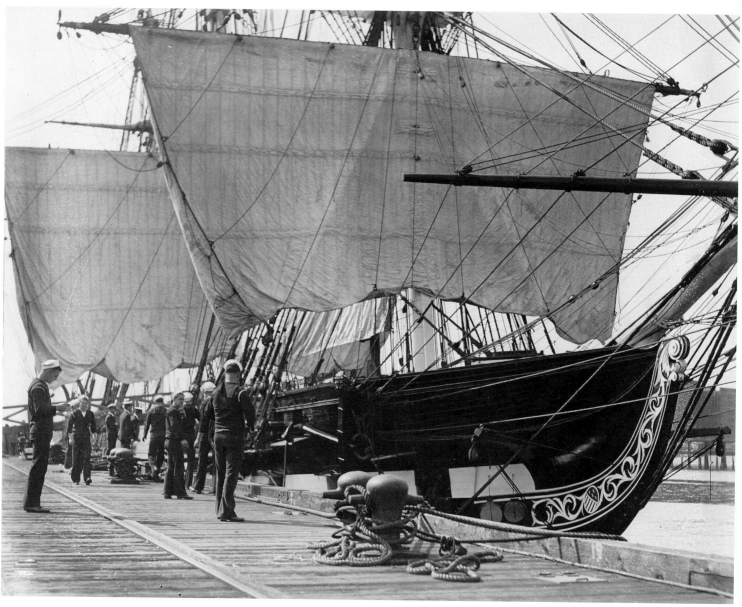

On a cold New Year's Day, 1931, men huddle in a bread line at 42 Hanover Street in the North End. Squabbling with the legislature over funding, Boston mayor James Michael Curley contended that bread lines did not exist in Boston.

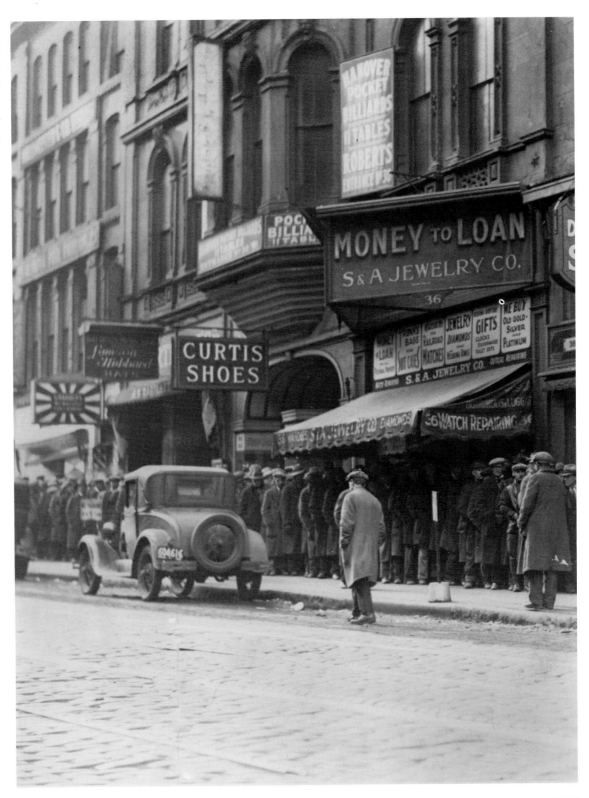

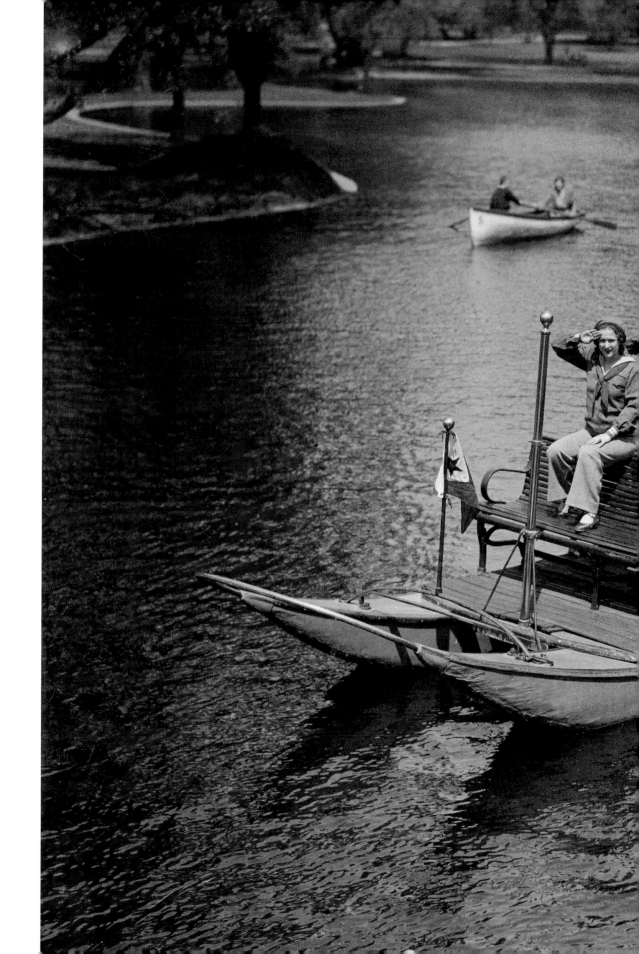

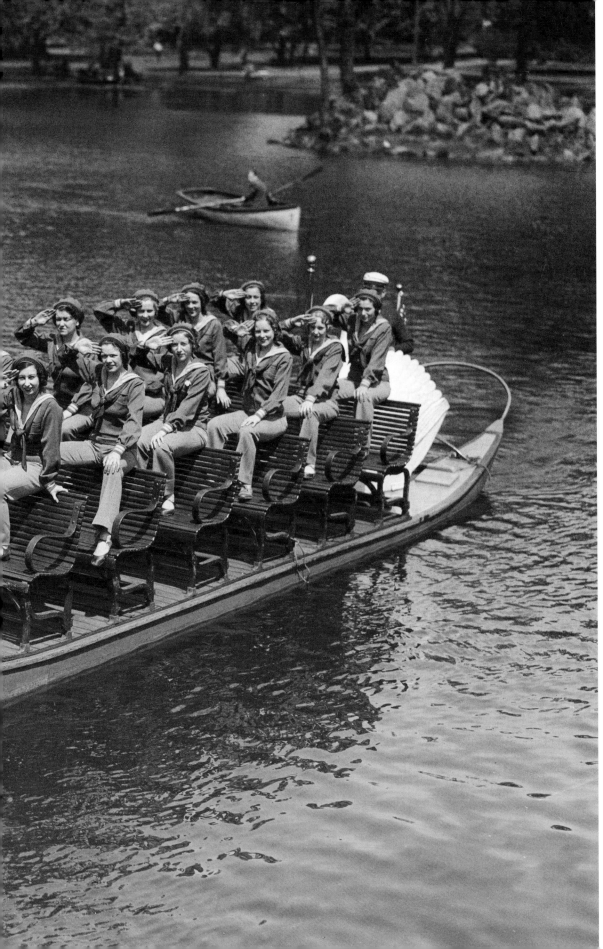

In May of 1932, members of the Women's Naval Reserve ride a Swan Boat at the Public Garden. Devised in 1877 by Robert Paget, the Swan Boat is a catamaran fitted with a paddlewheel. It is powered by a bicycle mechanism operated by its captain, who sits in the swan. The pond at the center of the Public Garden was modeled after the Serpentine in London's Hyde Park.

Arthur Stanek of Boston's West Roxbury neighborhood campaigned against Prohibition in 1932 at the Massachusetts State House. The 18th Amendment to the Constitution began Prohibition in 1920 by outlawing the manufacture, transport, and sale of alcoholic beverages in the United States. Late in 1933, the 21st Amendment repealed Prohibition.

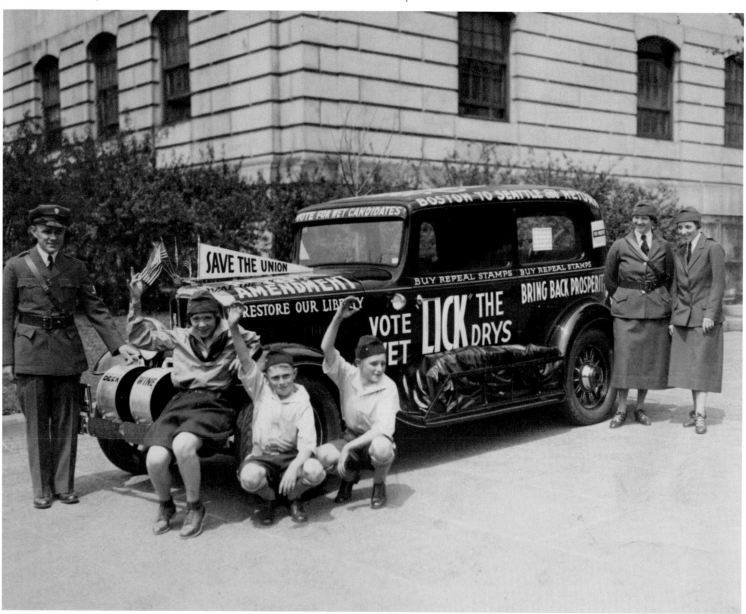

Auto racing began at Readville Race Track in 1903 and had displaced horse racing by the late 1920s. This view, from July 1932, shows pit crews working on their vehicles before the race. In the early 1930s, the track's owners used fill from the excavation of the Sumner Tunnel to build and bank the track for automobiles. Races continued through 1937.

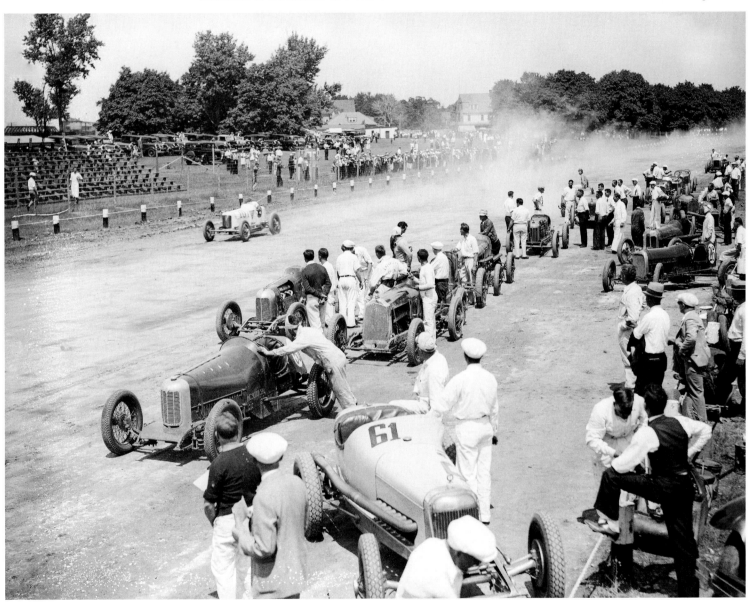

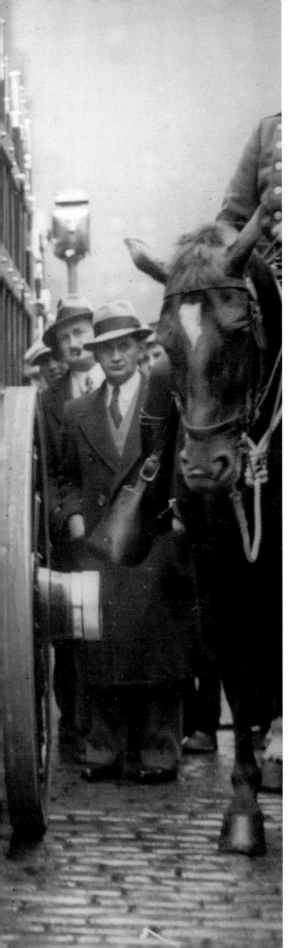

Mayor James Michael Curley welcomed Budweiser back to Boston in 1933. The Blaine Act allowed the sale of 3.2 percent beer on April 7. Bostonians celebrated across the city. Downtown cafes filled with patrons, while society matrons, gentlemen in derby hats, and Harvard students lined up at the S. S. Pierce and Co. warehouse in Brookline to buy crates of beer.

Franklin Delano Roosevelt speaks in Boston from his automobile, likely in late October 1932, during his campaign for the presidency. "FDR" had many Boston connections, having graduated from Groton School (in Groton, Massachusetts) and Harvard. Despite being partly paralyzed in 1921, Roosevelt campaigned successfully for Governor of New York (1928-32) and President (1933-45).

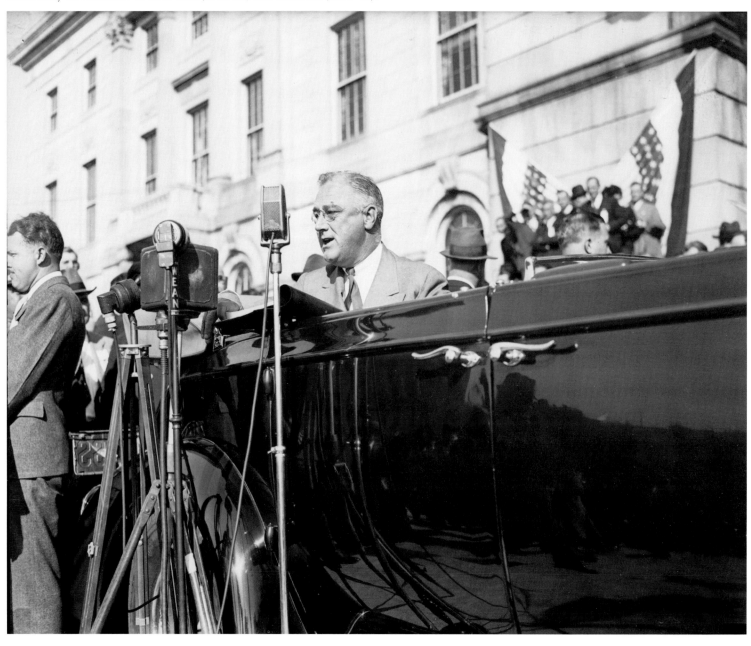

On January 5, 1934, a 5-hour fire severely damaged Fenway Park. New owner Tom Yawkey fireproofed parts of Fenway, including replacing the wooden center-field bleachers with concrete ones. When Fenway reopened for the season on April 17, 1934, it was substantially the stadium we know today.

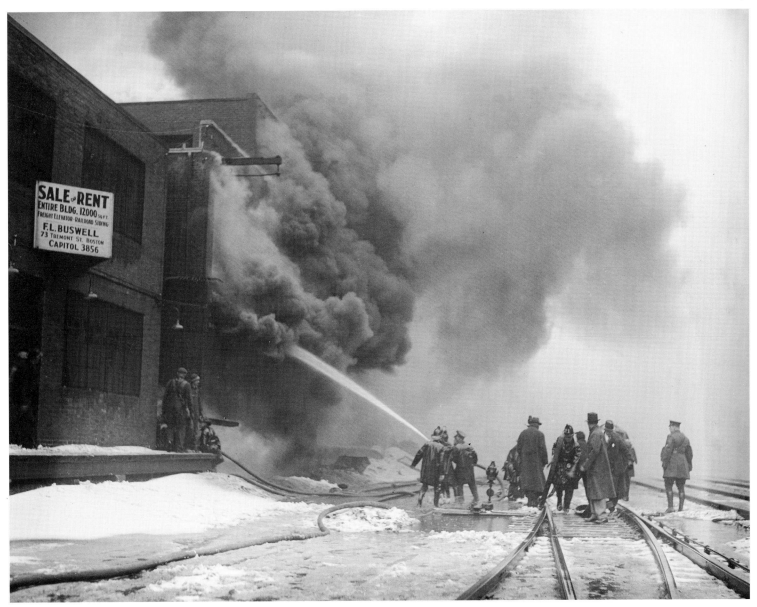

Horse racing at Suffolk Downs in 1935, the year it opened. Massachusetts legalized pari-mutuel betting in 1935, and Suffolk Downs was built in 62 days upon former mudflats in East Boston. On July 10, 1935, 35,000 spectators turned out for the first race. Seabiscuit raced here in 1937 and the Beatles played their last Boston concert here in 1966.

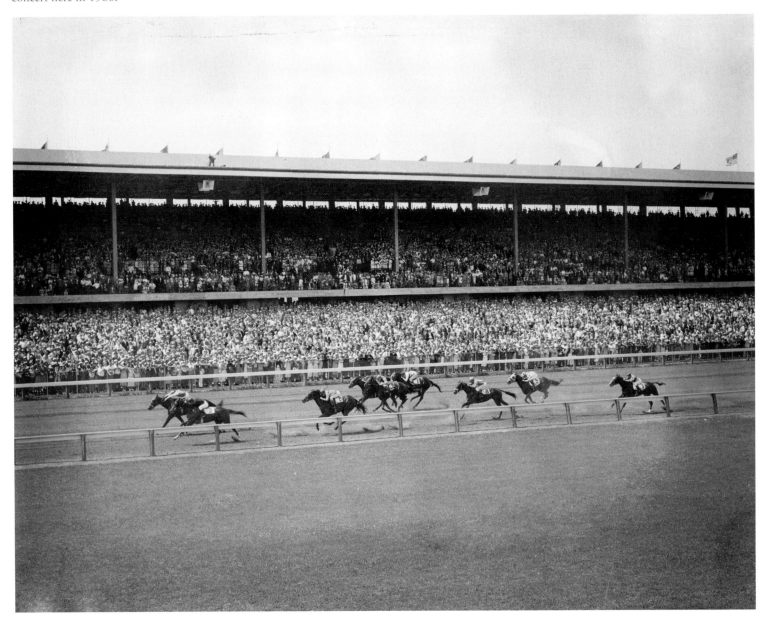

Shown about 1935, the *Nantasket* (built ca. 1902) sailed regularly from the Atlantic Avenue piers south to Connecticut. Behind it is the Eastern Steamship Line's *Belfast* (built in 1909 at the Bath Iron Works in Maine), which sailed regularly between Boston and Bangor, Maine. The Eastern Steamship Line, formed in 1901 from the merger of several New England lines, offered regular service along the coast until 1941.

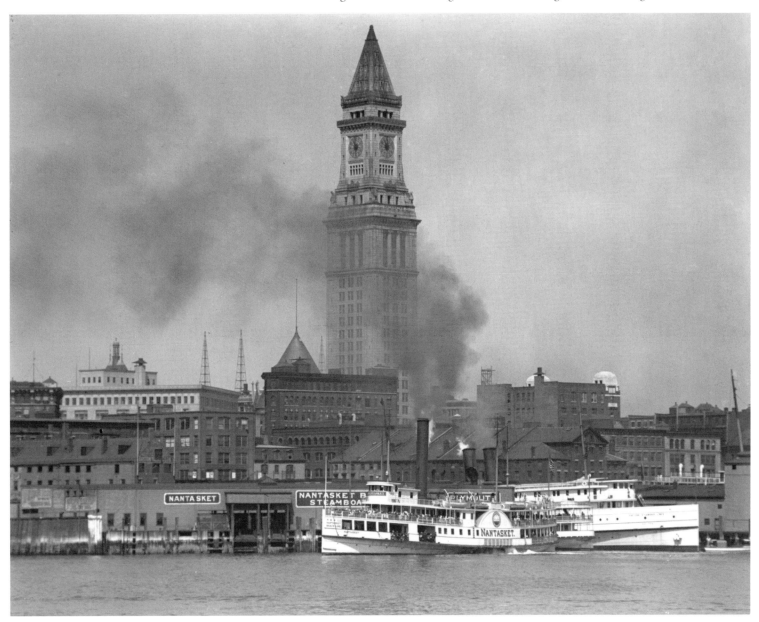

A native of West Medford, Massachusetts, Johnny Kelley won the Boston Athletic Association Marathon on April 19, 1935. Kelley also won the Boston Marathon in 1945 and placed second 7 times, competing a record 61 times before his death in 2004. The oldest (1897) and most revered marathon in the U.S., the Boston Marathon was inspired by the Athens Olympics of 1896.

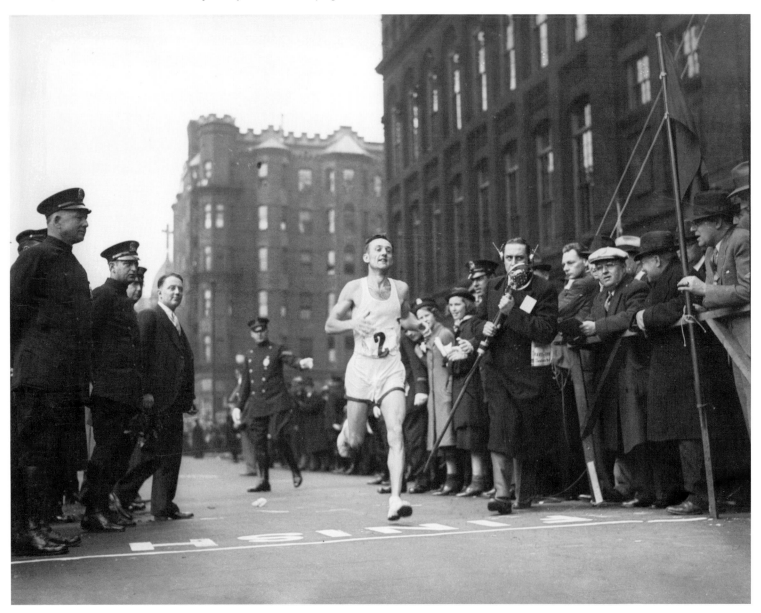

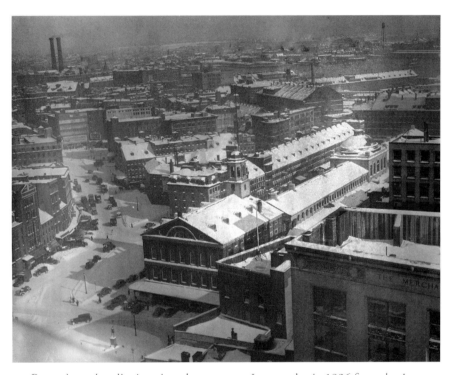

Boston's market district, viewed on a snowy January day in 1936 from the Ames Building. Automobiles had already begun to affect Boston: the narrow downtown streets near Faneuil Hall have been straightened or widened, and other buildings have disappeared for parking. The statue in front of Faneuil Hall is of Samuel Adams, by sculptor Anne Whitney.

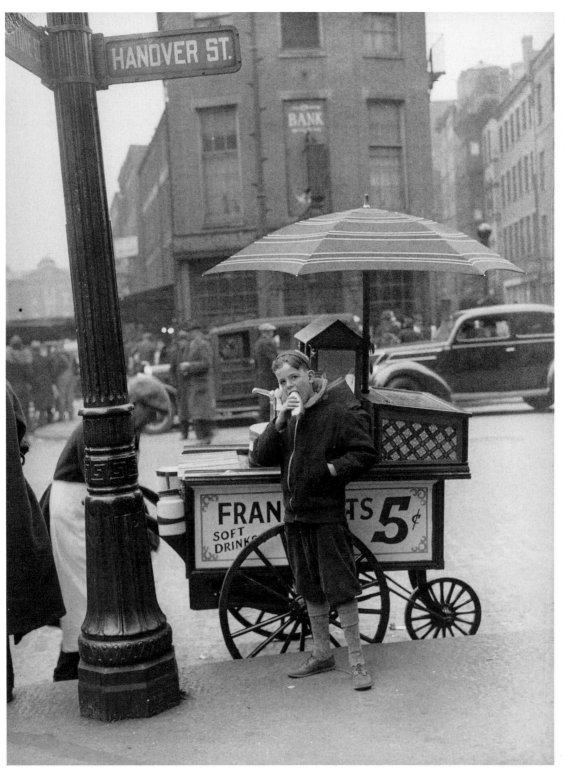

A boy enjoys a nickel frank from a pushcart in 1937. The transaction took place at the corner of Hanover and Blackstone streets between the North End and Scollay Square. The eastern side of Blackstone Street was leveled in the 1950s for the ramps of the elevated Central Artery.

A pushcart vendor pauses at
Quincy Market in 1937.

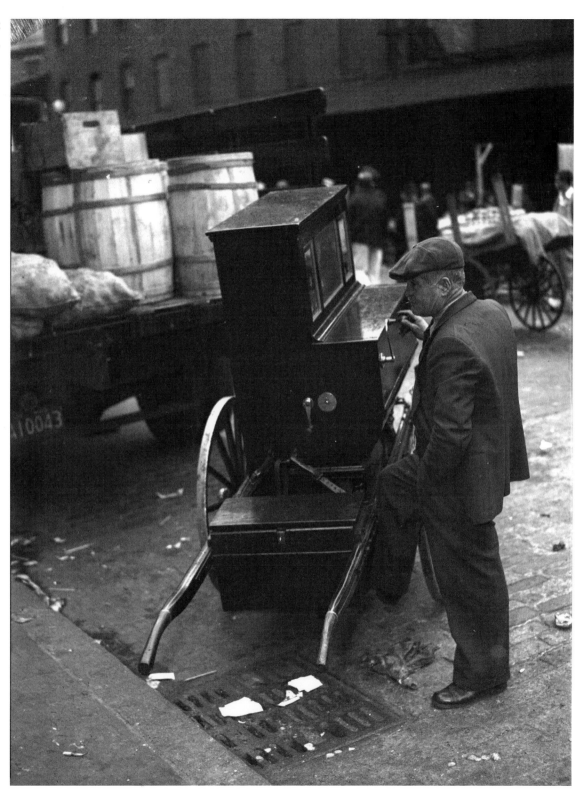

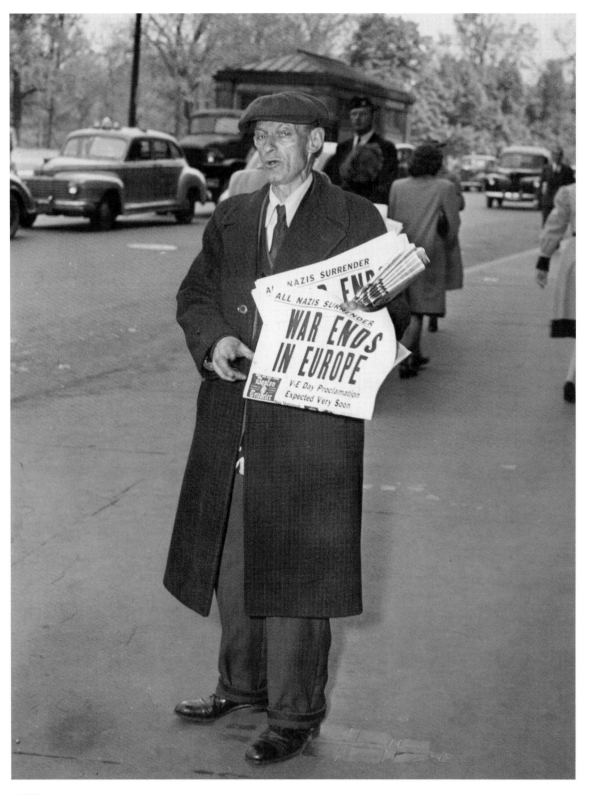

Fred Apt, newspaper vendor for the Boston Traveler, spreads the news of the end of the war in Europe on May 7, 1945, the day Germany surrendered. Americans celebrated V-E (Victory in Europe) Day the following day, on May 8, and then V-J Day on August 15, 1945, after Japan surrendered.

War, Recovery, and Boston at a Crossroads

1940–1960s

The Pearl Harbor attack shocked Bostonians, and many Boston soldiers gave their lives in the Second World War. But the war effort also swept away the lingering effects of the Great Depression. Boston's sleepy port reawakened, its shipyards, factories, and munitions plants expanded, and its military bases were active once again. After the war Boston's economy collapsed again. The city's population peaked at 801,444 in 1950, but then plummeted to 562,944 in 1980, its lowest point. Although many older cities faced a similar hollowing out in the postwar years, Boston's fall was particularly hard.

Boston began a slow, difficult rebuilding under a series of reform-minded mayors. Mayor John Hynes built a new coalition, crossing old boundaries of race, sex, class, and ethnicity, and stressing accommodation over confrontation. Under urban renewal, Boston leveled entire neighborhoods of neglected housing, first in 1954 in the New York Streets neighborhood in the South End, then the West End (1958), then the commercial Scollay Square area, replacing them with industrial, housing, or civic complexes. Giant housing projects arose, much needed but usually isolated and segregated. Large-scale roadways such as the Route 128 and the elevated Central Artery (1951-56) sliced through other neighborhoods.

Boston remains a livable city, in part, because of citizen reactions to the excesses of these large-scale planning projects. Beginning with Beacon Hill in 1955, Boston established historic districts to protect vulnerable neighborhoods, including the Back Bay, Bay Village, St. Botolph, and the South End. Preservationists and developers teamed up on dozens of restoration and rehabilitation projects, most prominently the Faneuil Hall Marketplace (1976-78). Neighborhood associations, formed to resist urban renewal and superhighway intrusion, next turned their efforts to improving their surroundings. Other groups resisted gentrification and forced developers to build housing projects respectful of their residents, such as Villa Victoria (1972-82) and Tent City (1988).

Boston's preeminence in education helped it build new technology-based and innovation-based industries, such as medicine, computers, and biotechnology. Boston's skyline gained height as dozens of skyscrapers arose in the Financial District downtown and the High Spine (between the South End and Back Bay). Launching the complex and controversial Big Dig project in 1991, Boston demolished the elevated Central Artery and replaced it with an underground roadway. With population growth stabilized, a diverse work force, and considerable new development, Boston in the twenty-first century has remade itself as a city.

Salem Street on January 14, 1949, is alive with street vendors, shoppers, and businessmen. Boston's oldest neighborhood, the North End has hosted this mix of business and residential uses since the 1630s. The neighborhood was sustained by waves of immigrants: the Irish in the 1850s and Jews from Poland and Russia in the 1870s. By the 1920s, 90 percent of North End residents were ethnic Italian.

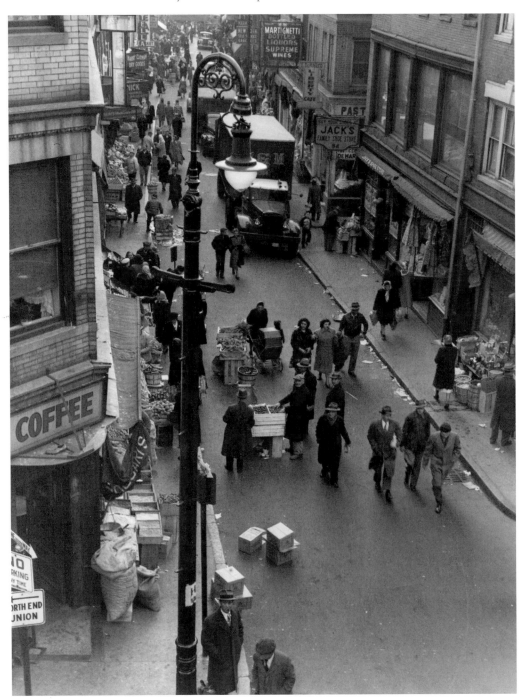

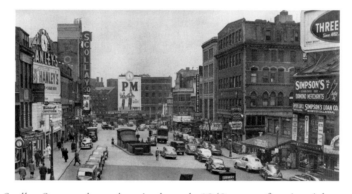

Scollay Square, shown here in the early 1940s, was a favorite nightspot for sailors from the nearby Charlestown Navy Yard. The neighborhood entertained them with its arcades, bars, burlesque clubs, photo studios, restaurants, and tattoo parlors. Scollay Square paid for its sins when urban renewal leveled it in the early 1960s.

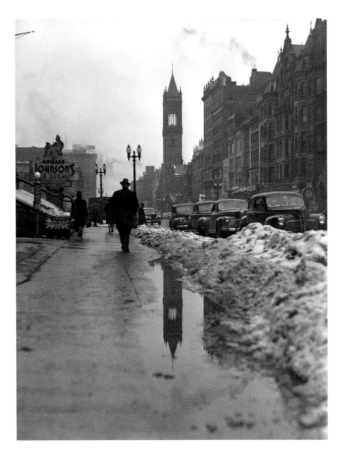

A dreary winter day, ca. 1941, is redeemed by the reflection—in
a puddle on Boylston Street—of the tower of the New Old South
Church. Despite its completion in 1875, the Old South Church
seems forever prefaced by "New." Formed in 1669, the congregation
left its downtown home—the Old South Meeting House—after the
Civil War and built this church on Copley Square.

Leroy "Satchel" Paige, pitcher for the Kansas City Monarchs in the Negro League, warms up before a game at Braves Field in August 1943. Paige toured the country during World War II, raising money for war bonds. In 1948 he became the first African American pitcher in American League baseball. Braves Field (1915) hosted major league baseball until 1952; today it is Nickerson Field at Boston University.

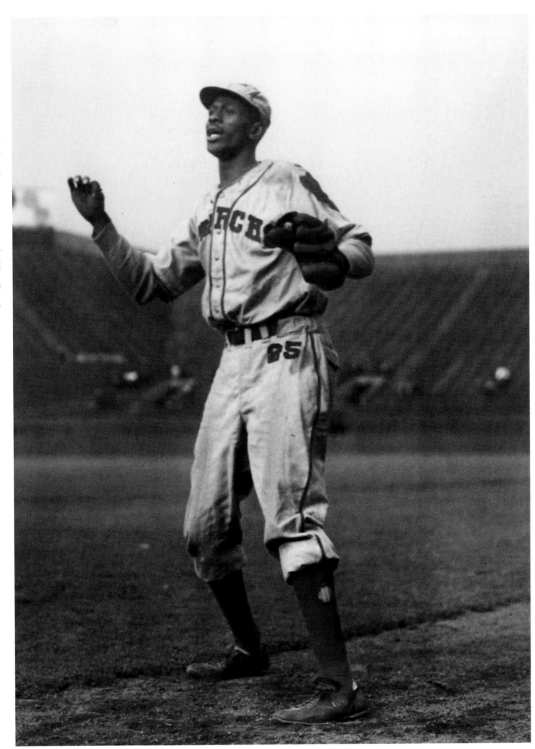

Captain Robert Morgan and the crew of the *Memphis Belle* ride singly in Army jeeps down Tremont Street in June 1943. The *Memphis Belle,* a Boeing B-17 Flying Fortress, became the first plane to complete its 25 bombing missions in World War II, and its crew escaped injury. Important symbols, the plane and crew were dispatched on a nationwide tour to support the war effort.

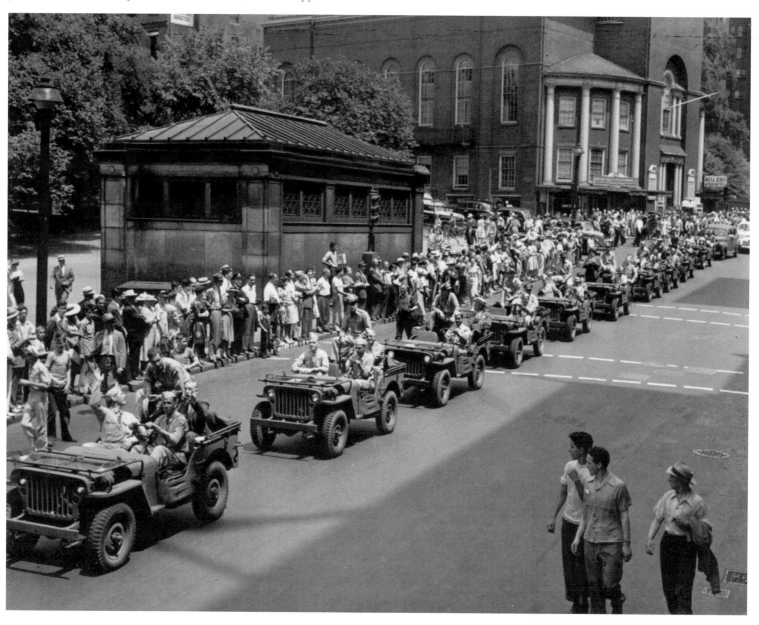

Two Boston heroes throw out the honorary first ball at Fenway Park in April 1946. Army Sgt. Charles McGillivary (right) won the Medal of Honor for knocking out four German machine gun emplacements during the Battle of the Bulge. Navy Lt. John F. Kennedy, honored for rescuing a crewman when his PT-109 was sunk in the South Pacific, was elected President in 1960. Both now rest in Arlington National Cemetery in Virginia.

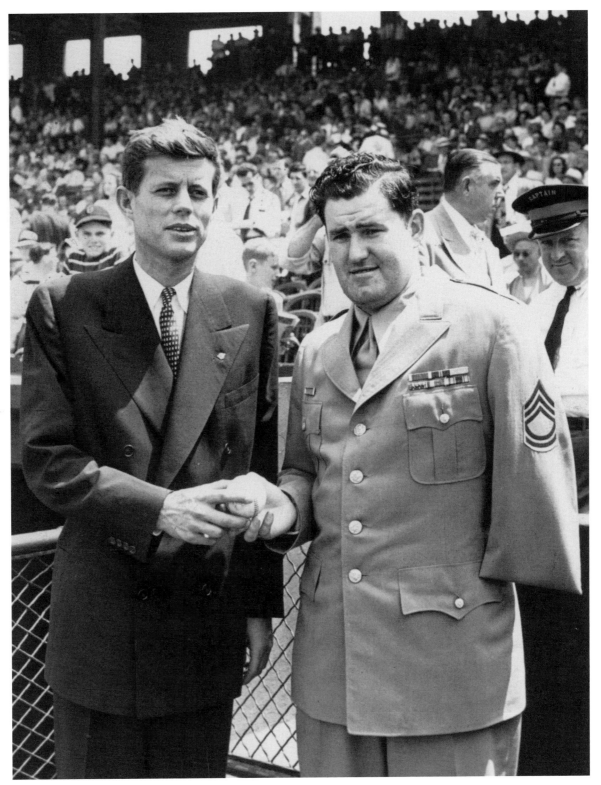

Fields Corner in Dorchester, looking south on Dorchester Avenue, on March 25, 1948. Isaac and Enos Fields ran a grocery store at Dorchester Avenue and Adams Street, giving Fields Corner its name. By the 1920s, the commercial blocks seen here were built and gave the neighborhood its character.

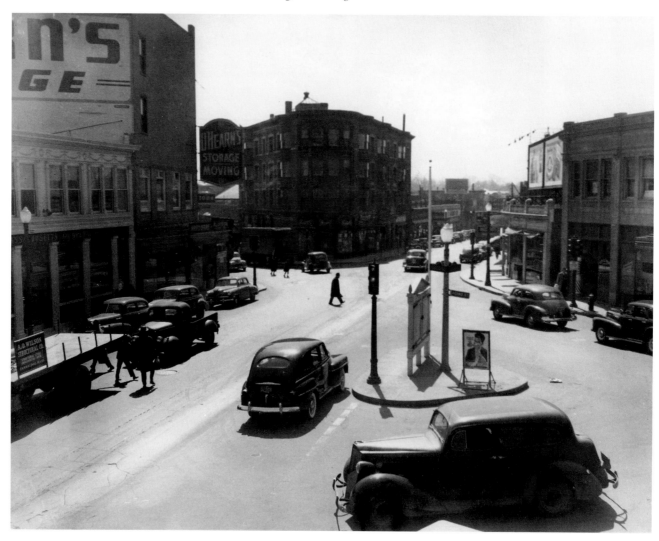

Everyday life in Boston shortly after the Second World War, here at the corner of Thacher and Washington streets in the North End. At 4:45 in the afternoon, on August 8, 1948, a man in a T-shirt pauses mid-step to glance at the photographer.

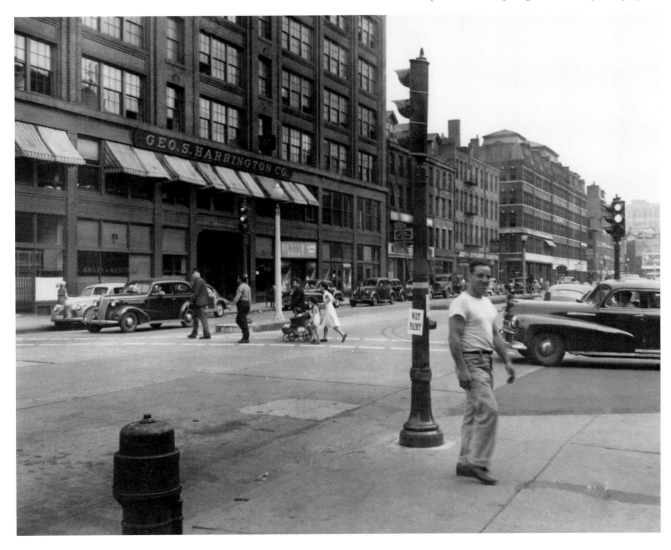

On September 21, 1948, at the corner of Blue Hill Avenue and Quincy Street, residents mingle in front of Katz Drugstore. Known as Cherry Valley, these blocks on the border between Dorchester and Roxbury were home to families from Nova Scotia and Jewish merchants. Neighbors bought day-old Whoopie Pies from Drake's Bakery factory or shopped at the Max Andrews delicatessen.

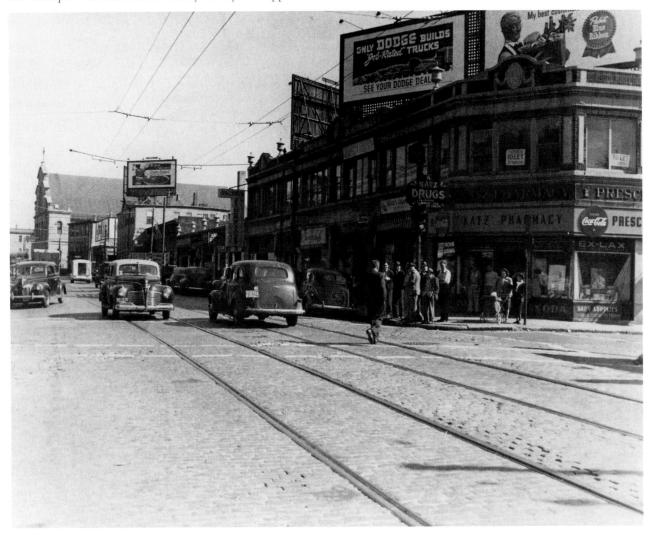

Construction began in 1939 on the main block of classrooms at Boston University; the completed building is shown here in 1948. The tower at the far end would be joined within a year by a twin, which anchors a second block. This gothic-moderne rampart, designed by Cram and Ferguson, and Coolidge, Shepley, Bulfinch, and Abbott, began a new campus for a university that had previously been on Beacon Hill, downtown, and in Copley Square.

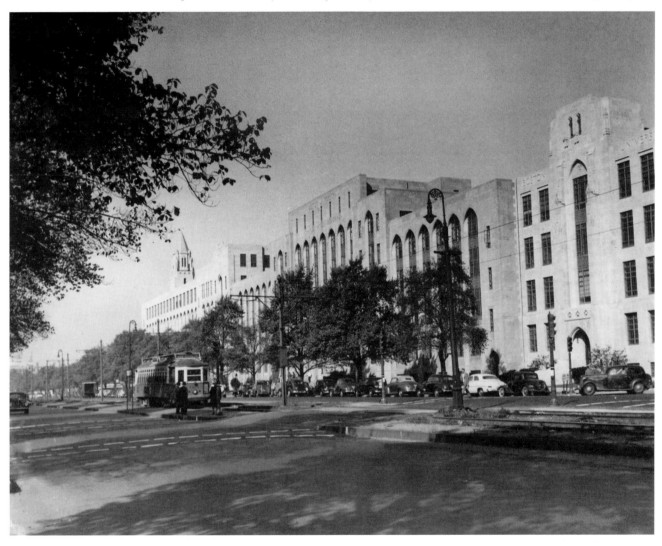

In the 1950s and 1960s, football surpassed baseball nationally as America's most popular sport, especially when professional football teamed up with television. But most football competitions took place on gridirons unnoticed by television. On October 28, 1950, a Dartmouth player tackles a Harvard player during a junior varsity game at Soldiers Field, next to Harvard Stadium.

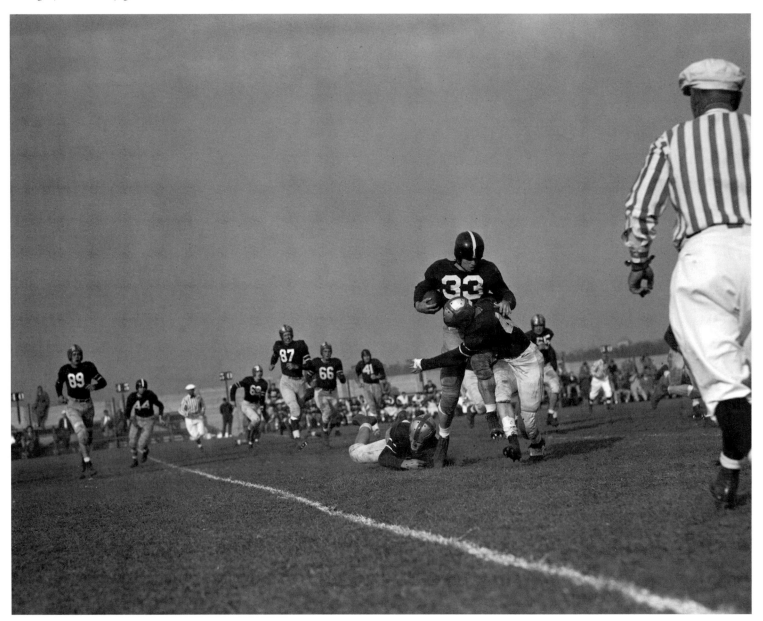

On a February day in 1950, vintage autos had the honor of going first through the southbound tolls at the opening of the Mystic River Bridge. Connecting Charlestown and Chelsea, the bridge is a vital Route 1 link between Boston and the North Shore communities. In 1967, this cantilevered truss bridge was renamed for former Boston mayor and Massachusetts governor Maurice Tobin.

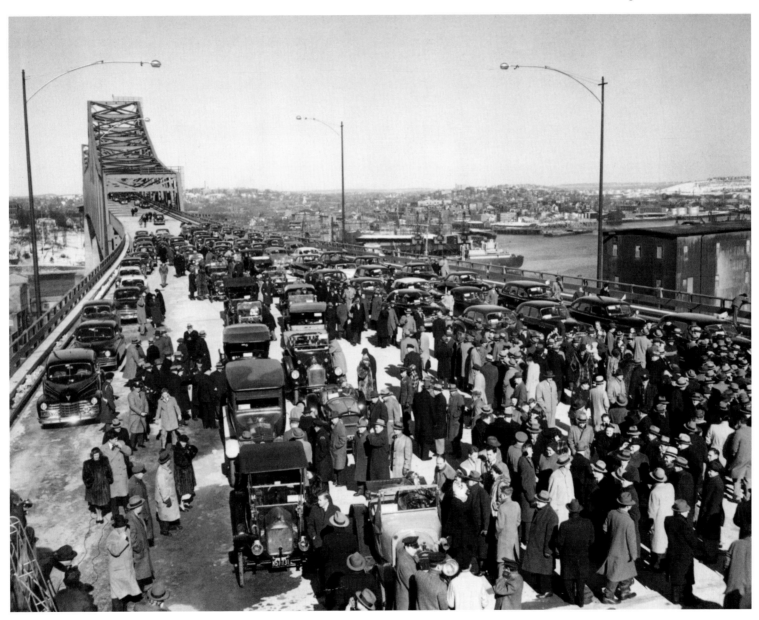

A policeman directs traffic at the corner of Dover and Harrison streets in 1952. Dover Street in the South End had been the heart of a crowded Jewish immigrant community early in the century. First-generation immigrant Mary Antin described Dover Street as simultaneously "a gate of paradise" and "prison" in her 1912 memoir, *The Promised Land*.

A decade before the elevated Central Artery cut Cross Street into pieces, automobiles had already taken over. From the traffic, to the curbsides, to the billboards above, this view from ca. 1948 shows the automobile driving Boston to change.

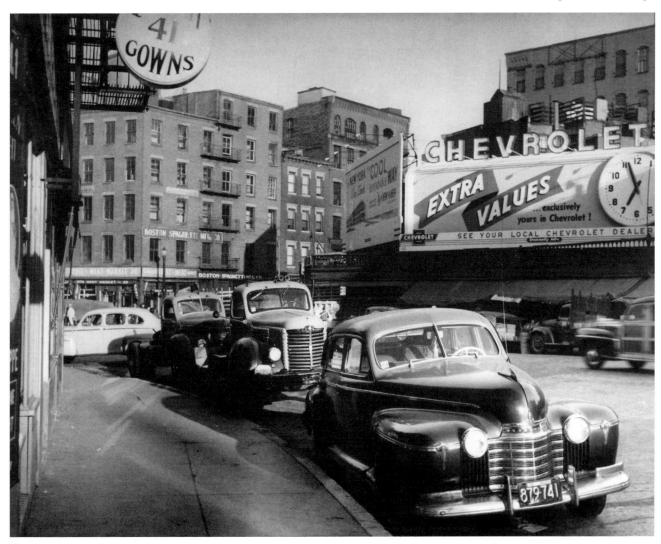

By contrast with streets overrun by automobile
traffic, this unidentified Boston street corner, ca.
1948, teems with women and children.

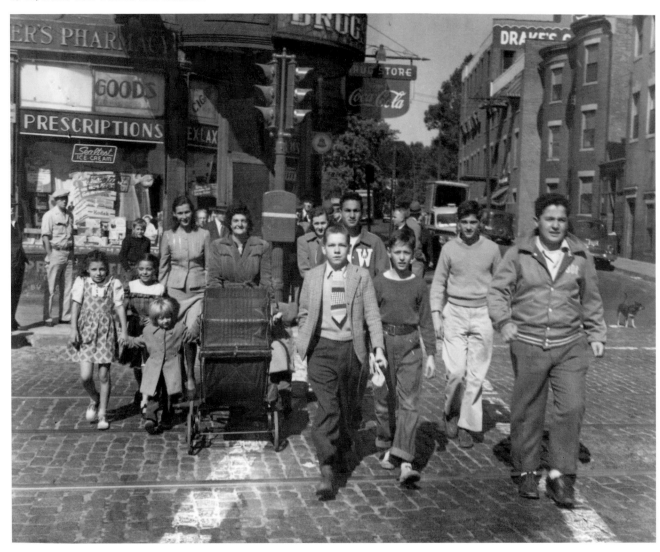

On this quiet Boston street on June 24, 1952, children play, mothers shop, and a few horse-drawn carts remain amid the automobiles.

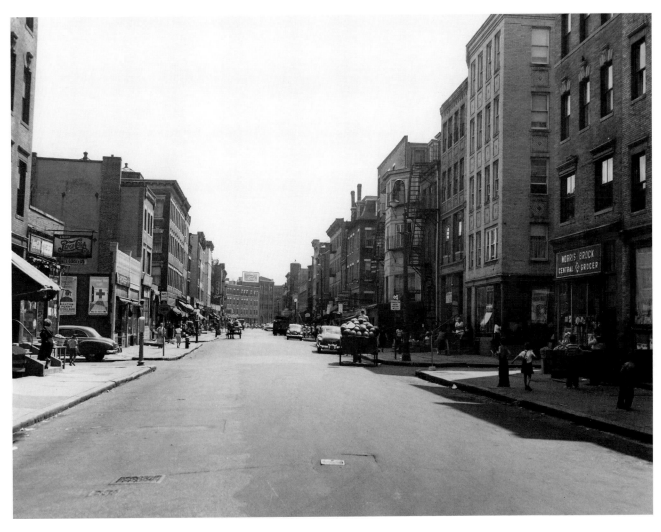

Dwight D. Eisenhower rides in an open car down Blue Hill Avenue on November 3, 1952, the day before he was elected President. Republican candidate Eisenhower carried Massachusetts, over Democrat Adlai Stevenson, by 54 percent in 1952 and 59 percent in 1956.

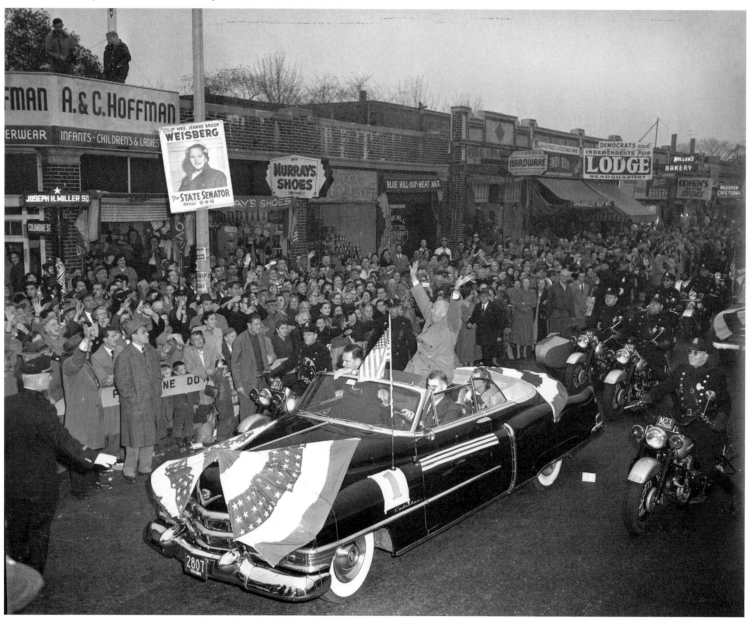

Neighbors and customers mingle outside a liquor store at Dover and Harrison in the South End, in 1953. Within five years of this image, urban renewal had leveled the "New York Streets" tenement district to the north, and Dover Street had disappeared from the maps, renamed East Berkeley Street.

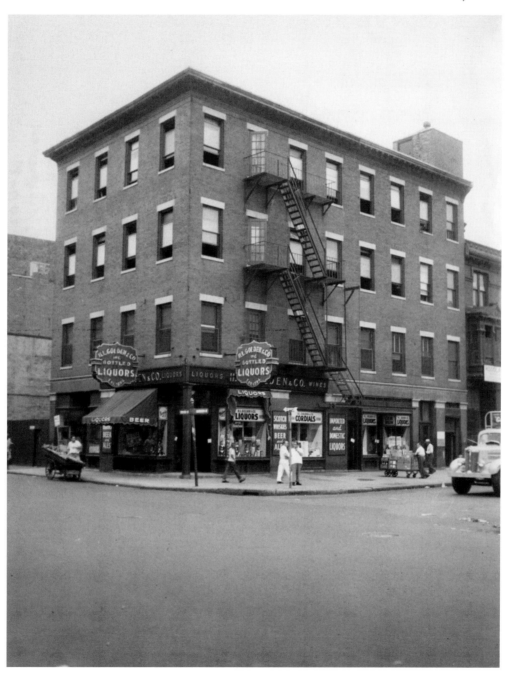

In September 1954, construction of the elevated Central Artery crawls toward the seaward end of Quincy Market. In the background, just to the left of the new highway, is Boston Garden and North Station. The artery cut off the North End and the Boston waterfront—to the right—from the rest of Boston.

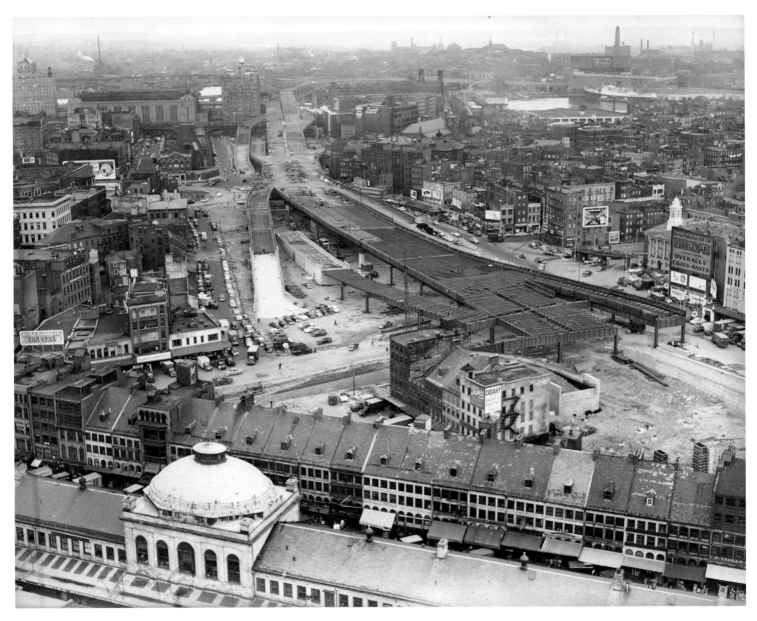

On April 4, 1955, the *Boston Traveler* newspaper published this action shot of Bob Cousy at the Boston Garden. Cousy drives past Dick McGuire of the New York Knickerbockers while Celtics center "Easy" Ed McCauley looks on. Nicknamed "Houdini of the Hardwood," Robert Joseph Cousy played point guard for the Boston Celtics from 1950 to 1963, helping lead the Celtics to six NBA championships.

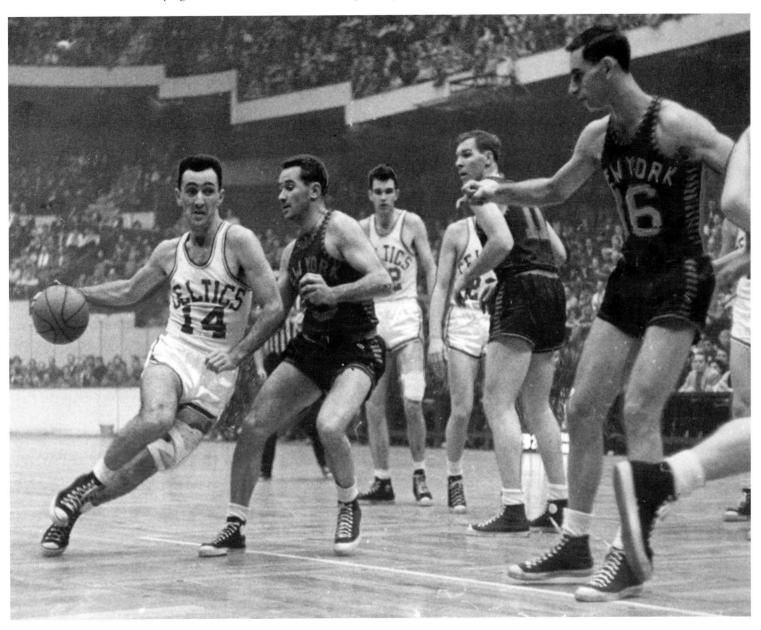

A new ramp of the Central Artery provides a vantage point for this June 29, 1956, view of Blackstone Street. Despite challenges, the Haymarket continues the traditions of four centuries of open-air produce market in downtown Boston. Photographer Leslie Jones may have wanted his photograph to show the Central Artery sweeping past old traditions, but fifty years later, the Central Artery is gone and Haymarket remains.

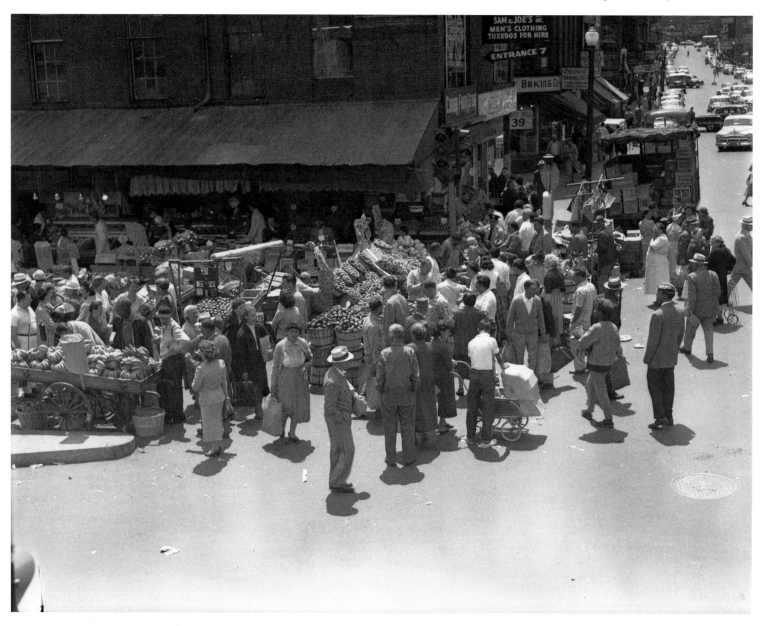

This October 1956 view of Copley Square, from the New Old South Church, shows the second John Hancock building in the Back Bay, rising behind Trinity Church (Episcopal). Designed by Cram and Ferguson and completed in 1947, its pyramidal tower and weather beacon became a Boston landmark. In 1975, the third John Hancock—New England's tallest skyscraper—arose between Trinity Church and the Copley Plaza Hotel.

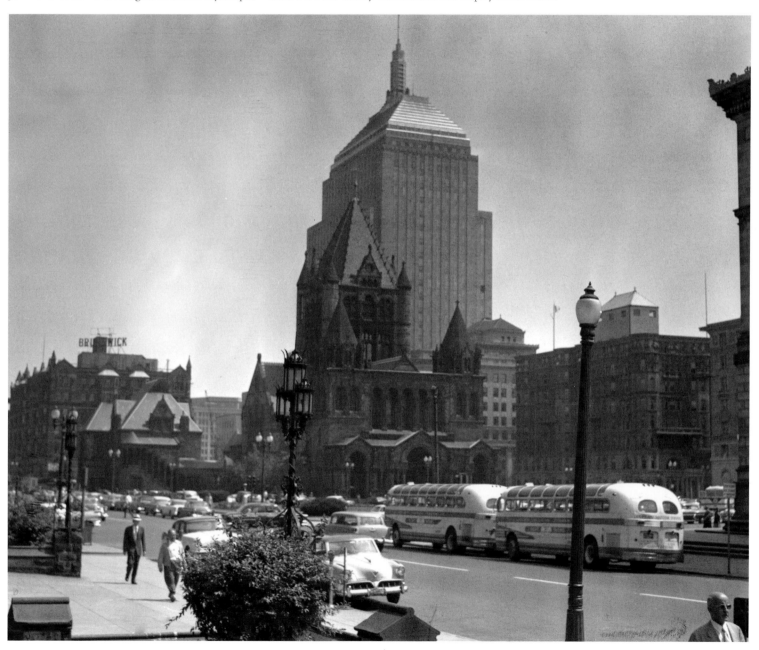

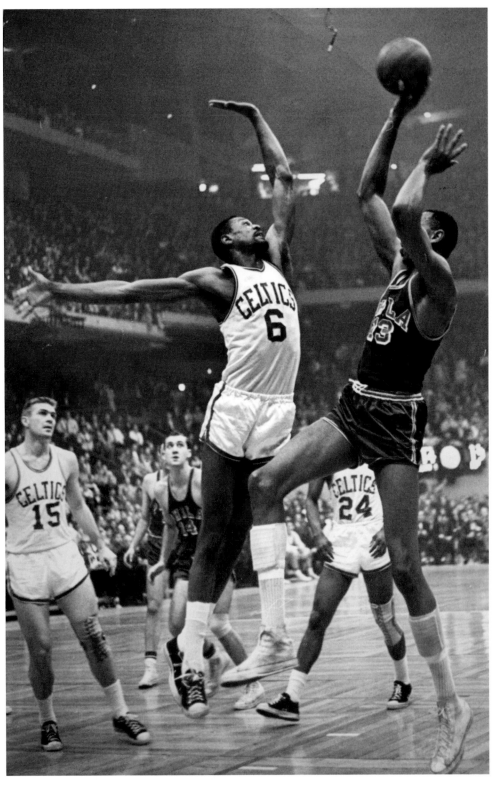

Bill Russell of the Boston Celtics revolutionized basketball with his defensive game, especially his shotblocking and rebounding. William Felton Russell led the Celtics to 11 championships in 13 years (1957-69) and won five MVP titles. His greatest opponent was Wilt Chamberlain. Here Russell reaches to block Chamberlain's shot for the Philadelphia Warriors on March 30, 1962, at the Boston Garden.

Downtown Boston from the air, in May of 1961, shows a city in change. The elevated Central Artery, slashing across the upper right from North Station to Quincy Market, is now open to traffic. In the extreme upper left, the buildings of the West End have been leveled. Scollay Square, the shorter brick buildings to the left of the Central Artery, will soon be replaced with the Boston City Hall and Government Center.

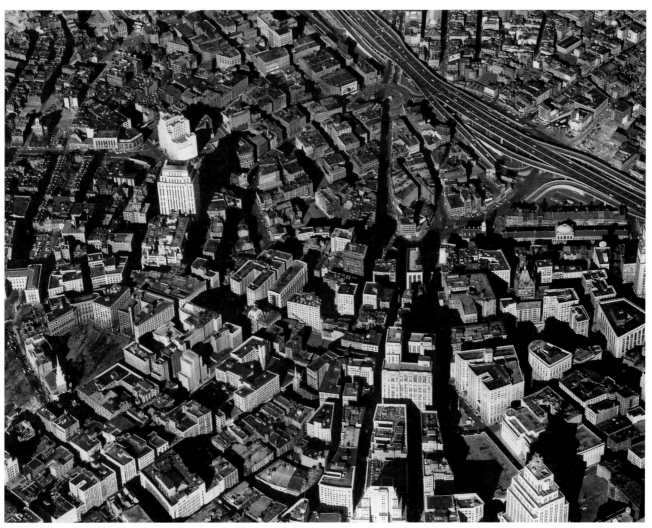

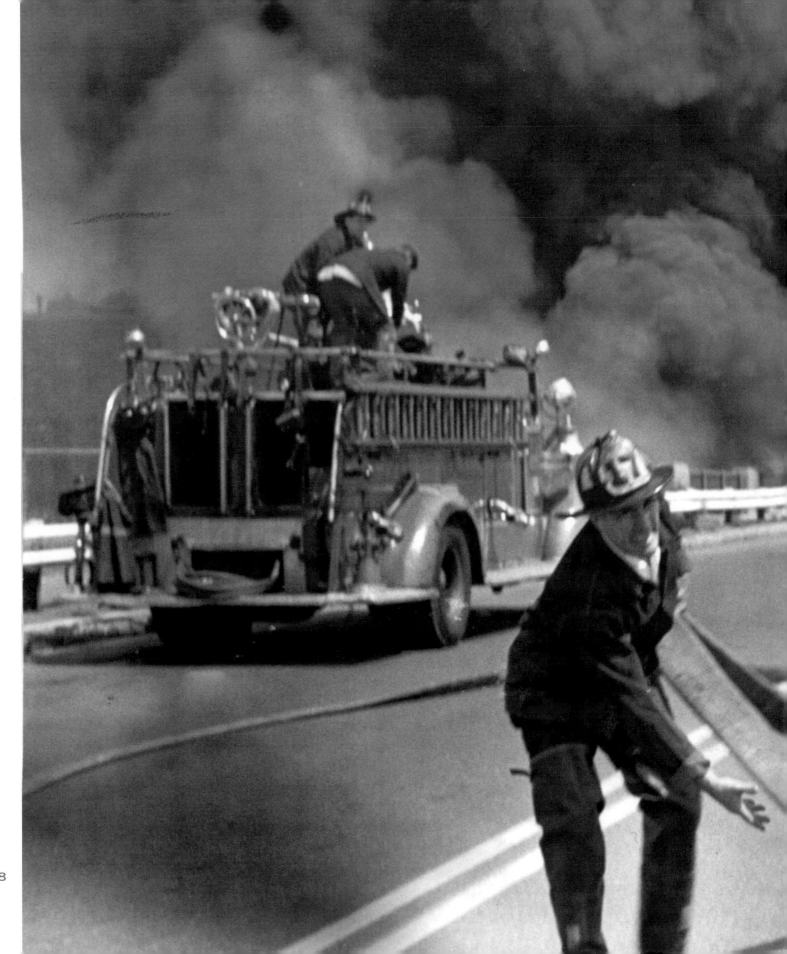

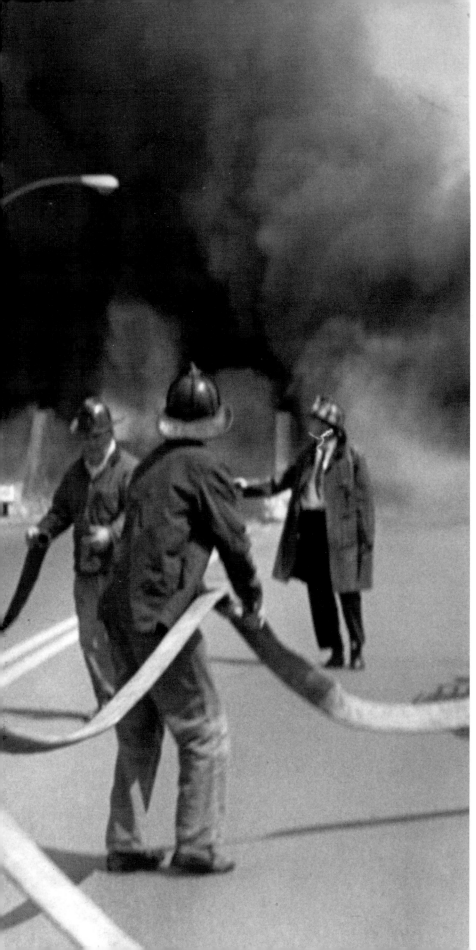

Fire destroys the Dover Street Bridge, over the Fort Point Channel, on July 21, 1965. Despite the best efforts of firemen, a 50-foot section of the bridge collapsed.

NOTES ON THE PHOTOGRAPHS

These notes, listed by page number, attempt to include all aspects known of the photographs. Each of the photographs is identified by the page number, photograph's title or description, photographer and collection, archive, and call or box number when applicable. Although every attempt was made to collect all available data, in some cases complete data was unavailable due to the age and condition of some of the photographs and records.

II BOSTON UNIVERSITY IN COPLEY SQUARE
Boston Public Library, Print Department
#46074

VI BOSTON AND LOWELL
Photo by Baldwin Coolidge
Boston Public Library, Print Department
#76620

X BOSTON AND PROVIDENCE
Boston Public Library, Print Department
#06277

3 CATHEDRAL OF THE HOLY CROSS
Boston Public Library, Print Department
#76681

4 LEWIS AND FULTON STREETS
Boston Public Library, Print Department
#30740

5 THE FRANKLIN STATUE
Boston Public Library, Print Department
#93995

6 INDIA AND CENTRAL WHARVES, 1857
Photo by Leslie Jones
Boston Public Library, Print Department
#07005

7 OLD NATIONAL THEATRE
Boston Public Library, Print Department
#76503

8 FEDERAL STREET CHURCH
Boston Public Library, Print Department
#07544

9 OLD TORRENT 6
Photo by A. H. Folsom
Boston Public Library, Print Department
#76142

10 OLD SOUTH MEETING HOUSE
Boston Public Library, Print Department
#19050

11 OLD MASONIC TEMPLE
Boston Public Library, Print Department
#93874

12 FANEUIL HALL SQUARE
Boston Public Library, Print Department
#76059

13 CENTRAL WHARF
Photo by Heywood
Boston Public Library, Print Department
#93370

14 U.S.S. KEARSARGE
Boston Public Library, Print Department
#53294

15 MASS. INSTITUTE OF TECHNOLOGY
Boston Public Library, Print Department
#32722

16 TEARING DOWN FORT HILL
Boston Public Library, Print Department
#06809

17 FRANKLIN STREET
Photo by James W. Black
Boston Public Library, Print Department
#76677

18 PEARL STREET
Boston Public Library, Print Department
#76617

19 UNION CLUB
Photo by James W. Black
Boston Public Library, Print Department
#06861

20 CITY SQUARE
Photo by James W. Black
Boston Public Library, Print Department
#84397

21 WATERFRONT OF BOSTON
Boston Public Library, Print Department
#93584

22 ROYAL ARCANUM
Boston Public Library, Print Department
#76138

23 BUNKER HILL MONUMENT
Boston Public Library, Print Department
#84350

24 WASHINGTON AND WARREN STREETS
Photo by Augustine H. Folsom
Boston Public Library, Print Department
#76141

25 CYCLORAMA BUILDING
Boston Public Library, Print Department
#76524

26 CITY SQUARE IN CHARLESTOWN
Photo by G. W. Freeman
Boston Public Library, Print Department
#84396

27 STATE STREET
Boston Public Library, Print Department
#76613

28 JOHN QUINCY ADAMS HOUSE
Boston Public Library, Print Department
#30752

29 ARLINGTON STREET CHURCH
Boston Public Library, Print Department
#77048

30 THE ADAMS HOUSE
Photo by Charles Pollock
Boston Public Library, Print Department
#77751

31 BOYLSTON MARKET
Photo by Baldwin Coolidge
Boston Public Library, Print Department
#76493

32 SCOLLAY SQUARE
Boston Public Library, Print Department
#76990

33 WASHINGTON STREET
Boston Public Library, Print Department
#76343

34 CHINESE FUNERAL #2
Boston Public Library, Print Department
#06673

35 HARVARD COLLEGE MEDICAL SCHOOL
Boston Public Library, Print Department
#29994

36 TRINITY CHURCH
Boston Public Library, Print Department
#94290

37 FANEUIL HALL
Photo by Frank T. Layden
Boston Public Library, Print Department
#06150

38 THIRD BATTALION, BOSTON LATIN SCHOOL
Photo by Augustine H. Folsom
Boston Public Library, Print Department
#76166

39 GRANITE BLOCK
Photo by Boston (Mass.) Street Department
Boston Public Library, Print Department
#mb_bk00137

40 THE OLD WELLS HOUSE
North End
Boston Public Library, Print Department
#53784

41 PILGRIM CHURCH
Boston Public Library, Print Department
#05_01_000301

42 CORNER OF PRINCE AND SALEM STREETS
Boston Public Library, Print Department#96033

43 TRIAL RUN OF SUBWAY CAR
Boston Public Library, Print Department
#23238

44 TRIAL RUN FROM PARK STREET STATION
Boston Public Library, Print Department
#76376

45 SOLDIER'S MONUMENT
Boston Public Library, Print Department
#06866

46 SUFFOLK COUNTY COURTHOUSE
Boston Public Library, Print Department
#53901

47 BOYLSTON STREET
Boston Public Library, Print Department
#77072

48 COPLEY SQUARE
Boston Public Library, Print Department
#76267

50 UNION OYSTER HOUSE
Boston Public Library, Print Department
#76240

51 ST. PETER'S CHURCH
Boston Public Library, Print Department
#06040

52 TREMONT THEATRE
Boston Public Library, Print Department
Photo by Reichner Brothers
#76485

53 PARK SQUARE
Boston Public Library, Print Department
#76661

54 POST OFFICE SQUARE
Boston Public Library, Print Department
#32509

55 MERCHANT'S ROW
Boston Public Library, Print Department
#76060

56 CASTLE SQUARE THEATRE
Boston Public Library, Print Department
#94279

57 PARK STREET
Boston Public Library, Print Department
#89155

58 TEMPLE PLACE
Photo by Thomas E. Marr
Boston Public Library, Print Department
#93915

59 MAJESTIC THEATRE
Photo by Reichner Brothers
Boston Public Library, Print
Department
#76487

60 BOSTON STREET SCENE
City of Boston Archives

61 BEACON STREET
Boston Public Library, Print
Department
#76401

62 OLD PROVIDENCE
RAILROAD DEPOT
Boston Public Library, Print
Department
#77213

63 VIEW OF THE WEST END
Boston Public Library, Print
Department
#76278

64 UNION STATION
Photo by Thomas E. Marr
Boston Public Library, Print
Department
#94386

65 VICE PRESIDENT
THEODORE ROOSEVELT
Photo by Thomas E. Marr
Boston Public Library, Print
Department
#84480

66 DEDICATION OF THE
GENERAL HOOK STATUE
Boston Public Library, Print
Department
#76435

67 PRINCE HENRY'S VISIT
TO THE STATE HOUSE
Boston Public Library, Print
Department
#89008

68 PARKER HOUSE HOTEL
Photo by Edmunds E. Bond
Boston Public Library, Print
Department
#89048

69 ENGINE ON
WASHINGTON STREET
Photo by Thomas E. Marr
Boston Public Library, Print
Department
#77430

70 LALLY BROTHERS
Boston Public Library, Print
Department
#02412

71 LOU CRIGER AND CY
YOUNG
Photo by Edmunds E. Bond
Boston Public Library, Print
Department
#st11320

72 JIMMY COLLINS
Photo by Edmunds E. Bond
Boston Public Library, Print
Department
#st10622

73 CROWD ON THE FERRY
Boston Public Library, Print
Department
#76247

74 SHERWIN-WILLIAMS
Boston Public Library, Print
Department
#06_01_000645

75 SPRING STREET AND
POPLAR STREET
Photo by Edmunds E. Bond
Boston Public Library, Print
Department
#02207

76 HANOVER ALLEY
Photo by Edmunds E. Bond
Boston Public Library, Print
Department
#06_01_000646

77 WASHINGTON STREET
Photo by Thomas E. Marr
Boston Public Library, Print
Department
#76581

78 PAUL REVERE HOUSE
Photo by Thomas E. Marr
Boston Public Library, Print
Department
#76829

79 CLEANING CREW
Photo by Thomas E. Marr
Boston Public Library, Print
Department
#77010

80 BOSTON PALACE CAR
Boston Public Library, Print
Department
#77025

82 SUFFOLK COUNTY
COURTHOUSE
Photo by Leslie Jones
Boston Public Library, Print
Department
#05_01_000282

83 SCOLLAY SQUARE
Boston Public Library, Print
Department
#76987

84 WALTER BROOKINS
Boston Public Library, Print
Department
#76845

85 SLEIGHING ON BEACON
STREET
Photo by Thomas E. Marr
Boston Public Library, Print
Department
#93920

86 CHAMBERS AND SPRING
STREETS
Boston Public Library, Print
Department
#53791

88 LOUISBURG SQUARE
Boston Public Library, Print
Department
#76957

89 CHARLESTOWN
Photo by Leslie Jones
Boston Public Library, Print
Department
#02377

90 HARVARD STADIUM
Photo by Leslie Jones
Boston Public Library, Print
Department
#st11286

92 HARVARD STADIUM FROM
THE AIR, AS IT USED TO
BE
Photo by Leslie Jones
Boston Public Library, Print
Department
#st10175

93 GRANITE WORKS
Photo by Leslie Jones
Boston Public Library, Print
Department
#06_01_000643

94 RED SOX AT FENWAY
PARK
Boston Public Library, Print
Department
#18902

96 CORNER OF MASS AND
WESTLAND AVES.
Photo by Thomas E. Marr
Boston Public Library, Print
Department
#02062

98 BOWDOIN SQUARE
BAPTIST CHURCH
Boston Public Library, Print
Department
#89149

99 NORTHERN AVENUE
BRIDGE
Boston Public Library, Print
Department
#77238

100 FIRST MASSACHUSETTS
MILITIA
Photo by Leslie Jones
Boston Public Library, Print
Department
#02190

101 BEACON HILL
Photo by Thomas E. Marr
Boston Public Library, Print
Department
#07199

102 INFANTILE PARALYSIS
Photo by Frank B. Conlin
Boston Public Library, Print
Department
#76444

103 MOLASSES DISASTER
Photo by Leslie Jones
Boston Public Library, Print
Department
#02143

104 PANORAMA OF THE
MOLASSES DISASTER
Photo by Boston Globe
Boston Public Library, Print
Department
#77103

105 COPLEY SQUARE
Photo by Leslie Jones
Boston Public Library, Print
Department
#02164

106 NORTHERN AVENUE
BRIDGE
Photo by Leslie Jones
Boston Public Library, Print
Department
#02375

108 NEW SPRINKLING
DEVICE
Photo by Leslie Jones
Boston Public Library, Print
Department
#06_01_000628

110 READVILLE TRACK
Photo by Leslie Jones
Boston Public Library, Print
Department
#st10594

111 GOV. COOLIDGE AND
BLACK JACK PERSHING
Photo by Leslie Jones
Boston Public Library, Print
Department
#89081

112 VIEW TOWARD DOCK
SQUARE AND NORTH
END
Photo by Leslie Jones
Boston Public Library, Print
Department
#29615

114 THE STATE HOUSE
Photo by Leslie Jones
Boston Public Library, Print
Department
#06902

115 HOTEL SOMERSET
Photo by Leon Abdalian
Boston Public Library, Print
Department
#02194

116 CHARLES PONZI
Photo by Leslie Jones
Boston Public Library, Print
Department
#02152

117 SOUTH BOSTON FISH
PIER
Photo by Leslie Jones
Boston Public Library, Print
Department
#96060

118 FIRE ENGINE
Boston Public Library, Print
Department
#23346

119 M.S.P.C.A. FOUNTAIN
Photo by Leslie Jones
Boston Public Library, Print
Department
#29754

120 HARVARD UNIVERSITY
Boston Public Library, Print
Department
#st10979

122 STUART STREET
Photo by Leslie Jones
Boston Public Library, Print
Department
#02326

123 LOEW'S ORPHEUM
Boston Public Library, Print
Department
#84876

124 FAN PIER
Boston Public Library, Print
Department
#29944

125 QUINCY MARKET
Boston Public Library, Print
Department
#06_01_000640

126 STUART STREET
Photo by Herald-Traveler
Boston Public Library, Print
Department
#84943

127 FANEUIL HALL AND
QUINCY MARKET
Photo by Leslie Jones
Boston Public Library, Print
Department
#06_01_000635

128 LINDY, CHAMBERLAIN, AND
BYRD
Photo by Leslie Jones
Boston Public Library, Print
Department
#07053

129 BUSY TREMONT STREET
Photo by Leslie Jones
Boston Public Library, Print
Department
#06_01_000625

130 AMELIA EARHART
Photo by Leslie Jones
Boston Public Library, Print
Department
#02026

131 Art Ross, Jr., and
Benny Grant
Photo by Leslie Jones
Boston Public Library, Print
Department
#st10565

132 Haymarket Square
Relief Hospital
Photo by Leslie Jones
Boston Public Library, Print
Department
#07663

133 Christmas Shoppers
Photo by Leslie Jones
Boston Public Library, Print
Department
#06_01_000642

134 Spirit of St. Louis
Boston Public Library, Print
Department
06_01_000618

135 Custom House Tower
Photo by Leslie Jones
Boston Public Library, Print
Department
#06_01_000623

136 Passenger Plane
Photo by Leslie Jones
Boston Public Library, Print
Department
#02122

137 North Street
Photo by Leslie Jones
Boston Public Library, Print
Department
#06810

138 Gillette Factory
Boston Public Library, Print
Department
#77227

139 United Shoe
Machinery Building
Photo by Leslie Jones
Boston Public Library, Print
Department

140 Boston Common
Photo by Leslie Jones
Boston Public Library, Print
Department
#06_01_000633

141 Copley Square
Photo by Leslie Jones
Boston Public Library, Print
Department
#30360

142 Neighborhood Boys
Boston Public Library, Print
Department
#06_01_000620

143 Commander Byrd
Boston Public Library, Print
Department
#06_01_000619

144 Horse on Stable
Roof
Photo by Leslie Jones
Boston Public Library, Print
Department
#06_01_000629

145 Pushcart Rush
Photo by Leslie Jones
Boston Public Library, Print
Department
#06992

146 Bathing in the Frog
Pond
Photo by Leslie Jones
Boston Public Library, Print
Department
#02654

147 American House
Photo by Leslie Jones
Boston Public Library, Print
Department
#06_01_000641

148 City Hospital
Photo by Leslie Jones
Boston Public Library, Print
Department
#84965

150 Sound Truck
Boston Public Library, Print
Department
#76371

151 State House
Photo by Leslie Jones
Boston Public Library, Print
Department
#02574

152 Guay's Bakery
Photo by Leslie Jones
Boston Public Library, Print
Department
#02525

153 Market District
Photo by Leslie Jones
Boston Public Library, Print
Department
#02033

154 Tremont Street
Photo by Leslie Jones
Boston Public Library, Print
Department
#89161

155 Big Blizzard
Boston Public Library, Print
Department
#89180

156 The U.S.S. Constitution
Photo by Leslie Jones
Boston Public Library, Print
Department
#02174

157 Bread Line
Boston Public Library, Print
Department
#76551

158 Women's Naval Reserve
Photo by Leslie Jones
Boston Public Library, Print
Department
#04991

160 Campaign Against
Prohibition
Boston Public Library, Print
Department
#76163

161 Readville Race Track
Photo by Leslie Jones
Boston Public Library, Print
Department
#st10466

162 Budweiser
Boston Public Library, Print
Department
#77040

164 Franklin Delano
Roosevelt
Photo by Leslie Jones
Boston Public Library, Print
Department
#02446

165 Fighting Fire
Photo by Leslie Jones
Boston Public Library, Print
Department
#st10188

166 RACE AT SUFFOLK DOWNS
Photo by Leslie Jones
Boston Public Library, Print Department
st10592

167 THE "NANTASKET"
Photo by Leslie Jones
Boston Public Library, Print Department
#06_01_000622

168 JOHNNY KELLEY
Photo by Leslie Jones
Boston Public Library, Print Department
#02141

169 CRADLE OF LIBERTY
Photo by Leslie Jones
Boston Public Library, Print Department
#06_01_000637

170 HOT DOG STAND
Photo by Leslie Jones
Boston Public Library, Print Department
#06099

171 VENDOR AND CART
Photo by Leslie Jones
Boston Public Library, Print Department
#53477

172 WAR'S END
Boston Public Library, Print Department
#93715

174 BUSY STREET SCENE
City of Boston Archives

175 SCOLLAY SQUARE
Photo by Leslie Jones
Boston Public Library, Print Department
#06_01_000632

176 OLD SOUTH CHURCH
Photo by Leslie Jones
Boston Public Library, Print Department
#06_01_000630

177 "SATCHELFOOT" PAIGE
Boston Public Library, Print Department
#st11288

178 "MEMPHIS BELLE" CREW
Boston Public Library, Print Department
#93721

179 JOHN F. KENNEDY WITH CHARLES A. MACGILLIVARY
Boston Public Library, Print Department
#77940

180 BOSTON INTERSECTION
City of Boston Archives

181 THACHER AND WASHINGTON STREETS
City of Boston Archives

182 BLUEHILL AVENUE AND QUINCY STREET
City of Boston Archives

183 BOSTON UNIVERSITY
City of Boston Archives

184 GAME AT SOLDIERS FIELD
Photo by Leslie Jones
Boston Public Library, Print Department
#st10309

185 DEDICATION OF THE MYSTIC RIVER BRIDGE
Photo by Arthur Hansen
Boston Public Library, Print Department
#77752

186 DOVER AND HARRISON
City of Boston Archives

187 CROSS STREET
City of Boston Archives

188 CROSSING THE STREET
City of Boston Archives

189 STREET SCENE, 1952
City of Boston Archives

190 IKE IN BOSTON
Photo by Leslie Jones
Boston Public Library, Print Department
#02427

191 GOLDEN PROPERTY
City of Boston Archives

192 NEW HIGHWAY
Photo by Leslie Jones
Boston Public Library, Print Department
#02067

193 MR. BASKETBALL AT WORK, BOB COUSY AT THE BOSTON GARDEN VS. THE KNICKS
Photo by Russ Adams
Boston Public Library, Print Department
#st10930

194 BLACKSTONE STREET
Photo by Leslie Jones
Boston Public Library, Print Department
#06_01_000636

195 COPLEY SQUARE
Photo by Leslie Jones
Boston Public Library, Print Department
#06_01_000624

196 "THE ETERNAL BATTLE"
Photo by Ollie Noonan, Jr.
Boston Public Library, Print Department
#st11340

197 1961 AERIAL VIEW
City of Boston Archives

198 DOVER STREET BRIDGE
Boston Public Library, Print Department
#77232